THE COMPLETE
COLOR
HARMONY
PANTONE EDITION

Inspiring | Educating | Creating | Entertaining

Brimming with creative inspiration, how-to projects, and useful information to enrich your everyday life, Quarto Knows is a favorite destination for those pursuing their interests and passions. Visit our site and dig deeper with our books into your area of interest: Quarto Creates, Quarto Cooks, Quarto Homes, Quarto Lives, Quarto Drives, Quarto Explores, Quarto Gifts, or Quarto Kids.

© 2017 Quarto Publishing Group USA Inc.

First Published in 2017 by Rockport Publishers, an imprint of The Quarto Group,
100 Cummings Center,
Suite 265-D,
Beverly, MA 01915, USA.
T (978) 282-9590
F (978) 283-2742
QuartoKnows.com

Rockport Publishers titles are also available at discount for retail, wholesale, promotional, and bulk purchase. For details, contact the Special Sales Manager by email at specialsales@quarto.com or by mail at The Quarto Group, Attn: Special Sales Manager, 401 Second Avenue North, Suite 310, Minneapolis, MN 55401, USA.

10 9 8 7 6 5 4 3

ISBN: 978-1-63159-296-6

Digital edition published in 2017

Library of Congress Cataloging-in-Publication Data

Names: Eiseman, Leatrice, author. I Pantone (Firm)
Title: The complete color harmony : new and revised, expert color information
 for professional color results / Leatrice Eiseman.
Description: Pantone edition. I Beverly, MA : Rockport Publishers, 2017.
Identifiers: LCCN 2017027148 I ISBN 9781631592966 (paperback)
Subjects: LCSH: Color--Psychological aspects. I BISAC: ART / Color Theory. I DESIGN / Decorative Arts.
Classification: LCC BF789.C7 E38 2017 I DDC 701/.85--dc23 LC record available at https://lccn.loc.gov/2017027148

Contributing Editor: Melissa Bolt
Design: Burge Agency
Cover Image: Glenn Scott
Photography: Shutterstock

Printed in China

THE COMPLETE
COLOR
HARMONY
PANTONE EDITION

EXPERT COLOR INFORMATION FOR PROFESSIONAL RESULTS

LEATRICE EISEMAN EXECUTIVE DIRECTOR PANTONE COLOR INSTITUTE

ROCKPORT

CONTENTS

FOREWORD: A JOURNEY IN COLOR

Imagine for a moment what it would be like to live in a world without color, a world where we could only see black and white and shades of gray. It is almost impossible for us to imagine as color defines our world. The first thing you remember and the last thing you forget, color is an identifier; the visual cue that engages us; drawing us in to feel a connection with our environment and the things we love.

Like artists and designers have done throughout time, many of us look to color as a fantastic way to express ideas and emotions; turning to bright and bold shades to convey energy or softer quieter shades when we want to create a feeling of calm. However, there is so much more to learn about the power of color and the role that this unique mode of communication plays in our lives. As the single most important design element in creating mood and style, the influence color has on our feelings, our well-being, and our perceptions cannot be underestimated.

This is something I don't think I fully appreciated until I came to Pantone and met Leatrice Eiseman. Like Dorothy waking up in the Land of Oz, Leatrice Eiseman unlocked a door; opening my eyes, leading me into her captivating world of color where I discovered a new language and a new way of being.

Color plays such a vital role in conveying a message and establishing an ambiance. As Executive Director of the Pantone Color Institute and author of this book, Lee Eiseman has filled its pages with colorful inspiration and ideas as well as colorful combinations to help you create the magic and the mood you are looking for. Throughout these pages Lee has used the PANTONE PLUS color palette so you can match your color choices exactly. Having a precise way to communicate and replicate your color choices will help ensure you are able to accurately bring your colorful vision to life.

We at Pantone congratulate Lee for this beautiful book; we appreciate her unique color savvy and thank her for all of her work in consumer color research, color trend forecasting, and color education, which she has so generously shared.

To my guide, my mentor and my colorful hero, Leatrice Eiseman; I cannot thank you enough for unleashing my creative spirit: you inspire me every single day and it is through your tutelage that I learned so much and have come to love and embrace all that this magical world of color has to offer. And to you, our reader, whether you are first learning about color or are already an acknowledged color aficionado, we hope this book will open your mind, arouse your imagination, and, most importantly, color your world.

Laurie Pressman, Vice-President, Pantone Color Institute

INTRO: **COLOR HARMONY**

From the time we were tiny children, we innately understood that color is a vital part of our lives. When offered a box of crayons, we scribbled with great delight and abandon—never mind staying within the lines of the coloring book. Color provided the freedom to express ourselves, gaining approval and appreciation from doting parents.

As we grew older, we became more conscious of the emotional components of color and how effective it can be in directing and diverting the eye. In fact, there are subtleties and nuances in numerous hues, tints, tones, shades, and intensities to excite or calm, pacify or energize, and even suggest strength or vulnerability. They can nurture you with their warmth, soothe you with their quiet coolness, and heighten your awareness of the world around you. Color enriches the universe and our perception of it.

We respond to color at a very visceral level and our preferences can often be the key to understanding memories and buried emotions. They can produce what is termed a mnemonic association by reminding us of another time or place. Throughout our waking hours and even in our dreams, color is a constant presence.

There is color in landscape and seascape, and a riot of color under a tropical sea or in a rainforest. The desert yields subtle tonal variations of sand and dunes, and even the snow-covered North Pole shows variations of white, depending on the weather conditions. The native people who inhabit the region apply a multitude of different names to the varying shades of white.

Because of color, we take pleasure in the wonders of nature—a glowing orange, vermillion, and lavender sunset; the magenta and purple pattern on butterfly wings; the iridescent spread of teal and cobalt blue of a mallard duck floating on a peaceful pond; the changing green leaves of autumn to russets and golds; and the aubergine leaves on the forest floor.

From a broad perspective, animals are colored for disguise or for display, especially in attracting a suitable and healthy mate. A male locust turns vibrant yellow when it is sexually mature. A male peacock proudly spreading his wings is impossible to ignore against any background, while some species of frogs and chameleons are capable of changing color to suit their environment to escape predators. The survival of the fittest is well served by color.

As for humans, from a purely practical standpoint, color is essential to our very existence, as it enables us to judge the freshness of ripe fruit, berries, vegetables, and other foodstuffs. It helps us to identify birds, insects, fish, flora, and fauna—those to enjoy and those to avoid, or at least, to exercise some caution around them. It can inform us that we must stop at a red light and go on green. Color stimulates and works synergistically with all the senses—sight, smell, hearing, taste, and touch, evoking enjoyment, or, at the opposite extreme, repulsion and rejection.

Wassily Kandinsky, the renowned abstract artist, heard the sound of musical instruments when he painted. He stated: "The sound of colors is so definite that it would be hard to find anyone who would express bright yellow with base notes or dark lake with the treble." Kandinsky seemed rather an eccentric in his day, but recent research shows that a condition called synesthesia exists and Kandinsky was one of the rare individuals who had it. It is defined as a condition in which one sense (for example, hearing) is simultaneously perceived by one or more senses, such as sight. So it is a double-whammy of two senses working synergistically together, especially when color is involved. To call it a "condition" as if it is a medical affliction seems rather strange to some of us, as we would welcome that multi-sensory experience with color!

Color can mark territory, provide way-finding in difficult to navigate spaces, manage personal space, and, along the way, create illusions or ambience. It is a major identifier for tribal groups, whether in a remote region of the world or on the playing field.

On a personal level, color can emphasize physical features or provide camouflage where needed. And, most certainly, as demonstrated by the cosmetic, hair coloring, grooming, and fashion industries, color can enhance self-image and self-esteem.

By creating an emotional connection in the human mind, color can express and give meaning to fantasies and aspirations, and provide wish-fulfillment. Scientific evaluations

actually given great attention much earlier. In 1810, the highly respected German writer and philosopher, Johann Wolfgang von Goethe, published his treatise titled Theory of Colors, in which he studied and wrote about several color families.

He said about green:

"The eye experiences a distinctly grateful impression from this color."

About yellowish red, he stated:

"The active side is here in its highest energy, and it is not to be wondered at that impetuous, robust, uneducated men, should be especially pleased with this color."

Studies show that green is indeed still considered a restful color to the eye. However times and tastes can change and although red would still be regarded as a symbol of the highest energy, a red power tie or scarf could be very effectively worn by any man or woman, whether educated or not!

Currently, through credible testing, research, experience, and marketing studies, information gathered about the psychology of color is understood as a primary resource for arriving at the colors for all design areas, including product development, industrial design, graphics, packaging, print, websites, and signage, as

well as fashion, personal image, cosmetics, interiors, crafts, and floral design.

Equally important, at every level of the marketplace, color emphatically establishes a brand image and testifies to the qualities and goals of the company it represents. There is a brand equity that is built around the thoughtful use of color that suggests an appropriate emotional ambiance or mood. And that is what this book is all about—color and the creation of mood. It is for the professional involved with color in any field or anyone else fascinated by color.

Knowledge, judgment, and intuition are all involved in mastering color. Harmonious colors can be found in traditional teachings, such as the use of the color wheel, but times, tastes, and trends can and do change and along with them, the "directives" for harmony. What you will find in the following pages are not rigid rules, but flexible guidelines that will help jumpstart your imagination or validate your thinking.

The famed artist, author, print-maker, educator, and color theorist, Josef Albers compared good coloring to good cooking—they both demand repeated tasting.

Read on for the recipes.

of the physiological and psychological influence of color and color combinations show us that hues do take on a persona that can broadcast messages and meanings to the world at large.

The psychology of color might seem to be a relatively new area of study, refined and researched extensively beginning in the twentieth century. But the emotional meaning of color was

THE PHENOMENON OF COLOR

Light is the source of all color and our sense of sight functions only when light reaches the eye. There is no perceptible color without natural or artificial light. Poetically put, light is the messenger and color is the message.

To see fine details precisely, the eye contains a lens that can focus light onto the sensitive cells within the retina, triggering nerve impulses connected to the brain, where a visual image is formed. There are two types of light sensitive cells called rods and cones. Rods work in dim light, while cones, responding only in bright daylight, contain pigments sensitive to the different spectral wavelengths.

Visible light waves are among several forms of electromagnetic energy and the forms of energy differ as they travel at different wavelengths. The quantity of electromagnetic energy determines the luminance. Specific waves of energy are referred to as the "visible spectrum" and every hue has

author presumes do contain all the colors and tints in nature when mixed or blended with each other in various proportions of their powers."

Taking nature as his "guide and assistant" he terms the principal colors "the primitives," while orange, green, and purple, the "mediates," stating "these are the colors with which she (Mother Nature) has decorated most of her flowers."

While we know there are many more examples coming from nature and beyond, the color wheel does provide some basic understanding that can aid in choosing effective color combinations. However, the color wheel should not be regarded as the only source for creating combinations. They can also be spawned from the imaginative and innovative designer's mind, or for any other reader of this book who chooses color based primarily on the moods they create. The emotional impact and the psychology of color also come into play and they will be explored in another chapter.

its own wavelength which determines its place in the spectral order. Between each of the hues there are gradations of color.

Awe-inspiring rainbows are the most beautiful examples of this spectral order, with red having the longest wavelength and violet the shortest.

In 1672, Sir Isaac Newton, an English physicist and "scientific intellect," developed a theory of color based on his research proposing that a prism decomposes white light into the many colors of the visible spectrum. He was largely responsible for demystifying and clarifying the origin of light and color. In his work "Opticks," he stated, in a rather "olde English" fashion: "The Rays, to speak properly, are not coloured. In them there is nothing else than a certain Power and Disposition to stir up a sensation of this or that colour. So Colours in the Object are nothing but a Disposition to reflect this or that ray more copiously than the rest."

A more modern way to put it is that when a lemon appears yellow, it is because the surface of the fruit reflects yellow rather than because it actually is yellow. Similarly, the sky is blue, the grass is green, and parrots can be red, orange, or purple because, when struck by light, they each reflect a specific color and absorb all the others.

We do have to credit the prolific Sir Isaac for the invention of the very first color wheel as he "bent" his experimental rays into a circle. However, almost 100 years later, another Englishman, engraver and entomologist Moses Harris, published the "Natural System of Colors." This is the true granddaddy of more complex color wheels and still serves as a model for modern-day wheels. In Moses' own words: "The present mode adapted from this attempt is to discover all the variety of colors which can be formed from Red, Blue and Yellow; which three grand or principal colors the

A COLOR CONVERSATION: DEFINING THE BASIC TERMINOLOGY

Become more conversant in color with the following definitions that clarify and express the most basic terminology.

Hue

Hue is a synonym for color that distinguishes one from another. The spectral hues of red, orange, yellow, green, blue, and purple are referred to as chromatic. Black, white, and gray or other grayed neutral shades are referred to as achromatic, meaning "without color." However, in a broader sense, they are treated as colors because of their visual and psychological presence.

Value

The relative lightness or darkness of a color is called its value, depending on the amount of light the hue reflects. When light-reflecting white is added without changing the hue, it is called a tint or high value color. When light-absorbing black is added and a color is darkened without changing the hue, it is called a shade or low value color. Pink is a high value of red and burgundy is a low value. A mixture of light and dark values of the same hue is called a medium value.

A value pattern refers to the arrangement and amount of variation in light and dark. When the value contrast is minimal and kept to a limited range with small variations, the result is restrained, subtle, discreet, and understated. Soft edges are created by arranging colors in close value, while drama, excitement, and/ or conflict are expressed through sharp changes in value. Where extreme light and dark contrast come together, a center of attention is created called a focal point.

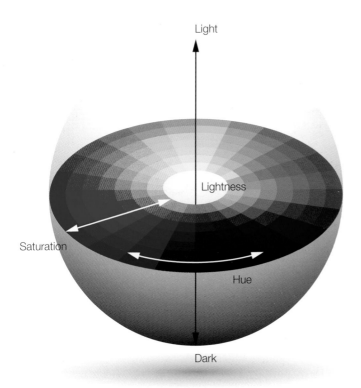

Light

Lightness

Saturation

Hue

Dark

Trace/Tinge
A trace or tinge is a barely discernible hint of a hue.

Tone
A pure color that has been modified by the addition of black or gray (a shade) or white (a tint) is called a tone. It is sometimes used interchangeably with tint and shade and referred to as tonal variation. Tone is sometimes used interchangeably with the word hue, or any slight variation from a hue, as in a tone of blue.

Tonality
Tonality describes a color scheme or a range of tones.

Undertone
Undertone denotes an underlying color within any given hue. For example, red in reddish-violet, blue in grayish blue. Another term for undertone is "cast", as in black with a brown cast and taupe with a rose cast.

Shade
Although a shade, technically, is the modification of a pure color by the addition of black or gray, the usage of the word has been expanded to be synonymous with hue or color.

Shading
Shading reflects the effects of shadow on flat surfaces or three-dimensional forms made by gradations of gray or color.

Palette
A palette is a group of colors often used to describe an overarching mood or theme.

Additional synonyms for lighter values are: light or lightness, reflectivity, and, for deeper values: density, depth of shade, and darkness.

Saturation
Saturation or chroma describes the intensity and strength of a color; how much or how little gray it contains. Maximum chroma describes a hue in its purest form. The purer a color, the more it approaches the colors of the spectrum and the greater its saturation. The grayer and more neutral a color, the less its saturation. Royal blue is a color of strong chroma or saturation; powder blue is a color of weaker chroma or saturation.

Colors that are not grayed and are at their ultimate brilliance are said to be at their fullest intensity. The most commonly used words to describe strong saturation

or chroma are: strength, clarity, purity, brilliance, richness, boldness, vividness, intensity, and truth. Lowered saturation levels may be described as subdued, diffused, misty, dusted, subtle, soft, toned-down, muted, restrained, hushed, understated, and quiet.

The perception of a color is greatly altered by its value or saturation. A darkened value of purple, such as plum, is more powerful than a lightened softer value of lavender. An intensely saturated chartreuse is more exhilarating than a pale, grayed celadon green.

In planning a color scheme, value and saturation are as important as the choice of a hue.

Tint
A lightened color, because of the addition of white, is called a tint. Pale or pastel colors are tints.

Color wheel—
labeling warm and
cool areas, primary,
secondary, and
tertiary colors.

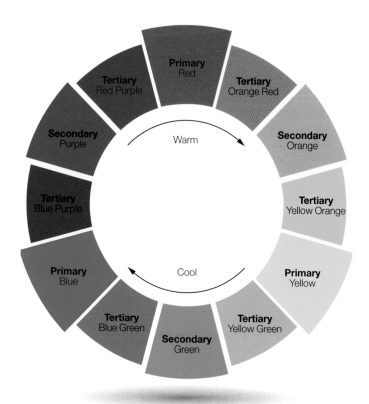

THE COLOR WHEEL: WHAT'S THE TEMP?

The color wheel illustrated in this book is far less complicated than some historic versions, yet it still effectively illustrates the positioning of the primary, secondary, and tertiary hues. The primary hues are red, yellow, and blue, although black and white are also needed to make a complete range of colors. The secondary hues, orange, purple, and green, are each obtained by mixing two of the primaries. Resulting from a combination of a primary hue and a secondary hue, the tertiary shades are: red orange, yellow orange, yellow green, blue green, blue purple, and red purple, although the term has been extended to darkened tones such as brown and maroon.

A very important aspect of the wheel as a tool is that it demonstrates that color is perceived as having a temperature: hot or cold, warm or cool, or somewhere in between. These are vital components in delivering a specific color message. Colors are perceived of

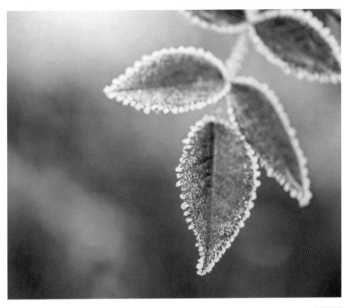

as having differing temperatures because of ancient and universal associations. Red, orange, and yellow radiate warmth as they are associated with the heat of fire and sun, while blue, green, and purple cool things down as they connect in the mind's eye with broader expanses of sky, sea, foliage, and outer space.

Generally speaking, combinations of warm colors send a more energetic, outgoing, dynamic message that effectively demands attention. Physiologically, warm colors actually do advance to the eye. Cool colors recede, making them seem more distant, restrained and calm. The eye discerns warm colors more immediately than cool. However, a vivid, pure, cool color can appear to visually advance and almost overwhelm a subtle, grayed, warm color. As cool hues grow more vibrant, so do their personalities and messaging.

Changing the undertones of a color can alter the temperature a bit. The redder a purple, the hotter and more provocative it becomes; bluer purples are less sensual and more meditative. Yellow reds are hotter than blue reds. Blue greens are as cool as the lagoon-like bodies of water that inspire them, while earthy yellow greens have quite the opposite effect.

Both the green and purple families are the most adaptable to a change of temperature because they bridge the gap between warm and cool on the color wheel. Orange is viewed as the hottest color, while blue is seen as the coolest.

A color's relationship to adjacent colors often determines how cool or warm it appears. In monochromatic combinations of the red family, a blue red would be viewed as the coolest color, in a different combination combined with blues, blue red would be seen as the warmest tone.

The intensity or value of a color can alter both the perception of temperature and the psychological message of a hue. For example, icy blue appears to be wet, cold, and silent. Electric blue, just as the name implies, suggests a bolt of lightning, excitement, and vibrancy, while dark blue suggests the ocean's depths—intense and substantial.

The psychological association of a color can often be stronger than the visual impression.

WHIRLING THE WHEEL: COLOR COMPATIBILITY

The classic color wheel renders some basic terminology and guidelines for color selection. Note the use of the word "guidelines" and not "rules." Most of the following color schemes are based on the positioning of the colors on the wheel and provide standard harmonies of color, while others tweak conventional thinking about color compatibility.

However, when you need a bit of direction, inspiration, or simply need to kick-start a concept, color terms and guidelines can help to push the process along. There is no right or wrong here, simply alternatives that will enlighten and encourage you to play with the possibilities.

Monotone

A monotone scheme is the use of a single neutral in varying tints and shades. Off-whites, beige, grays, and taupe (also called greige) are among the most-used neutrals. Pure white is not literally a neutral as it does not offer the versatility or variations of the off-whites. Pure white is truly an eye-catcher and is perceived as brilliant because of its highly reflective glare. While that might be a disadvantage in interior spaces, in packaging or advertising it can call out as loudly as a chromatic color. Similarly, classifying black as a neutral is questionable as it is such an imposing visual and psychological presence.

Neutrals are non-offensive and subtle. However, there are many nuances and undertones that can express either warmth or coolness. To best get the message of temperature across to the viewer, all undertones should be consistent when using neutrals together.

There is a downside to using monotones as they can get monotonous. That is easily remedied by using different textures, finishes, and forms within the same color family. This could work in many applications, from fashion and interior design applications with obvious tactile qualities, to imagery or packaging that creates the illusion of texture. For example, a metallic silver gray against a light gray matte background adds a touch of elegance and alleviates visual boredom.

In actual usage, monotone schemes seldom are totally neutral. A room done in varying tones of beige may have a large window where the outdoor colors become part of the ambiance: a container of wildflowers might pop on a table of an all-white room, a pastel watercolor will bring color effects into a dove gray atmosphere, no matter how subtle.

Monotone schemes are also not absolutely neutral when used in clothing because the personal coloring of the wearer provides contrast. In signage, packaging, advertising, and other graphic applications, monotones can appear to disappear if they are so muted as to be unreadable. Then it can be necessary to either outline the neutral or to provide another contrasting hue to the scheme.

Monochromatic

Monochromatic color schemes use only one hue family in varying tints, tones, and shades. If the hue is red, for example, the variations are very broad, starting with the slightest tinge of a pale rose to the richest jewel tones of a faceted ruby. This is a scheme that emphasizes a specific color family, making it a very effective tool for capturing the essence and message of any color family.

Monochromatic schemes can be dramatic in special settings, such as costuming or lighting for stage or film. But they can be equally effective in graphic design applications that highlight either blended effects or appreciable contrast.

Analagous

Because of their proximity on the color wheel, analogous colors are among the most harmonious and foolproof of color schemes. They are also referred to as adjacent or neighboring hues. A classic analogous set—one primary, one secondary, and one tertiary— are adjoining hues, and flow quite easily from one to another, for example, blue, blue green, and green. As these colors share the same undertones, they will always please the eye and bring a sense of harmony to the mix.

When an analogous combination spans one quarter of the color wheel, harmony is guaranteed. However, reaching out just a bit further to include a segment of another adjoining color, such as green, blue green, blue and blue purple can add a new dynamic to the mix.

To offer even more variety to an analogous grouping, a wide range of light and dark intensities can be added. Introducing neutral tones and/or complementary tones gleaned from across the color wheel can add an interesting contrast to the picture (see complementary colors.)

Interestingly, when an orange chair bought online arrives and it seems outrageously brighter than what was seen on the screen (and there is no option to exchange it) an adjoining color like a yellow-orange pillow can help to extinguish the fire a bit. It seems a bit counter-intuitive, but it does work.

Complementary

The word "complimentary"—with an "i" in the middle—means "flattering" (or perhaps a free ticket to a concert). In color parlance, the word complementary—with an "e" in the middle—refers to hues that lie directly across the color wheel from each other. They are called complementary as the literal meaning is "that which completes or makes perfect."

Although the concept of perfection is in the eye of the beholder, we do know that colors coupled as complementaries exhibit a natural balance; every pair contains a warm and a cool hue. In grade school, a teacher might have tried this optical illusion test on you. You would have stared intently at a color for a minute and when you looked away to a white surface, the complementary color appeared. This was not a magic trick, but the physiological reality of what is called an after-image.

The after-image phenomenon has been used to great advantage in operating rooms where medical personnel concentrate on red (as in blood and tissue) to the point of tiring the nerve endings in their retinas. Hospitals have long used soothing greens and blue greens in the OR to rest the eyes of the attending nurses and surgeons.

This same solution to tired eyes would work in industry as well. In a cosmetic lab where quality control focuses on reddish nail polish or lipsticks and then looks away to a white wall, a green after-image appears. It might help to soothe the eye, but it doesn't help if the co-worker appears to have a green halo around his or her head. The solution is to paint the wall a blue green, a soothing and popular variation of green, and the after image would be negated.

Complementary colors enhance or emphasize the qualities of their opposites. The selection of specific opposites should not be too restrictive as colors should be thought of as families. The yellow family is enhanced by supportive purples, the orange family is balanced by the blues, while reds and greens, whether blue-based or yellow-based, have a natural affinity.

When complements are placed immediately next to each other, they appear more intense. This is called simultaneous contrast—each complement intensifies

the brilliance of the other and seems to visually vibrate along the edge of the area where they come together. This perception of seeming movement can be used to great advantage in sports gear, flags, banners, advertising, packaging or websites that depict activity.

Intense colors might also shift slightly, depending on the color of the background, often moving to the complement of the background color. For example, placed against a purple background, bright green will shift somewhat to yellow green because purple is the complement to yellow. This is termed successive or consecutive contrast. The outcome of consecutive contrast is not always a consideration when we view printed textiles, surfaces, advertisements, and digital devices, because our eyes rarely fixate on one point but move quickly from one area to another.

In interiors, bright complementaries might get a little raucous—not necessarily a good thing for a hyper-active kid or adult. When intense or strongly contrasting shades are offset by neutrals, such as taupe, gray, or beige, the combinations get more manageable. The neutrals provide a buffer to the bright contrasts, making them easier to view.

Try to think outside the circle when considering the use of

complementary combinations. Step beyond the stereotypical suggestion, for example, of a red and green together that will most often conjure up a mental picture of Christmas tree ornaments or stoplights. Translate red and green into deepened shades of wine and teal and a sophisticated, complex, and upscale combination emerges.

Conversely, lightening complementary couplings to pastels can afford many beautiful and easy-to-live with alternatives, such as apricot and cerulean blue or heathery violet and a hazy golden yellow.

Complementaries can also be used effectively to revive a faded look. Patterned towels laced with leafy greens can be an antidote to the tired pink tiles of a bathroom in need of an update. A faded blue chair in a sunny room can be resurrected by placing a touch of coral on the wall behind it or the pillow sitting on it.

From a personal stand-point, the complexion can also be affected by bright complementaries. A flushed or ruddy skin will appear even more so when a bright green is worn. A lightened or deepened green is a better alternative for a florid skin. Blonde hair will appear shinier and more vibrant when vivid violet is worn, and hazel-green eyes sparkle next to garnet red.

Split Complementary

A split complementary scheme utilizes a hue from one side of the wheel with the two hues that lie on either side of the complement directly opposite. Nature offers some of the most magnificent examples of this scheme. For example, purple combined with both yellow orange and yellow green. This makes for a visually stunning combination, one that is both complex and uniquely diversified. These hues can be lightened or darkened for various effects.

Triads

A scheme of triads utilizes three equidistant hues on the wheel, either primary, such as red, blue, and yellow or the secondary tones of orange, green, and purple. In the brightest intensities, the primaries are more spirited, primitive, and /or childlike. In less saturated or deeper values, they're not quite as noisy. Orange, green, and purple are more complex and off-beat as bright combinations, but they too can be lightened, darkened or grayed. These types of combinations can create elegant, interesting, or unusual combinations such as fuchsia, terra cotta and a deep lichen green.

Tetrads

Tetrads utilize four colors that are actually two sets of complementary colors. This scheme can get complicated, and it can be a challenge for even the most practiced and creative eye, but the results can be exceptional. In brighter variations or prints, such as paisleys that involve different levels of color, including midtones and pastels, tetrads can be extremely dramatic and eye-arresting.

COMPLEX COLORS

Colors that display variation in texture or in the hue itself are referred to as complex. This also includes colors that change subtly under ambient light as in pearlescent or opalescent shadings. Beautiful fabrics such as silk shantung, dupioni, and taffeta, exhibit these chameleon qualities. The colors themselves are frequently described in more complex ways, often involving an "ish" word, for example: a cool, greenish blue or a subtle, mauve-ish purple.

Various metallic treatments have a changeable quality, especially as recent technologies, such as those developed in the futuristic techniques coming from the auto and electronics industry, have rendered even more special effects. This intriguing and visually appealing complexity is also frequently found in jewel tones, gemstones, and minerals.

We all understand the endless quest for seashells on the shore, particularly when prying open a homely shell reveals delicate patterns of coloration. We're in wonder at the display of a peacock, the markings of a butterfly or a mallard duck, and are fascinated by shimmering shades even while navigating a mundane oil slick on a grimy street.

On a cosmetic counter, a drugstore shelf, or in artfully crafted ads, the luminosity, glitter, and glam of nail polishes and eye shadows in striated finishes and colorations irresistibly transfix and tempt us to purchase even more than we already own.

Social anthropologists tell us that the human eye is inevitably drawn to changing color patterns as they often undulate in the same way that a body of water moves and changes. The rationale is that because humans need water in order to survive they are also drawn to the fluctuating movement of changeable colors. Whether we're thirsting for an object of beauty, or simply thirsty, we can't deny that there is a fascination for complexity in color.

At the opposite extreme are the fluorescent colors. First developed by two American brothers, Bob and Joe Switzer, in the 1930s, the uses of Day-Glo, or fluorescents, really took off by helping in the war effort of the 40s. The colors were used on fabric panels to send signals from the ground that could be seen from the air. They were also used in lifeboat panels to gain attention for rescue as well as in buoys to show that mines had been cleared from an area. Crews clad in Day-Glo suits lit by ultraviolet lamps guided planes to night-time landings on aircraft carriers.

After the war, Day-Glo made its way into signs and soap boxes, traffic cones, dump trucks, golf balls, goalposts, hula hoops, and the cover of *Popular Science* magazine. The use of these color effects continued in fits and starts through neon lights and black light posters, not to mention punk hair color.

More current usage shows both a fashionable and practical side to the use of fluorescents. They are a natural for signposts and the vests of highway workers. They are being used in sports gear and sports clothing—a fashion statement all its own. In addition there is the safety factor of using or wearing these bursting brights. They are also a natural for toys, bikes, and other consumer goods that beg for attention.

DISCORD AND DISSONANCE

In the world of music, the dictionary meaning of harmony is "a combination of simultaneously sounded musical notes to produce chords and chord progressions having a pleasing effect." With a slight change of verbiage, the same could be said for color.

We all love a pleasing effect, but there is also a case to be made for discord and dissonance in musical progressions that provide drama, intrigue, mystery, and other emotional components to the sound of music. Likewise, discordant colors can provide unique color combinations, surprise the eye, provide whimsical new approaches to an object, subject, or product while expressing specific ideas and concepts. Advertising, packaging, display, fashion, cosmetics, and theatrical settings have certainly made good use of attention-riveting discord.

Standard pathways for harmony can be side-stepped or even ignored as they do not apply to discordant combinations. The fashion industry has seen a steady rise of what is referred to as "power clashing"; combining styles, patterns, and colors that defy the standard rules of dress. As we well know, what starts in fashion can easily spill into other

areas of design. There are several approaches to power clashing. One is the all out mash-up where nothing really matches. If your personal take on color means coordinated or matching pieces, power clashing can be downright offensive: Wearing polka dots, plaid, and herringbone all in different colors is not for you—It might remind you of an old uncle whose style sense was not the greatest.

Your personal color sensibilities might tell you that some linkage between the differing patterns will pull it all together. That is where color comes in, whether in your choice of clothing or in your work, creating a visual pathway and a connecting link.

Interestingly, clashing in both style and color started in interior design well before it gained momentum in fashion. Leopard-like prints on a gilded chair, perhaps a traditional Burberry-type plaid on another, a multicolored-floral patterned carpet and mismatched pillows are not untypical of what can be seen in the home décor of some of the very rich and famous. It's not for everyone, especially those who prefer minimal to maximal. However, as the glossy shelter magazines and television makeover shows have presented in recent years, the choice is there for a more eclectic and diverse approach in style and color.

Discord truly lies in the eye of the beholder. What is unpleasant and jarring for some tastes might be stimulating and exciting for others. "Perfect harmony" (if that truly exists) is not always the goal of a color combination. Discordant color can be used intentionally to manipulate emotion—to arouse, disturb, titillate, exaggerate, or to create tension. If the dissonance is used thoughtfully, it can be a powerful tool in the marketplace.

THE PSYCHOLOGY OF COLOR

Color invariably conveys moods that attach themselves to human feelings or reactions. Part of our psychic development, color is tied to our emotions as well as our intellect. Every color has meaning that we either inherently sense, or have learned about by association and/or conditioning, which enables us to recognize the messages and meanings delivered.

A large part of our associational reaction to color is related to natural phenomena.

For example, yellow is the color most often attached to the warmth and joyfulness of the sun and blue to the constant presence of the sky and the ultimate dawning of another day.

We also anticipate certain tastes that come with specific colors. Orange juice is expected to be tangy and perhaps a bit sweet. Lime is even zestier and more pungent. We are taught to stop at a red light as that can signal danger, and there is the promise of safety when green signals go.

We also have specific reactions to color that are spawned by a belief system founded in specific principles. In the Catholic Church, purple is the color of Lent and repentance. Paradise is described in the Quran as a place where people will wear fine green garments.

There are certain cultural, historical, and traditional aspects of color that can also shape the perceptions of color that are passed on from generation to generation with or without the benefit of personal experience. In the Chinese practice of Feng Shui, red is the symbol of prosperity. In Greece, as well as many other areas of the world, blue is the most protective color.

There is political symbology that is reflected in color as well. Orange became the color of protest in the Ukraine as the result of a disputed presidential run-off. Black has been associated with both anarchism and

authoritarianism while white is linked to pacifism or surrender.

Humanitarian causes and movements are also identified with specific colors. Pink has long been identified as the color for Women's Breast Cancer Awareness and how could the environmentally concerned Greenpeace be any other color?

Then there is the autonomic, unconscious reaction to color that goes beyond the psychological into the physiological. Our response is involuntary and we simply have no control over it. Think of the first crush you ever had and every time you caught sight of him or her, your heart would skip a beat (or two) and you could feel the warm pink flush rising on your cheeks. If it were less about love and more about anger, you could even turn a bit redder with rage. So there can be a physical manifestation of what is going on in your psyche.

Often rooted in childhood, personal experiences and subsequent reactions certainly play into the psychology of color. For example, you might have been promised a brand new bike in any color you chose. Let's say it was a bright lemon chrome yellow. You could hardly wait to get it. Then you took it out for a ride and promptly fell off it the first time out and broke your ankle. To add insult to injury, your friends all got to ride their bikes while you were sidelined for what seemed like an eternity.

You experienced happiness at first, then trauma, and eventually sadness—the perfect recipe for disliking vibrant yellow as it could stay imbedded in your psyche forever more. That's unfortunate because you might be depriving yourself of a hue that could bring you great pleasure personally but could also limit your color options professionally.

So that brings us to the moral of the story. If you are a professional working with color, it is really important to separate the professional perspective from a personal reaction. Once you recognize what caused the trauma, you can choose to remember the joy of anticipation, and that is what color is all about!!

RED

Red, with all of its compelling attributes, is deeply ingrained in the human psyche. The very word "ingrained" has its origins in the ancient method of dying fibers with cochineal and kermes, ground up insects that render an intense red that is permanent and indelible. The presence of this demanding hue is intrinsically understood, commanding, determined, and un-ignorable.

Several kinds of appetites are stimulated by red, whether present in a plump cherry pie, in a smooth, svelte, and sexy negligee, or in a sleek and muscular sports car. It tantalizingly reaches out to us so that we want to own it, savor it, experience the scent and the speed of it, and, most of all, revel in it.

There is no escape from its power as its physiological effects are deeply imbedded within us. As a matter of fact, the presence of red does increase our appetites, pulse rate, muscle strength, and blood pressure, and causes an adrenalin rush. The human mind is hardwired to act or react to red and we inevitably do. Recent studies have shown that when humans see red, their reactions become faster and more forceful.

Why this inevitable reaction to red? Social anthropologists inform us that the vibrant hue is connected intrinsically to the color of fire and blood, both life-sustaining and life threatening at the same time. We need fire to cook our food and keep us warm, yet we understand the need to protect ourselves from it. We comprehend that blood is a life force necessary for survival but we are repelled by the sight of bloodshed. Fortunately, our exposure and experience with red invariably leads to a more positive view of this brave and emphatic hue.

In the brightest variations, it is the color of great contrasts: the symbol of courage and valor, a heart full of love, or a raging revolution. Red encourages us to stop at that inevitable sign or to go forward with determination and vigor. It is nature's signal color that tempts the birds and the bees as well as animal and humans. It is the siren call to seduction and sensuality and the cosmetic industry has long understood how to attract the consumer with this sultry shade.

The yellow-undertoned chili pepper reds get warmer by degrees until they turn hot and even more voluptuous. Although there are blue-toned reds, it is difficult for us to wrap our heads around the concept of red as cool. In variations of deeper shades of wine, burgundy, and maroon, the undertone of red remains decidedly a suggestive presence, but because of the darkened value, there is more depth, gravitas, elegance, poise, and finesse implied.

Although rarely described as a light red, pink is the progeny of red, so some of the same characteristics are present, but in a much more subtle manner. Red is sexy and passionate, while light pinks are demure and romantic, tempering passion with purity, eliciting an aura of intimacy and gentleness. Muted, dusted, and ashy pinks are seen as cultivated and refined, while the brilliant shocking pink and magentas move closer to mother red and share the same dynamism. Once thought of as a strictly feminine color, there is now a newer understanding and appreciation of the so-called "feminine characteristics" of pink caused by a gender blur from the millennial generation that has less concern about being typecast or judged.

BLUE

The earth may shake, volcanoes erupt, tornadoes and fierce winds wreak havoc, yet somehow the sky has never fallen—it is simply always there. It might be covered with dense clouds on dismal gray days, but we know that when the clouds disperse there will be a beautiful patch of clear blue. This azure blue of the daylight sky promises us the continuity of yet another day—dependable, constant, and ever-faithful.

As it is so inherently connected to the sky above us, blue also provides a view of vast distances, allowing us to look beyond the obvious, increasing our perspectives, and opening the flow of communication. It is both thoughtful and thought-provoking, contemplative and reflective.

Blue hues also evoke thoughts of cleansing waters, the serenity of quiet streams. Of all of the colors in the spectrum, blue is seen as the coolest, both in temperature and in temperament, inducing a feeling of calm and relaxation to counteract agitation, confusion, or commotion.

From a spiritual perspective, pure blue is believed to be the color of inspiration, sincerity, truth, moderation, piety, faith, and devotion. The Virgin Mary is often depicted wearing blue garments as were the Hebrew high priests. In the Middle East it is regarded as a protective color, often decorating revered mosques.

In mythology, three of the greatest goddesses were symbolically clothed in blue. The veil of Juno, goddess of air, is blue. Diana, goddess of the moon, is clothed in blue and white or blue and silver. Minerva, the goddess of wisdom and thought, is often

described as "azure-eyed" and she is draped in a diaphanous blue gown that matches her eyes.

Darker midnight blues suggest the shades of far-off galaxies and outer space, or the deepest ocean depths, implying an air of mystery or the unknown. These are the serious, more cerebral and meditative blues. Navy blue leans heavily toward black, retaining some of black's power and importance without its dark and more sinister implications. That is why uniforms for pilots and police are most apt to be navy.

Some of the sobriety of blue is tempered when a bit of warmth is added as an undertone. It is playful periwinkle that brings a sprightly and whimsical touch to blue, while electric blue, just as the name implies, adds a jolt of energy, similar to a discharge of atmospheric or cosmic electricity.

Denim is the workhorse of the blue family. Now available in a wide range of shades, it is the typical slightly grayed, mid-tone blue that speaks of service, purpose, and reliability. Similarly, indigo brings a certain authentic and artisanal feel to blue.

Blue is the most popular hue worldwide and, not surprisingly, one third of the world's branding images are blue. In addition, the Internet's most heavily trafficked websites are colored liberally with many shades of blue.

BLUE GREEN

When we think of the blue greens, one of the first of that color family that comes to mind is turquoise. Combining the most positive emotional attributes of both the blues and greens, turquoise is seen as especially meaningful as a color of loyalty, serenity, and wisdom imparted by blue and the soothing, healing, and compassionate qualities, both to mind and body, ascribed to green. From a metaphysical perspective, the turquoise gemstone represents self-realization that leads to analytical thinking and improved communication skills.

The turquoise stone has a long history in many cultures. It was originally brought from mines in Turkey to the European continent during the time of the Crusades. Persian turquoise stones are thought to be among the oldest on earth and much revered by the people. They understood it to be the color that helped them differentiate between good and evil, a concept that continues to this day. Turquoise stones were found in ancient tombs dating from 3000 BC as the Egyptians thought it to be the color of faith and truth that they would take with them when transported to the afterlife.

The Chinese decorated icons with it and the Tibetans crushed the stones and made ink for writing their prayers. In India, the stones were worn to banish bad dreams. Both the Afghans and the Greeks believed turquoise stones pressed to the eyes could improve eyesight. They also adorned their heroic statues depicting ancient Greek gods with turquoise eyes.

The Navajos traditionally believed turquoise to be a piece of fallen sky. Other Native American people of the southwest, including the Zunis and Hopis, made amulets with the skills they had learned from Spanish artisans, the Aztecs, and the Mexicans. Today the symbolism has also ingrained itself in other geographic areas where turquoise is mined, notably in South Africa, Australia, South America, and as remote as Siberia. The universality of this protective color and the belief system around it goes well beyond borders.

In the Mediterranean region and in the tropics, turquoise is not only the color of the surrounding waters but it is the shade that is most frequently used in textiles and artwork to depict a watery mood. Because of the constant light infusion from the sun, this variation of turquoise appears a bit warmer, yet still embodies the refreshing sense of renewal.

When the daylight turquoises descend into the teal shades of the evening sky, there is an even deeper sense of calm instilled. It is a beautifully transitional color, bridging the blue greens of day into the meditative twilight. There is an air of mystique, grace, and sophistication around the blue-green teals.

The lighter aqua tones are invariably connected with cleansing waters, often with names that aptly describe the mood: surf spray, soothing sea, clearwater, and waterfall.

GREEN

In many languages, the word green is invariably connected to nature and growth. The modern English derivation, as well as the Anglo-Saxon word "grene," comes from the same Germanic root "grun" as the words "grass" and "grow." Similarly, the Romance languages, Slavic, and Greek connect green to fresh, sprouting vegetation and although the Japanese word for green "midori" is inclined to a more bluish tone, still it means: "to be in leaf, to flourish."

In China, the meaning veers more to the symbol of fertility. In Islamic countries, green represents the lush vegetation of Paradise. In ancient Egypt, green represented regeneration and rebirth and the hieroglyph for green depicted a growing papyrus sprout. Romans greatly appreciated green, as it was the embodiment of Venus, the goddess of gardens and vineyards.

In more recent history, because of its strong association to nature, green has taken on the symbolic meaning of environmental causes that have spawned political movements deeply committed to the preservation of the earth. To be a green industry is a mark of honor, indicating a company dedicated to the thoughtful protection of the environment, of re-use and recycling.

The yellow greens are most often associated with first days of spring when the young shoots emerge from the earth, promising more pleasant days ahead after winter's dullness. Those lush greens speak to revival, restoration, and renewal. These verdant tones actually encourage us to breathe more deeply, bringing more oxygen into our systems, enabling us to reinvigorate and replenish.

The Japanese art of shinrin-yo-ku urges us to take a walk in the forest, to further experience the replenishing use of the omnipresent greens. Broadleaf forests actually have a yellow-green glow above them as the trees filter the light. Many health professionals tell us to surround ourselves with some green in our home or work space, so that, although we may not live near a forest, we can still benefit from the therapeutic effects of green.

To eat a diet rich in greens is considered most beneficial to health and the use of green in packaging and advertising reinforces the natural and organic concept of the color.

Although there are many positives associated with green, there are also some negative connotations. Slimy and slithering reptiles are often green, as are other examples of weirdness in the color of skin as portrayed in film or theater. Shakespeare spoke of the jealousy that is depicted in his "green-eyed monsters." Green can also signal poison that had ninteenth-century roots in the association to paints and pigments that contained arsenic, causing illness or even death to those who chose to decorate with it.

Today, green is less ominous than in previous times. Whimsical yellow-green creatures live on in legends and folklore, especially those emanating from the Emerald Isle in the form of leprechauns, fairies, sprites, and pixies. In current animated films, dragons, gremlins, and Shrek-like characters are far more benevolent than scary and foreboding.

BLACK

When we hear the fashion pundits declare: "black is back," we wonder, where did it ever go? Was it in hiding? Had it fallen into a black hole or a bottomless pit? Anyone believing in black knows that it is eternally present in clothing, décor, product, and graphic application, and never really goes out of style. Although more recent times exhibit an increasing sensibility and color awareness, black has always retained its positioning and power. As John Harvey points out in his book *Men in Black*: "In spite of the dark values black has often had, one would no more want to cut it out of clothing than one would want people to have no weight or shadow."

In wearing apparel, it was William the Good (aka, ironically, the duke of Burgundy) who started the trend of wearing black as a statement of temperance and self-discipline as he felt it represented the seriousness required of the rising merchant class of the 15th century.

There is great dichotomy and paradox in the meaning of black. While nighttime offers hours of rest and restraint, under cover of darkness, nefarious deeds can be done. To be in a black mood is to be in an unhappy, rather gloomy state of mind, and black humor is cynical, even somewhat macabre. A black look from a teacher or a boss is not a welcome sight. It is the heavy color of grief, of priests, monks, and Puritans, while at the same time, it is the shade favored by movie star mafiosi, rebellious adolescents, and ominous villains. It is the master of disguise.

However, in today's world, the positive aspects of black are far more prevalent. Its power speaks more to experience and elegance. It is the embodiment of sophistication in the true sense of the word: worldly wise, knowledgeable, cultivated, and poised. It is Holly Golightly in *Breakfast at Tiffany's*, and chosen by a multitude of other svelte and stylish women. In the world of high-tech, it is a viable option, as it is perceived of as advanced, modern, state of the art, avant-garde, and highly evolved.

It is the color of mystery, but also of mysteries solved; the quintessential essence of cool, not in temperature, but in attitude. As every big-city dweller or frequent flyer knows, it is practical, yet glamorous, handsome and Armani-esque.

It is perceived of as the heaviest color in weight, yet we are told we look slimmer in black. It is considered heavy-duty, stealthy, and sleek. One thing we are absolutely sure of is that black is never frivolous. Contained, strong, purposeful, and impenetrable, this deepest of shades is not only powerful, but it is also empowering to those who choose it, as it exudes authority, strength, and confidence.

If our business is finally in the black, it is very good news, as it means we are debt-free, solvent, financially sound, and credit-worthy. Black is omnipotent and omnipresent. Although occasionally slipping back into the shadows to work its magic, it is a force to be reckoned with.

Children instinctively understand the pure joy of yellow—give them a yellow crayon or a paint box and a picture of the yellow sun will appear in the right top corner or the left upper side of the paper, depending on their personal proclivities. The yellow smiley face that emerged in the 60s has morphed into the tiny smiley faces that liven up your text messages, although the iconic emojis now reflect a growing smorgasbord of emotions and accent colors.

Physiologically, yellow is the most visible color in the spectrum, advancing forward in our line of vision so we simply cannot ignore its presence. It is believed to stimulate the left side of the brain to prepare for more logical thinking, clearing the mind in order to provide the clarity for reasonable decision making, and since we associate the sun's rays with positivity, yellow helps us to feel more optimistic. The vibrant sunflower has become the symbol for depression-successfully-treated.

In most societies around the world, yellow is the symbolic color of the sun, the inevitable presence that helps us to greet a new day or season—or at least the promise of a sunny day when the cloud cover and rain is gone. Just as we are invariably drawn to the sun's welcoming and enveloping warmth, we are drawn to the hue that suggests a glowing sunlight. Reflective and radiant, vibrant yellow is the symbolic color of hope, happiness, and good cheer. It is thought of as friendly, forthcoming, energizing, and enriching.

YELLOW

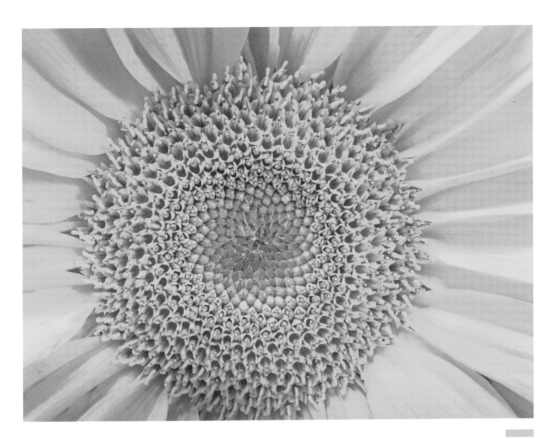

Psychologically, yellow expresses a quest and a challenge, a stimulus of mind and senses pressing forward toward new and developing concepts. In Jungian psychology, yellow represents intuition, what is described as "comprehension in a flash of light." It not only represents the color of light, but also signifies the color of enlightenment—the quest to comprehend and see things more clearly. It is the color of intellectual curiosity and an inquiring mind.

Historically, gemstones have carried specific meanings. It is believed that yellow stones provide protection from lethargy and relief from "burn-out" or exhaustion and increase the ability to express oneself and to be more communicative. They are also said to lead to sharper memory skills and to stimulate movement.

Yellow is inevitably connected to comfort food and drinks, actually selling best in stressful times. Think buttery popcorn, chips, mac and cheese, custards and double creams, pale or amber ale, and, if your tastes are a bit more sophisticated, chardonnay, champagne, and chablis. The names of the colors will often tell us what we can expect to feel or taste: mellow yellow, cornsilk, banana pie, lemon drop, or lemon zest.

Lighter pastel yellows are seen as childlike and immature while canary yellow is feathery and soft to the touch. Slightly greenish Dijons and curries lean more to the exotic side of the yellow family, while ambers and topaz are viewed as more "upscale" and luxurious. The closer to orange it moves, the more garrulous and outgoing yellow becomes.

The offspring of dynamic red and radiant yellow, there is nothing reticent about orange. It seeks attention, as vivid red often does, but because of the inclusion of yellow's sunny disposition as an undertone, orange has an affable, warm-hearted, and non-aggressive manner. Because of these qualities, it is a color that encourages conviviality and good social interaction. It is both physically and mentally stimulating, a hue that connotes communication. Orange is categorized as a high-arousal color, one that stimulates conversation as well as appetites. Its physicality encourages spontaneity and some degree of impulsiveness.

After their initial attraction to the primary shades of red, yellow, and blue, children are drawn to fun-loving orange. It is often the color of sweet lollipops, gumdrops, and juicy popsicles, a shiny tricycle or a beloved carrot-topped Raggedy Ann or Andy doll that trigger happy thoughts and memories. This positive reaction to orange often re-emerges during adolescence, when they might be re-enacting the terrible twos and threes.

Perceived as the hottest of all colors, orange is never described as cold or cool. Color word association studies invariably link orange to a glowing sunset— luminous, hot, and a joy to behold. Like yellow, orange is considered optimistic, uplifting, cheerful, and energetic. Vibrant orange seems to be in constant, outward physical motion, much like the extroverts (or kids) who revel in it. The brighter tones can get a bit rambunctious but somehow the sense of humor and playfulness attached to it justifies the volume.

ORANGE

There are some who might refer to bright orange as loud; however, in the right context and appropriate usage, such as in signage or packaging, calling for attention with this exuberant hue is not necessarily a negative.

Orange does have multiple personalities, conveyed in ebullient brights to abundant earth tones such as terra cotta, russet, or baked clay, as well as the shades of pungent flavorings. Inevitably linked to falling leaves and the autumn season, it is the color of hearth and harvest, the sparkling embers of a warming fire, roasted carrots and yams and pumpkin pie straight from the oven.

It's the promise of abundance, whether close to home or from far-flung exotic destinations, redolent with spicy and aromatic tones that range from piquant to peppery with evocative names to match: saffron, turmeric, nasturtium, and cayenne powder. Orange conveys sweetness with a touch of tang: marmalade, nectarine, tangerine, kumquat, papaya, and orange zest.

There is a softer side to orange as well, depicting tactility and tastes that invite an observer to reach out and touch the subtle tones of peachskin and velvety apricot, or sift through the warm and inviting coral sands on a tropical beach. From the showy floral display of birds of paradise to the nourishing orange zinnias that were the first edible flowers to grow in space, orange flowers never cease to attract, amaze, enliven, and encourage us.

Although dynamic red and quiescent blue could not be more opposite in temperament and messaging, when they are blended to form another hue, the resulting purple can be quite magical. It has been called the color of show and shadow. The showy part is expressed when red is the major undertone, whereas the shadowy side features the blue undertone. As a consequence, purple can have distinctly different meanings and effects and it does take a special skill to handle them.

Skewed to the red side, it is perceived as hotter, more sensual, active, dynamic, exciting, and theatrical. Most fuchsia tones share this same spirited and high-powered energy. Leaning to the bluer and cooler side, purple has more dignity and serenity than the red purples. It is best to have a dominant "temperature" prevail so that the mind is not confused or conflicted as to the messaging. Defined as "psychologically oscillating," the purple family has its ardent champions or those who are really averse to the color.

Variations of purple and violet (a synonym for purple) cannot be described in just a few words—it is far too diverse and complex a color family. It is exactly that complexity that intrigues and excites the creatives who covet this color. To a layman, purple can be daunting; to a professional, it is a welcome challenge to engage the enigma that is inherent in the shade.

PURPLE

The history of purple lifts this shade to lofty levels, as it was so expensive to produce that only the very wealthy or those of royal status could afford to wear to the color. We understand the meaning of labor-intensive when we read that it took the ink of 250,000 tiny snails to make one ounce of the dye. It was worn and revered by Roman magistrates and Greek governors. It meant majesty and sovereignty to the Aztecs and the Incas. To the Chinese it was considered a superior shade, in Japan it stood for nobility and aristocracy. Eventually, in the 19th century, technology in the form of chemical synthesis brought an affordable purple to the people.

Frank Lloyd Wright, the brilliant architect with a towering ego to match, wore purple capes with great affectation. The following quote gives some insight into his personal color choice: "Early in life I had to choose between honest arrogance and hypocritical humility. I chose honest arrogance and have seen no occasion to change."

There is an air of grandeur about the color, yet in ecclesiastical symbolism there is a nobler calling to a higher authority present in purple as a representation of repentance, contrition, and humility. In the mid- to deeper or grayed-down versions, it is a mystical, enchanting, inscrutable, and mysterious color. In the lighter lavender or mauve, it is thought of as wistful or nostalgic. In the deepest shadings of aubergine, it articulates great sophistication.

Breathtaking when it is splashed against the sky in a desert sunset, viewed in a magnificent fan of a peacock display, seen in the cool retreating magnificence of a distant mountain range at dusk, purple intrigues the eye and forever fascinates.

White. It is the color of freshly fallen snow in the dead of winter, puffy clouds against a clear blue sky, billowing sails on a breezy day, scented gardenias in the garden, clean cool sheets on a warm summer's night. It is fresh milk and marshmallows, vanilla ice cream and whipped cream. It can be chaste and virginal, the traditional color for brides as well as the mythical stork that is the bringer of babies. They are all whites, yet think of the nuances, possibilities, and shadings that exist within this so-called non-color.

White is airy, filmy, floaty, diaphanous, wispy, and to the extreme, ghostly. It is the delicacy of an eggshell, lighter than air and, in fact, perceived as weightless. It is somewhat fragile and ephemeral, depicting innocence and virtue. A little white lie is considered harmless or benign as it is told to avoid hurt feelings.

In pigment, paint, and dyestuffs, white is considered the absence of color; in lighting it is all colors coming together as one. Most significantly, it is the white dove of peace.

Nature had been very stingy with pure whites, but lavish with those tones that are slightly off. However, in the 1920s, new industrial technologies rendered a whiter-than-white titanium-based paint. It was an instant success and before long was gracing homes, offices, and hospitals all in the quest for cleanliness and light. Evolving from a color that could easily yellow with age, the bleached white look became the symbol of modern minimalism and remains so even today.

WHITE

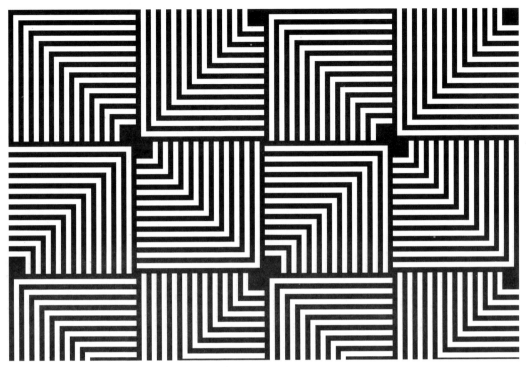

Simple white china, bed linens, toweling, terry robes, cleansing creams, and soaps are de riguer for those consumers who prefer what they consider classic choices. We pay attention to the admonition to "wash whites separately" as we want our whites to be immaculate.

It is purity objectified, bringing clarity and clear definition to things. Form, shape, and texture stand out more emphatically when dressed in chalky white. However, when used in broad strokes throughout a living or working environment, pristine white can become cold, sterile, and super-hygienic—good descriptive words when allied with certain drinks, detergents, or medical products, but not appealing when describing an interior.

White is the antithesis of black, and when used together, they represent the alpha and the omega or the yin and the yang of the world of color; the ultimate expression of opposites, both philosophically and psychologically. Against a white page, a black font delivers a solid message. In the written word (as opposed to word of mouth) it is suggested that what we see is more reliable and credible when printed in black and white, expressing clearly defined opposing principles or issues.

Various tones of gray, beige, and taupe are referred to as neutral or natural colors.

Neutrals are also termed achromatic, which means "without color," yet anyone who has worked with color (and even those who have not) has seen that all of these shades have various undertones that can add a specific nuance to a color. Ask any woman who wears make-up if she has ever had the problem of buying a shade called "beige," yet when she applies it to her skin, the rosy pink cast of the cosmetic finish doesn't blend with her warm, slightly golden skin. They might both be termed beige, yet there is a decided difference once applied.

The same is true when comparing paint colors or any other product that offers a broad selection of color choices. As every designer knows, opening a Pantone fanguide to a particular color family; whether in neutrals or any color family, better enables the eye to gauge the difference in undertone.

To calibrate your eye in discerning undertone, study the varying shades of beige when placed next to each other. The undertones will be more apparent to you. Some beiges will shift to a rosy undertone, others to a more yellowed aspect. With some beige undertones it is harder to discern whether or not they have more rose or more golden undertones and are most apt to be truer neutrals, expanding their usability.

NEUTRAL/ NATURAL

The name "beige" came originally from the French word denoting a natural wool that has not been bleached or dyed. It was the clever French designer Coco Chanel who helped to popularize the color in the 1920s. Astute businesswoman that she was, Coco managed to buy WWI surplus at very low prices and created beautifully crafted fashions for wealthy Parisians, starting a worldwide trend that was copied eventually by smart-looking women everywhere. Even in current day usage, it is considered an upscale but low-key color.

Some typical beige names will often signal the mood they create: warm sand, parchment, wheat, doeskin, shifting sand, linen, and grain.

The most negative response attached to beige is that some regard it as dull or bland. However, it is the very blandness that lends itself so well to performing as a neutral color. Beige supports the star players without detracting from their importance and performs exceedingly well as a buffer between vibrant colors, helping to contain them and calm down any stridency.

GRAY

Gray spans the space between black and white, creating a neutral territory between the extremes. Gray represents the philosophy that although there are extremes between black and white, the shades of gray appearing in between may provide more thoughtful, non-combative solutions, providing a middle ground.

Just as with beige, visually gray is a non-competing color that doesn't steal the show. However, there is a psychological significance to the color. Human perception of gray takes several forms. In nature, gray might be found in clouds or shadows, lightly obscuring a vista yet still defining shape and form. It is found in rock and stone, pebble and granite, those natural elements that have weathered and withstood the ravages of time.

In architecture, gray represents the longevity of ancient edifices, temples, and monuments—dependable, solid, and everlasting. It is also a pervasive color in more modern environments, massive and mechanical, made of industrial strength concrete, cinder block,

slate, and gravel. There is both seriousness and strength attached to gray.

There is elusiveness about the shade as well: It is gossamer cobwebs and a spent fire that results in gray ashes—a reminder of the passions of the past turned to dust. At the same time, it pays homage to aging and to the wisdom, experience, and intelligence that age brings.

Grays can vary greatly in temperature. Leaning to the blue, blue-green, or lavender side, they are infinitely cooler than grays that have a warmer undertone. The lightest grays can appear like a tinged white, taking on some of white's characteristics, while the light to medium grays are the most neutral of the neutrals. As grays start to darken and approach black, they take on some of black's characteristic power, although not quite as formidable or intense.

Taupe is the color that spans beige and gray. Also referred to as "greige," it is a rather poetic name for a neutral and totally befits this classic and classy shade. As it is a mixture of both beige and gray, it takes on many of the same characteristics of the colors it comes from, making it a non-assuming, composed, and balanced color, both in temperature and tone. Additional common terms for taupe lie within the mushroom family, with appropriate names like porcini, morel, chanterelle, and fungi.

Because of its mixed and balanced background, taupe is the chameleon shade amongst neutrals, easily picking up a hint of rose, a drop of mauve, a smattering of yellow green or khaki. When examining what seem to be gray rocks, stones, and pebbles, it is apparent they are often striated into tones of taupe as well, creating what is called an optical mix. Within the context of nature, it is the color that helps to protect many animals and birds, providing a natural blend to their surroundings.

TAUPE/
KHAKI

Taupe has steadily retained its popularity in interior décor both for home and office settings. Its dedicated devotees know that it's a tone they can depend on and that same reliable demeanor extends to the products or services that are clothed in the color.

Another essential neutral, khaki is one of those taken-for-granted colors that we reach for consistently. It never gives us pause to think about whether or not it works with red, pink, blue, green, turquoise, brown, black, navy, yellow, or any other hue. It is a standard chestnut of a shade that deserves a place alongside the other basic neutrals. Similar to the other basics already mentioned, khaki, too can change undertone easily, going from a brownish beige to a greenish tone.

There are additional sturdy khaki-like colors that are closely related, such as boulder, hemp, bog, and putty. The names are less than poetic; still they demonstrate the utilitarian and practical aspect of this forthright grouping.

The history of khaki is interesting to contemplate for all of its serviceability and camouflaging properties, not to mention the lives it might have saved. In 1836 a certain Punjab-based English Colonel, Harry Lumsden, thought it time to thrust aside his stifling and enemy-attracting pure white military issue jackets to do battle in the pajamas he had dipped into the river mud of the surrounding terrain. His entire regiment rifled through their pajama stash and followed suit. It took thirty-eight years before a colorfast dye was developed for khaki, and the rest is history.

Brown, the color of humble beginnings, has changed considerably over the ages. It was the color of pious monks, of hard working people who labored on the land, and the shade of the very soil they tilled. It's the color connected with making an honest living, considered dutiful, substantial, serviceable, earth-friendly, and, above all, authentic. As a result, historically brown is perceived as stable, honest, grounded, and rooted, the color of connections to the past, the shade of solid foundations, hearth and home, brick and wood.

Yet that same brick and wood could also be constructed into magnificent mansions, filled with beautifully scrolled mahogany furnishings, tasteful burl wood paneling, or highly polished dark oak flooring. The people who graced those mansions might have had a closet full of supple brown leather boots or shoes, attaché cases or designer handbags, perhaps a mink jacket or two. The variations of brown with names like sable, umber, cognac, and brownstone were decidedly sumptuous and rich. Interestingly, it is the concept of the richness of brown that provides a thread throughout many of the circumstances where the brown family is used.

BROWN

In more recent years, starting in the 1960s, brown took on a new role with the rise of more organic and natural foods like whole grains and whole wheat, brown rice, lentils, nuts, and multi-grained cereals. It was not only the age of Aquarius, but of the time of the granola girl, and brown was again recognized for its earthy and wholesome qualities.

Earthtones, including brown, continued to reign in the 70s. The 80s and conspicuously consuming 90s brought not only the return to lavish browns, but a renewed interest in gardening (thank you Martha Stewart) and the enjoyment of working with a rich compost-nourished soil. New levels of indulgence in elegant imported chocolates and equally rich coffees with names to match tempted the taste buds.

Who wouldn't be tempted by a mocha mousse or caramel crème? In the 2000s we saw the ultimate statement of richness with sparkling brown diamonds emerging.

Currently, there is even more interest in organic, unadulterated foods grown in a rich, pesticide-free soil. The influences around the meaning of brown are coming from almost polar-opposite places. Even though seeming a bit counter-intuitive, rich is a key word in the evolvement of brown.

Once thought of as strictly a country-color family, including tans with names like buckskin, bracken, camel, and biscuit, it is equally at home in a city such as Sienna, Italy. As with other color families, brown is especially all about context—how and where it is used.

Obviously, brown is no longer a dirty word.

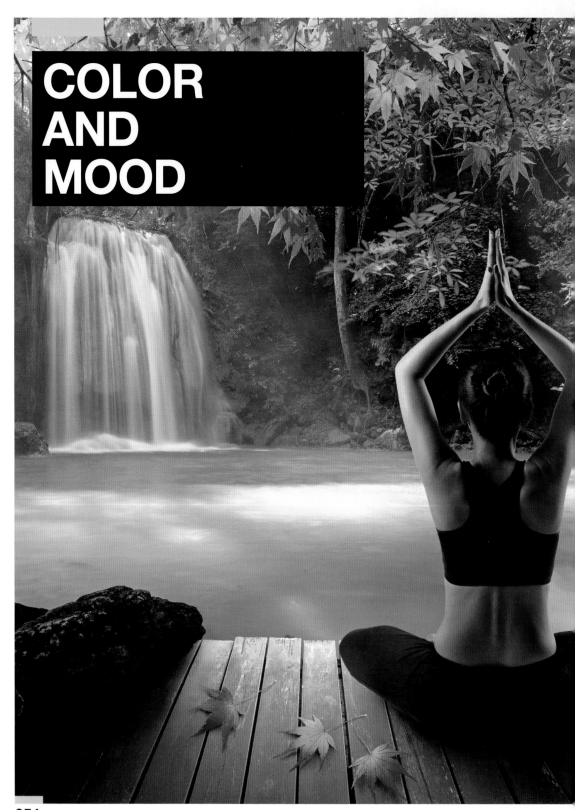

COLOR
AND
MOOD

COLOR CUES
AND CLUES

Rarely used in isolation, colors are most frequently combined. The most successful color combinations are those that contain visual cues for the viewer that help to spark a specific response and can best express the messaging, intention, mood, or ambiance of the project.

So that the purpose of the colors is well defined, proper proportion is important. A rank order of dominant, subordinate, and accent colors is visually understood and maintains the importance of the main color.

If only two colors are used in combination, in general one of those colors should be dominant. If more than three colors are combined, it is even more vital to have a dominant shade that reinforces the major message.

Each combination on the following pages is illustrated within a circle that shows the approximate proportion. If more than three colors are utilized within a combination, then another color or colors can be borrowed from surrounding circles.

Each example within a given mood will provide inspiration or validation for any color project. There are no absolutes in how many colors might be in a combination—the decision lies within the eye and judgment of the creator.

The following guidelines will provide you with a checklist in the color selection process:

Define the message: Are there keywords that describe the brand/product/project? Is it Playful, Powerful, or Piquant? Should it suggest Reliability or Timelessness?

Choose the mood that best demonstrates the major message.

Select combinations from within the chosen mood utilizing them as a "jump start."

Fine-tune the choices for the target audience.

If possible, check competitors' choices for similarities and tweak your choices when necessary.

DELECTABLE

Delectable is a sugary palette of sweets inspired by the retro goodies of childhood. Necco wafer assortments blend with double-dip pistachio and strawberry atop a waffle cone trimmed with pastel sprinkles; cotton-candy carnival pink and root beer floats, chocolate pudding and fluffy vanilla cupcakes. These are the hues that are pleasant reminders of happy times, special occasions, and delicious treats that continue to please as we grow into adulthood. The names might have changed as the flavors have morphed into equally colorful gelatos, smoothies, and gourmet coffees, but the promise of sweet memories remain.

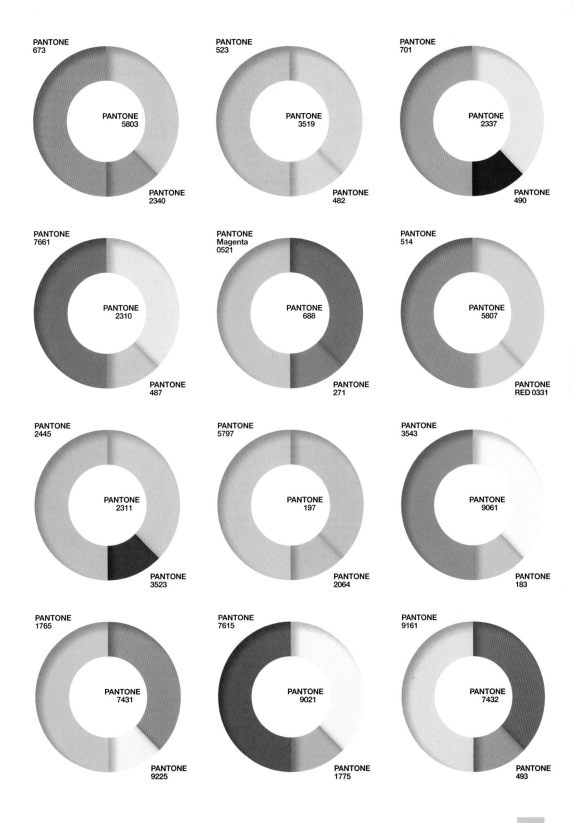

PANTONE
673

PANTONE
5803

PANTONE
2340

PANTONE
523

PANTONE
3519

PANTONE
482

PANTONE
701

PANTONE
2337

PANTONE
490

PANTONE
7661

PANTONE
2310

PANTONE
487

PANTONE
Magenta
0521

PANTONE
688

PANTONE
271

PANTONE
514

PANTONE
5807

PANTONE
RED 0331

PANTONE
2445

PANTONE
2311

PANTONE
3523

PANTONE
5797

PANTONE
197

PANTONE
2064

PANTONE
3543

PANTONE
9061

PANTONE
183

PANTONE
1765

PANTONE
7431

PANTONE
9225

PANTONE
7615

PANTONE
9021

PANTONE
1775

PANTONE
9161

PANTONE
7432

PANTONE
493

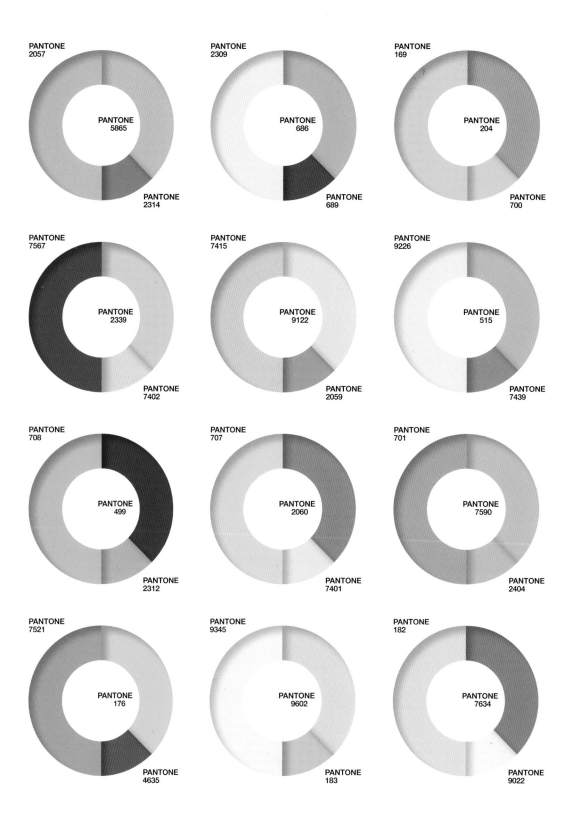

PANTONE
2057

PANTONE
5865

PANTONE
2314

PANTONE
2309

PANTONE
686

PANTONE
689

PANTONE
169

PANTONE
204

PANTONE
700

PANTONE
7567

PANTONE
2339

PANTONE
7402

PANTONE
7415

PANTONE
9122

PANTONE
2059

PANTONE
9226

PANTONE
515

PANTONE
7439

PANTONE
708

PANTONE
499

PANTONE
2312

PANTONE
707

PANTONE
2060

PANTONE
7401

PANTONE
701

PANTONE
7590

PANTONE
2404

PANTONE
7521

PANTONE
176

PANTONE
4635

PANTONE
9345

PANTONE
9602

PANTONE
183

PANTONE
182

PANTONE
7634

PANTONE
9022

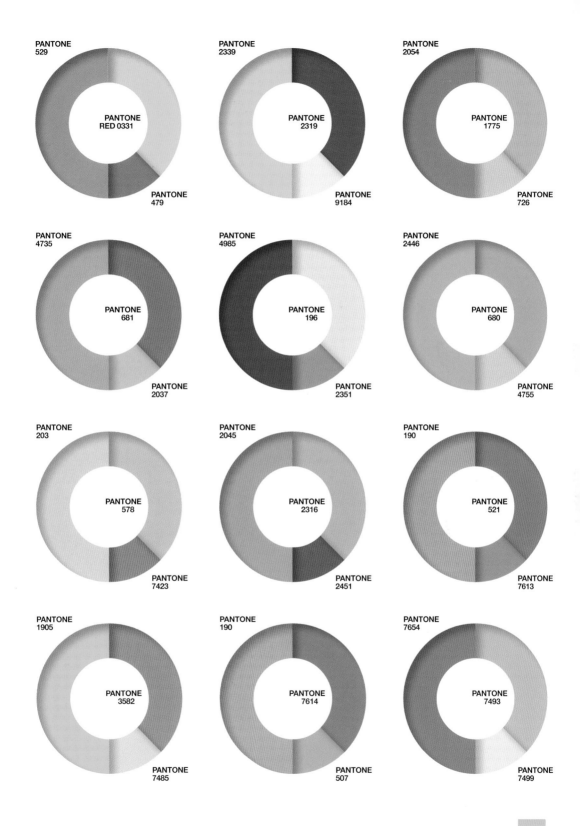

PANTONE
529

PANTONE
RED 0331

PANTONE
479

PANTONE
2339

PANTONE
2319

PANTONE
9184

PANTONE
2054

PANTONE
1775

PANTONE
726

PANTONE
4735

PANTONE
681

PANTONE
2037

PANTONE
4985

PANTONE
196

PANTONE
2351

PANTONE
2446

PANTONE
680

PANTONE
4755

PANTONE
203

PANTONE
578

PANTONE
7423

PANTONE
2045

PANTONE
2316

PANTONE
2451

PANTONE
190

PANTONE
521

PANTONE
7613

PANTONE
1905

PANTONE
3582

PANTONE
7485

PANTONE
190

PANTONE
7614

PANTONE
507

PANTONE
7654

PANTONE
7493

PANTONE
7499

CASUAL

A casual mood is one that is easy-going, relaxed, effortless, and most of all, unpretentious. It suggests the comfortable feel of wear-with-all blue jeans, a soft and well-worn plaid flannel shirt, a deep and roomy brown leather sofa, and an old pine table where you can put your feet up without danger of reprimand. There is some earthy red and foliage green in the palette to remind us that this is, after all, a natural fit for such an open, unaffected, affable, and no-frills color group.

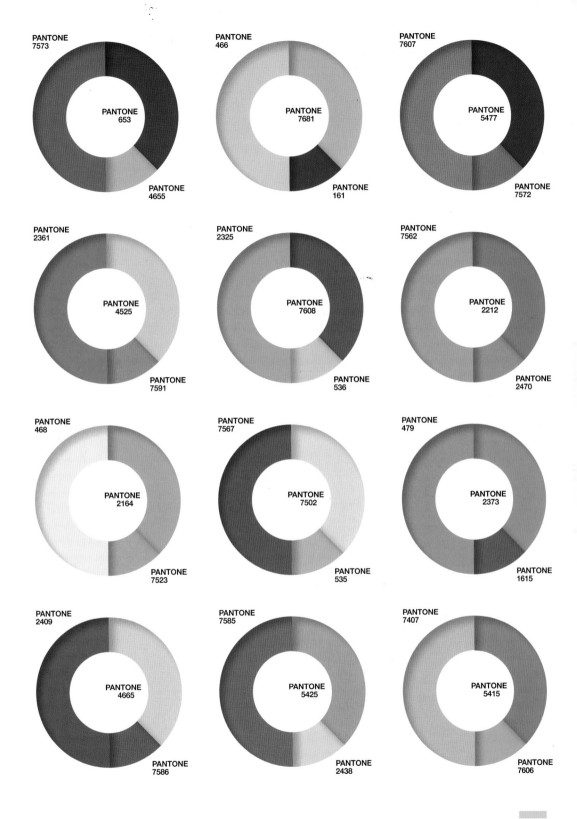

PANTONE
7573

PANTONE
653

PANTONE
4655

PANTONE
466

PANTONE
7681

PANTONE
161

PANTONE
7607

PANTONE
5477

PANTONE
7572

PANTONE
2361

PANTONE
4525

PANTONE
7591

PANTONE
2325

PANTONE
7608

PANTONE
536

PANTONE
7562

PANTONE
2212

PANTONE
2470

PANTONE
468

PANTONE
2164

PANTONE
7523

PANTONE
7567

PANTONE
7502

PANTONE
535

PANTONE
479

PANTONE
2373

PANTONE
1615

PANTONE
2409

PANTONE
4665

PANTONE
7586

PANTONE
7585

PANTONE
5425

PANTONE
2438

PANTONE
7407

PANTONE
5415

PANTONE
7606

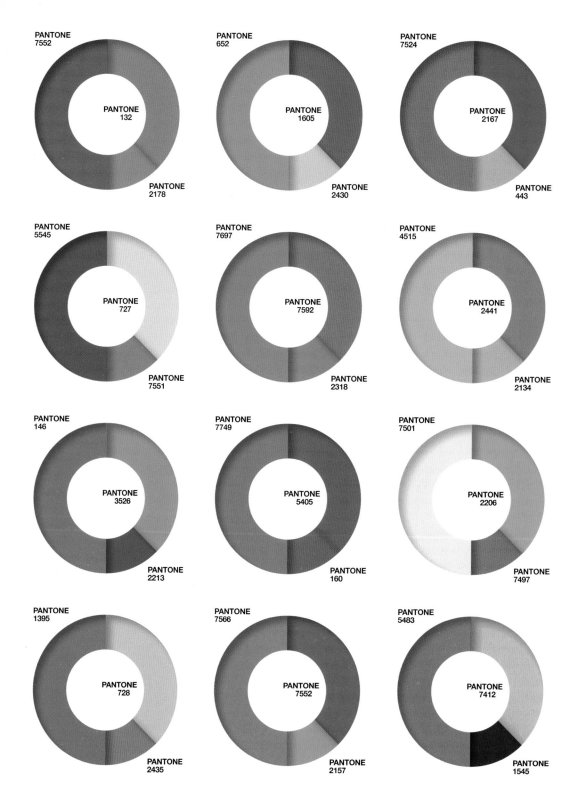

PANTONE
7552

PANTONE
132

PANTONE
2178

PANTONE
652

PANTONE
1605

PANTONE
2430

PANTONE
7524

PANTONE
2167

PANTONE
443

PANTONE
5545

PANTONE
727

PANTONE
7551

PANTONE
7697

PANTONE
7592

PANTONE
2318

PANTONE
4515

PANTONE
2441

PANTONE
2134

PANTONE
146

PANTONE
3526

PANTONE
2213

PANTONE
7749

PANTONE
5405

PANTONE
160

PANTONE
7501

PANTONE
2206

PANTONE
7497

PANTONE
1395

PANTONE
728

PANTONE
2435

PANTONE
7566

PANTONE
7552

PANTONE
2157

PANTONE
5483

PANTONE
7412

PANTONE
1545

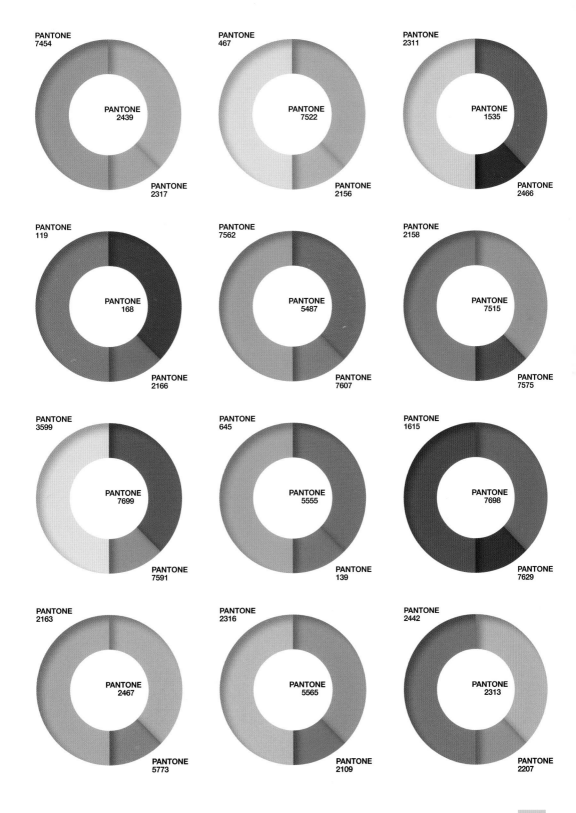

BOTANICAL

The need for a green palette testifies to the inevitable and life-affirming connection between humans and greenery, providing critical food, water, oxygen, and remedies. Holistic and harmonious living is linked to the efficacy of the yellow greens, blue greens, and greenish yellows. Food and beverage trends, lifestyles, and well-being are all closely connected to this color family. It is the largest of all hue groups, ranging from the lightest frost and sea spray to the deepest of evergreens; from sunny limes and bright chartreuse to deep lush mossy greens; from succulent aloe to sweet pea. The blue greens bring yet another wide extension of the green family in turquoise and deep teal to honeydew and cockatoo.

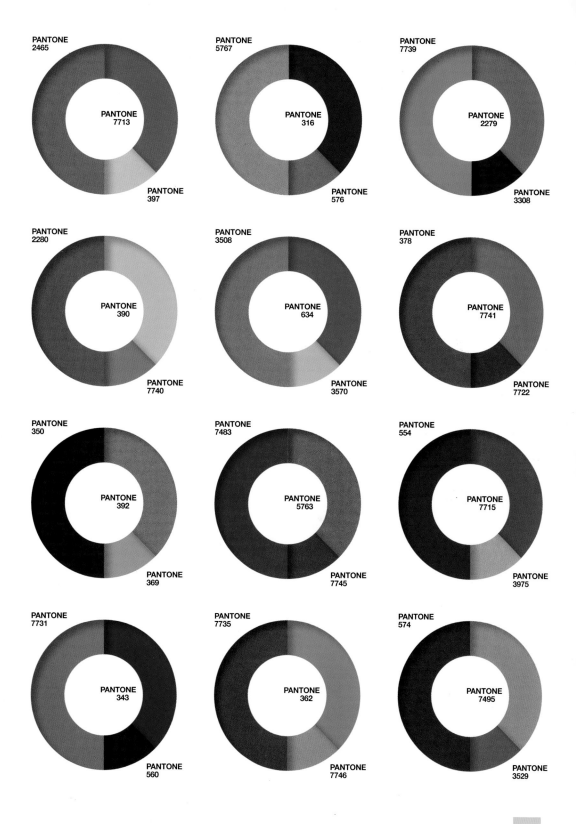

PANTONE
2465

PANTONE
7713

PANTONE
397

PANTONE
5767

PANTONE
316

PANTONE
576

PANTONE
7739

PANTONE
2279

PANTONE
3308

PANTONE
2280

PANTONE
390

PANTONE
7740

PANTONE
3508

PANTONE
634

PANTONE
3570

PANTONE
378

PANTONE
7741

PANTONE
7722

PANTONE
350

PANTONE
392

PANTONE
369

PANTONE
7483

PANTONE
5763

PANTONE
7745

PANTONE
554

PANTONE
7715

PANTONE
3975

PANTONE
7731

PANTONE
343

PANTONE
560

PANTONE
7735

PANTONE
362

PANTONE
7746

PANTONE
574

PANTONE
7495

PANTONE
3529

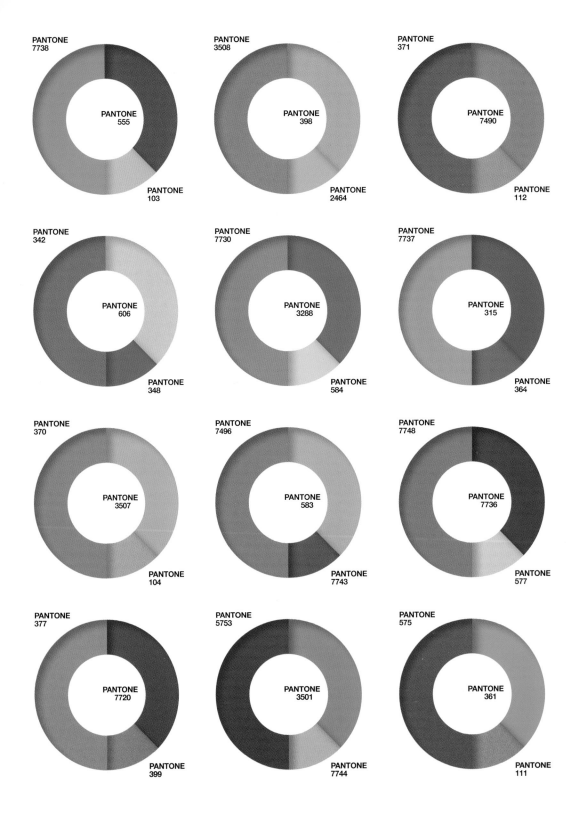

PANTONE
7738

PANTONE
555

PANTONE
103

PANTONE
3508

PANTONE
398

PANTONE
2464

PANTONE
371

PANTONE
7490

PANTONE
112

PANTONE
342

PANTONE
606

PANTONE
348

PANTONE
7730

PANTONE
3288

PANTONE
584

PANTONE
7737

PANTONE
315

PANTONE
364

PANTONE
370

PANTONE
3507

PANTONE
104

PANTONE
7496

PANTONE
583

PANTONE
7743

PANTONE
7748

PANTONE
7736

PANTONE
577

PANTONE
377

PANTONE
7720

PANTONE
399

PANTONE
5753

PANTONE
3501

PANTONE
7744

PANTONE
575

PANTONE
361

PANTONE
111

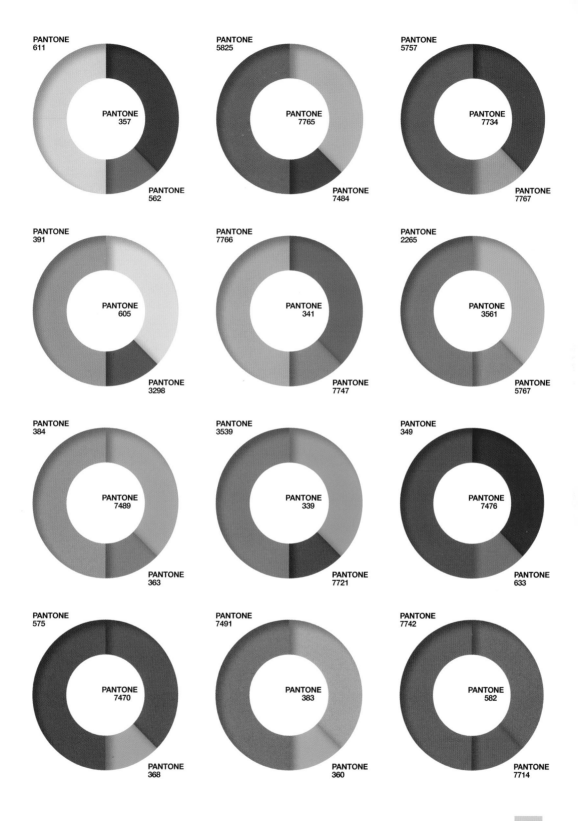

PANTONE
611

PANTONE
357

PANTONE
562

PANTONE
5825

PANTONE
7765

PANTONE
7484

PANTONE
5757

PANTONE
7734

PANTONE
7767

PANTONE
391

PANTONE
605

PANTONE
3298

PANTONE
7766

PANTONE
341

PANTONE
7747

PANTONE
2265

PANTONE
3561

PANTONE
5767

PANTONE
384

PANTONE
7489

PANTONE
363

PANTONE
3539

PANTONE
339

PANTONE
7721

PANTONE
349

PANTONE
7476

PANTONE
633

PANTONE
575

PANTONE
7470

PANTONE
368

PANTONE
7491

PANTONE
383

PANTONE
360

PANTONE
7742

PANTONE
582

PANTONE
7714

DELICATE

Ethereal and ephemeral, this is a palette of tender tints that instantly conveys a sense of the fragile. These are gentle, wispy pastels, barely kissed by color, having names that express their innate expression of quietude, softness, and vulnerability, among them: whispering white, petal pink, murmuring blue, hushed green, pale peach, sweet cream, moonlit mauve, and mellow yellow. These pale colorations of the lightest warm and cool tones happily co-mingle with the enduring nature of neutrals such as dove gray and greige.

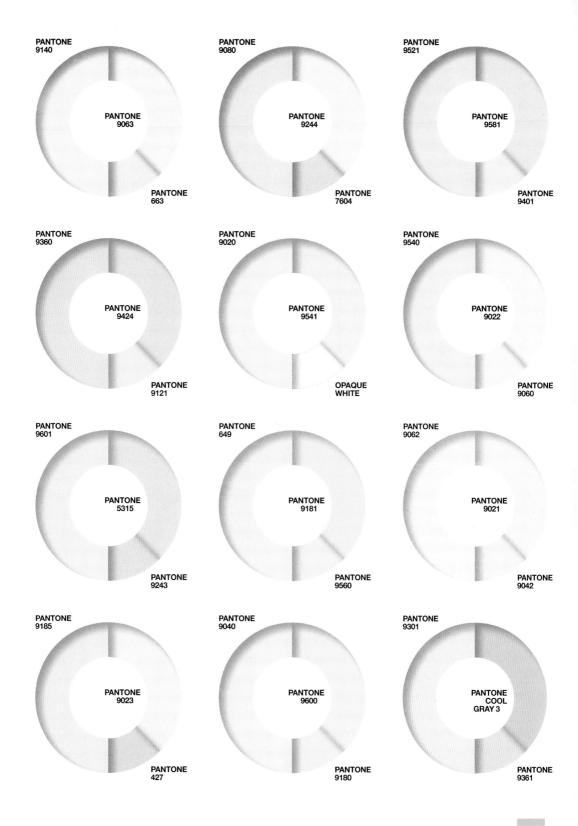

PANTONE
9140

PANTONE
9063

PANTONE
663

PANTONE
9080

PANTONE
9244

PANTONE
7604

PANTONE
9521

PANTONE
9581

PANTONE
9401

PANTONE
9360

PANTONE
9424

PANTONE
9121

PANTONE
9020

PANTONE
9541

OPAQUE
WHITE

PANTONE
9540

PANTONE
9022

PANTONE
9060

PANTONE
9601

PANTONE
5315

PANTONE
9243

PANTONE
649

PANTONE
9181

PANTONE
9560

PANTONE
9062

PANTONE
9021

PANTONE
9042

PANTONE
9185

PANTONE
9023

PANTONE
427

PANTONE
9040

PANTONE
9600

PANTONE
9180

PANTONE
9301

PANTONE
COOL
GRAY 3

PANTONE
9361

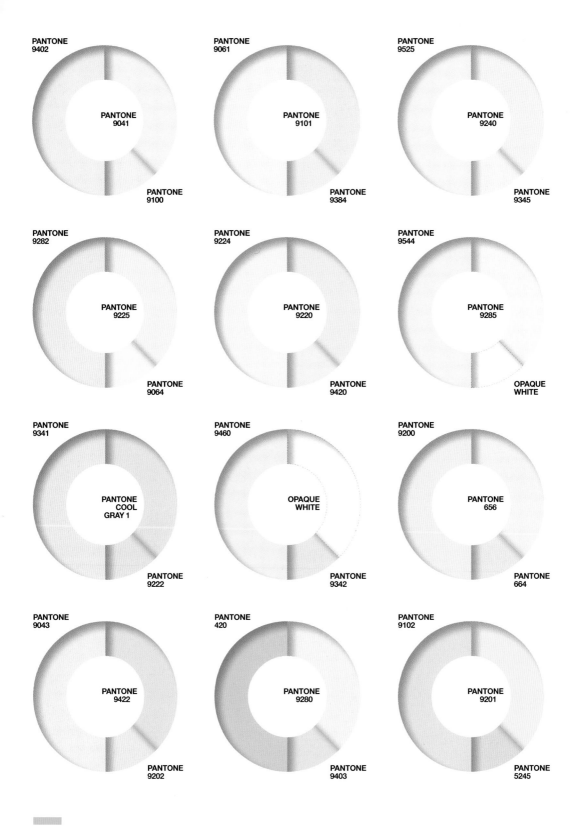

PANTONE
9402

PANTONE
9041

PANTONE
9100

PANTONE
9061

PANTONE
9101

PANTONE
9384

PANTONE
9525

PANTONE
9240

PANTONE
9345

PANTONE
9282

PANTONE
9225

PANTONE
9064

PANTONE
9224

PANTONE
9220

PANTONE
9420

PANTONE
9544

PANTONE
9285

OPAQUE
WHITE

PANTONE
9341

PANTONE
COOL
GRAY 1

PANTONE
9222

PANTONE
9460

OPAQUE
WHITE

PANTONE
9342

PANTONE
9200

PANTONE
656

PANTONE
664

PANTONE
9043

PANTONE
9422

PANTONE
9202

PANTONE
420

PANTONE
9280

PANTONE
9403

PANTONE
9102

PANTONE
9201

PANTONE
5245

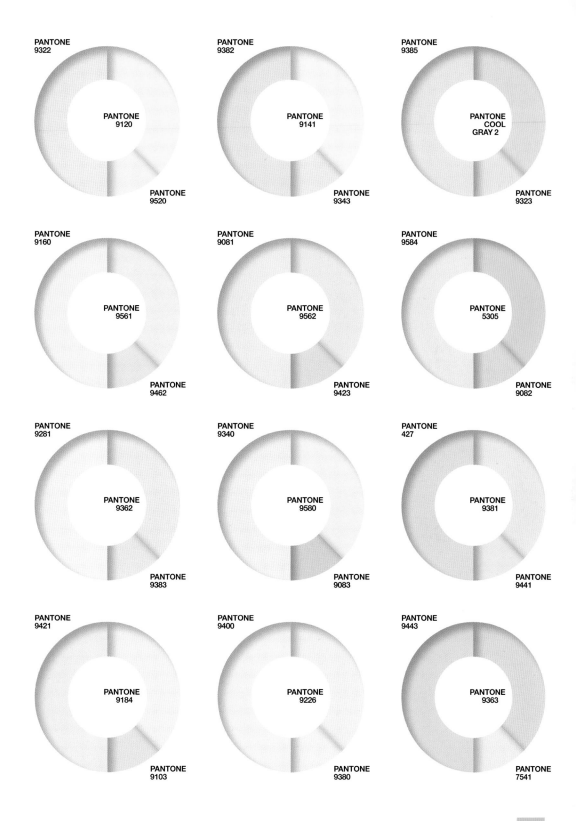

PANTONE
9322

PANTONE
9120

PANTONE
9520

PANTONE
9382

PANTONE
9141

PANTONE
9343

PANTONE
9385

PANTONE
COOL
GRAY 2

PANTONE
9323

PANTONE
9160

PANTONE
9561

PANTONE
9462

PANTONE
9081

PANTONE
9562

PANTONE
9423

PANTONE
9584

PANTONE
5305

PANTONE
9082

PANTONE
9281

PANTONE
9362

PANTONE
9383

PANTONE
9340

PANTONE
9580

PANTONE
9083

PANTONE
427

PANTONE
9381

PANTONE
9441

PANTONE
9421

PANTONE
9184

PANTONE
9103

PANTONE
9400

PANTONE
9226

PANTONE
9380

PANTONE
9443

PANTONE
9363

PANTONE
7541

VENERABLE

Venerable is a palette that speaks to a certain heritage, one that is a bit more formal and historical in nature. Another word that is frequently used to describe this palette of colors is "traditional," although traditions are most frequently based on culture and country. Holding on to some vestige of the past is deeply satisfying and reassuring to many. This is an "old school" kind of appeal, one that is rooted in deep to mid tones of colors such as: navy and cadet blue, regimental red, maroon, mahogany, hunter green, antique gold, mallard, teal, London fog, and gunmetal.

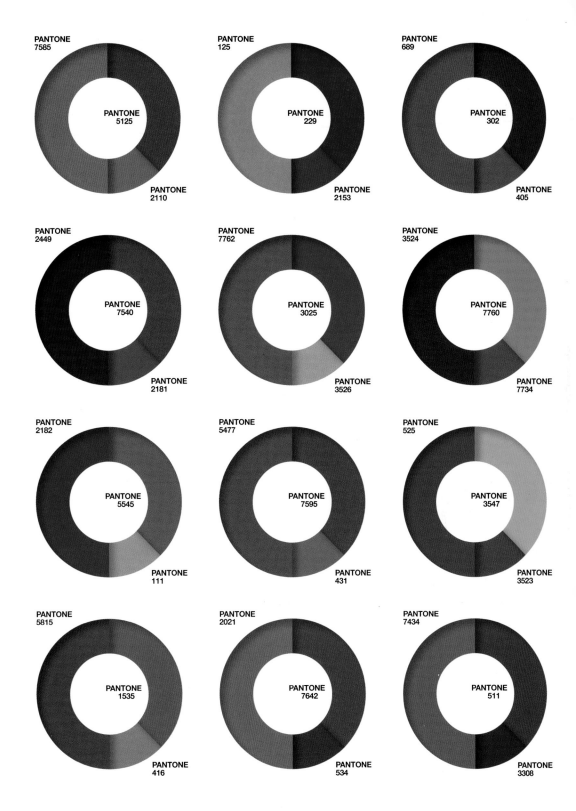

PANTONE
7585

PANTONE
5125

PANTONE
2110

PANTONE
125

PANTONE
229

PANTONE
2153

PANTONE
689

PANTONE
302

PANTONE
405

PANTONE
2449

PANTONE
7540

PANTONE
2181

PANTONE
7762

PANTONE
3025

PANTONE
3526

PANTONE
3524

PANTONE
7760

PANTONE
7734

PANTONE
2182

PANTONE
5545

PANTONE
111

PANTONE
5477

PANTONE
7595

PANTONE
431

PANTONE
525

PANTONE
3547

PANTONE
3523

PANTONE
5815

PANTONE
1535

PANTONE
416

PANTONE
2021

PANTONE
7642

PANTONE
534

PANTONE
7434

PANTONE
511

PANTONE
3308

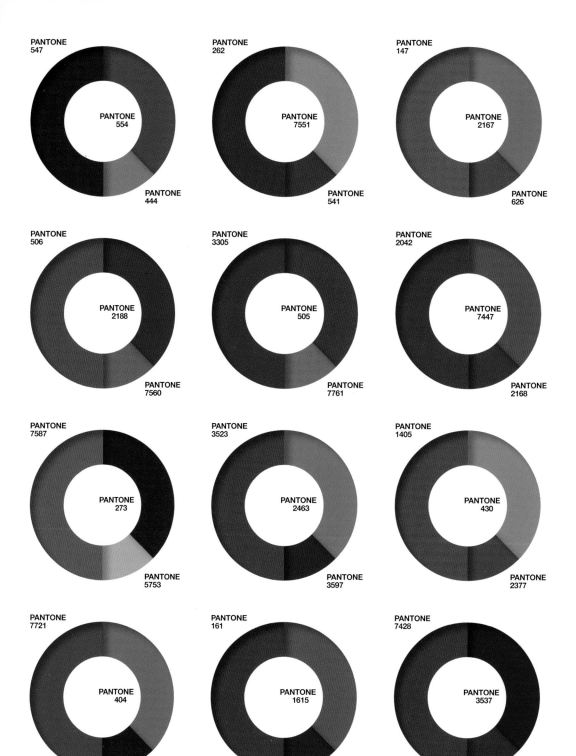

PANTONE
547

PANTONE
554

PANTONE
444

PANTONE
262

PANTONE
7551

PANTONE
541

PANTONE
147

PANTONE
2167

PANTONE
626

PANTONE
506

PANTONE
2188

PANTONE
7560

PANTONE
3305

PANTONE
505

PANTONE
7761

PANTONE
2042

PANTONE
7447

PANTONE
2168

PANTONE
7587

PANTONE
273

PANTONE
5753

PANTONE
3523

PANTONE
2463

PANTONE
3597

PANTONE
1405

PANTONE
430

PANTONE
2377

PANTONE
7721

PANTONE
404

PANTONE
2755

PANTONE
161

PANTONE
1615

PANTONE
3591

PANTONE
7428

PANTONE
3537

PANTONE
3566

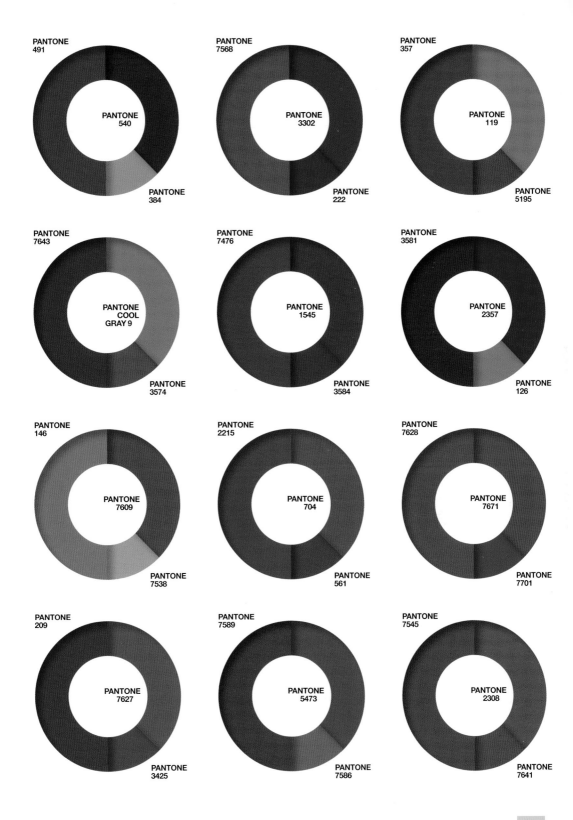

PANTONE
491

PANTONE
540

PANTONE
384

PANTONE
7568

PANTONE
3302

PANTONE
222

PANTONE
357

PANTONE
119

PANTONE
5195

PANTONE
7643

PANTONE
COOL
GRAY 9

PANTONE
3574

PANTONE
7476

PANTONE
1545

PANTONE
3584

PANTONE
3581

PANTONE
2357

PANTONE
126

PANTONE
146

PANTONE
7609

PANTONE
7538

PANTONE
2215

PANTONE
704

PANTONE
561

PANTONE
7628

PANTONE
7671

PANTONE
7701

PANTONE
209

PANTONE
7627

PANTONE
3425

PANTONE
7589

PANTONE
5473

PANTONE
7586

PANTONE
7545

PANTONE
2308

PANTONE
7641

EARTHY

More warm than cool, more country than city, a palette of earth tones brings to mind the colors of harvest and abundance. There are sumptuous pumpkin oranges and russets, forest greens and moss tones, pungently blackened browns, resonant umber browns, and honeyed yellows. Reminiscent of a walk in the woods on a brisk fall day, this autumnal assemblage of color leads us down a path filled with fallen leaves. Adding a surprising complexity to the color mix, there are intense tones of meadow violet and magenta, cranberry wine, and amber gold.

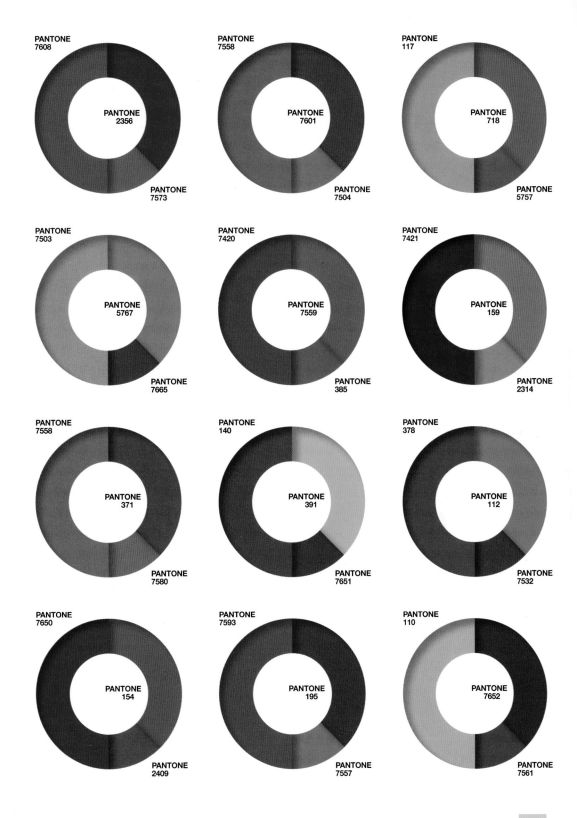

PANTONE
7608

PANTONE
2356

PANTONE
7573

PANTONE
7558

PANTONE
7601

PANTONE
7504

PANTONE
117

PANTONE
718

PANTONE
5757

PANTONE
7503

PANTONE
5767

PANTONE
7665

PANTONE
7420

PANTONE
7559

PANTONE
385

PANTONE
7421

PANTONE
159

PANTONE
2314

PANTONE
7558

PANTONE
371

PANTONE
7580

PANTONE
140

PANTONE
391

PANTONE
7651

PANTONE
378

PANTONE
112

PANTONE
7532

PANTONE
7650

PANTONE
154

PANTONE
2409

PANTONE
7593

PANTONE
195

PANTONE
7557

PANTONE
110

PANTONE
7652

PANTONE
7561

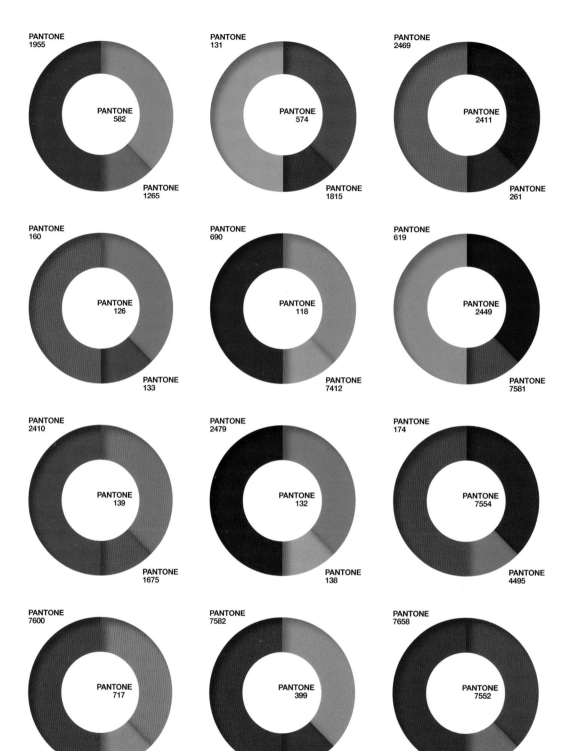

PANTONE
1955

PANTONE
582

PANTONE
1265

PANTONE
131

PANTONE
574

PANTONE
1815

PANTONE
2469

PANTONE
2411

PANTONE
261

PANTONE
160

PANTONE
126

PANTONE
133

PANTONE
690

PANTONE
118

PANTONE
7412

PANTONE
619

PANTONE
2449

PANTONE
7581

PANTONE
2410

PANTONE
139

PANTONE
1675

PANTONE
2479

PANTONE
132

PANTONE
138

PANTONE
174

PANTONE
7554

PANTONE
4495

PANTONE
7600

PANTONE
717

PANTONE
7556

PANTONE
7582

PANTONE
399

PANTONE
235

PANTONE
7658

PANTONE
7552

PANTONE
2307

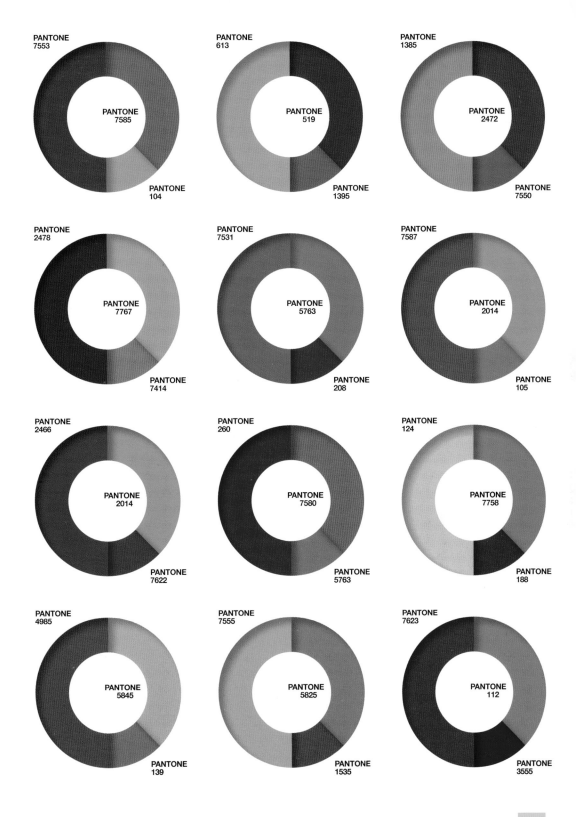

PANTONE
7553

PANTONE
7585

PANTONE
104

PANTONE
613

PANTONE
519

PANTONE
1395

PANTONE
1385

PANTONE
2472

PANTONE
7550

PANTONE
2478

PANTONE
7767

PANTONE
7414

PANTONE
7531

PANTONE
5763

PANTONE
208

PANTONE
7587

PANTONE
2014

PANTONE
105

PANTONE
2466

PANTONE
2014

PANTONE
7622

PANTONE
260

PANTONE
7580

PANTONE
5763

PANTONE
124

PANTONE
7758

PANTONE
188

PANTONE
4985

PANTONE
5845

PANTONE
139

PANTONE
7555

PANTONE
5825

PANTONE
1535

PANTONE
7623

PANTONE
112

PANTONE
3555

NATURAL

Natural tones are those that are perceived as unadulterated, unbleached, unrefined, unprocessed, wholesome, and organic. This is a palette that spurns artificiality, so anything fluorescent, neon, or flamboyantly colored will not work to get this natural message across. Whites are not pristine, bright, and bleached clean, but are slightly warmed to a parchment or ivory. Yellows are mellowed cornsilk and chamomile, while the orange family favors the softer tones of a prairie sunset, and pink is reflected in the shifting shades of evening sand. Toasty and whole-grained tans, bran brown, mushroom, and mineral gray, offer a grounded presence. Greens are well-represented in lichen, loden, seagrass, and vintage khaki.

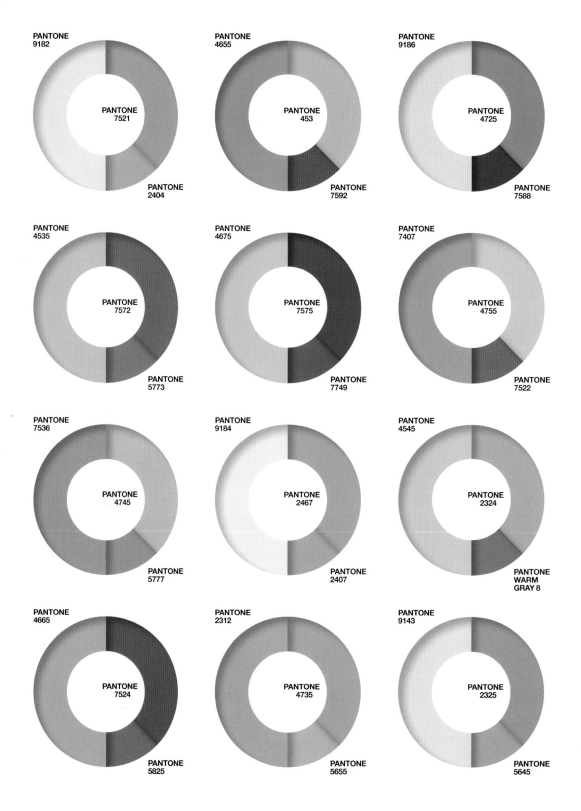

PANTONE
9182

PANTONE
7521

PANTONE
2404

PANTONE
4655

PANTONE
453

PANTONE
7592

PANTONE
9186

PANTONE
4725

PANTONE
7588

PANTONE
4535

PANTONE
7572

PANTONE
5773

PANTONE
4675

PANTONE
7575

PANTONE
7749

PANTONE
7407

PANTONE
4755

PANTONE
7522

PANTONE
7536

PANTONE
4745

PANTONE
5777

PANTONE
9184

PANTONE
2467

PANTONE
2407

PANTONE
4545

PANTONE
2324

PANTONE
WARM
GRAY 8

PANTONE
4665

PANTONE
7524

PANTONE
5825

PANTONE
2312

PANTONE
4735

PANTONE
5655

PANTONE
9143

PANTONE
2325

PANTONE
5645

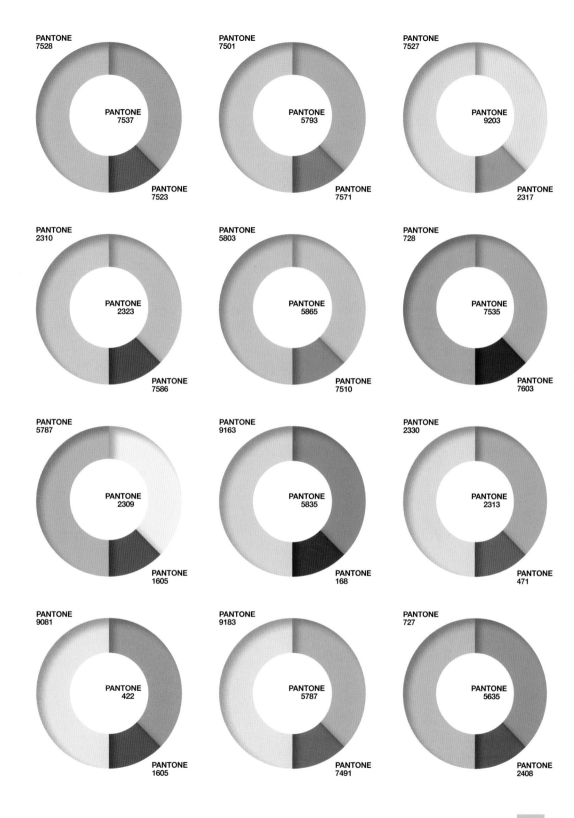

PANTONE
7528

PANTONE
7537

PANTONE
7523

PANTONE
7501

PANTONE
5793

PANTONE
7571

PANTONE
7527

PANTONE
9203

PANTONE
2317

PANTONE
2310

PANTONE
2323

PANTONE
7586

PANTONE
5803

PANTONE
5865

PANTONE
7510

PANTONE
728

PANTONE
7535

PANTONE
7603

PANTONE
5787

PANTONE
2309

PANTONE
1605

PANTONE
9163

PANTONE
5835

PANTONE
168

PANTONE
2330

PANTONE
2313

PANTONE
471

PANTONE
9081

PANTONE
422

PANTONE
1605

PANTONE
9183

PANTONE
5787

PANTONE
7491

PANTONE
727

PANTONE
5635

PANTONE
2408

PIQUANT

Reaching beyond what is generally referred to as "spicy," the Piquant palette is an intriguing potpourri of tastes and colors that reflect current day trends to more adventurous selections of foods, seasonings, and condiments. These are the hotter colors of chili-pepper red, blood orange, saffron, cayenne, persimmon, and Tandoori spice, harmoniously mixed with turmeric, cumin, and Dijon mustard. For added impact and flavor, there is purple tinged basil and sage as well as unique new purple veggies and drinks. As a final touch, there is an ample splash of lemon and lime.

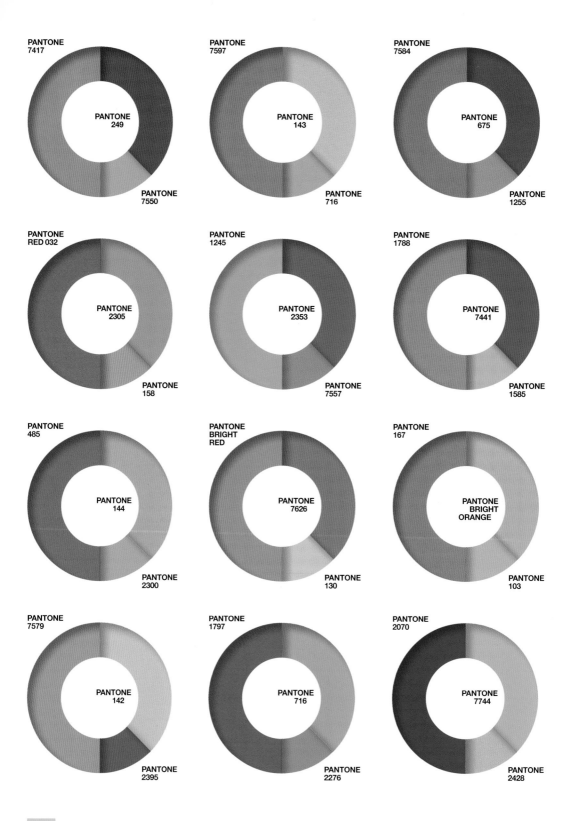

PANTONE
7417

PANTONE
249

PANTONE
7550

PANTONE
7597

PANTONE
143

PANTONE
716

PANTONE
7584

PANTONE
675

PANTONE
1255

PANTONE
RED 032

PANTONE
2305

PANTONE
158

PANTONE
1245

PANTONE
2353

PANTONE
7557

PANTONE
1788

PANTONE
7441

PANTONE
1585

PANTONE
485

PANTONE
144

PANTONE
2300

PANTONE
BRIGHT
RED

PANTONE
7626

PANTONE
130

PANTONE
167

PANTONE
BRIGHT
ORANGE

PANTONE
103

PANTONE
7579

PANTONE
142

PANTONE
2395

PANTONE
1797

PANTONE
716

PANTONE
2276

PANTONE
2070

PANTONE
7744

PANTONE
2428

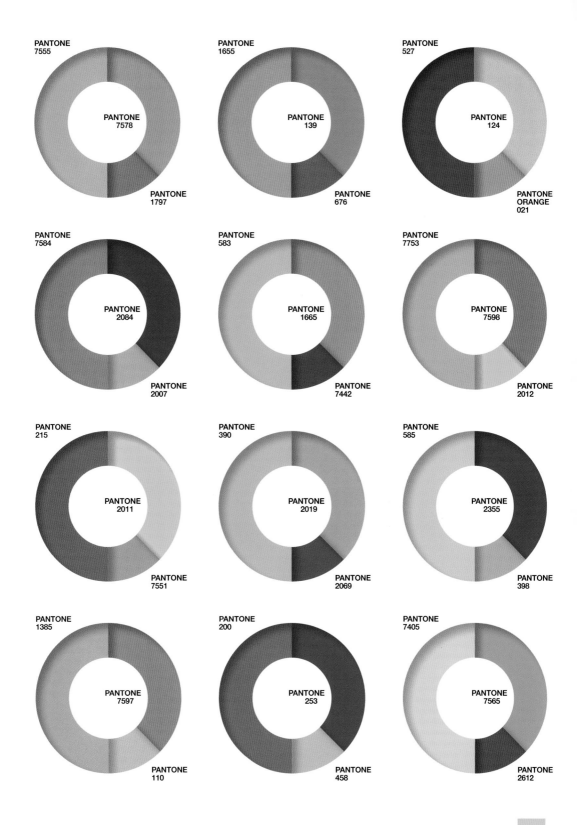

PANTONE
7555

PANTONE
7578

PANTONE
1797

PANTONE
1655

PANTONE
139

PANTONE
676

PANTONE
527

PANTONE
124

PANTONE
ORANGE
021

PANTONE
7584

PANTONE
2084

PANTONE
2007

PANTONE
583

PANTONE
1665

PANTONE
7442

PANTONE
7753

PANTONE
7598

PANTONE
2012

PANTONE
215

PANTONE
2011

PANTONE
7551

PANTONE
390

PANTONE
2019

PANTONE
2069

PANTONE
585

PANTONE
2355

PANTONE
398

PANTONE
1385

PANTONE
7597

PANTONE
110

PANTONE
200

PANTONE
253

PANTONE
458

PANTONE
7405

PANTONE
7565

PANTONE
2612

URBAN

An Urban palette expresses a metro feeling, with tall buildings and the dark shadows they throw; a cool concrete jungle filled with cement and paving. Mirrored against the glossy steel surfaces and multiple reflecting windows are the colors of the sky, from the grayed blues of dusk through the clear blues of daylight, culminating with moody twilight blues or vague purples. Big city black adds some sophistication while charcoal gray reminds us there is serious business to be transacted here. However, there is a touch of nature, as more cities embrace the therapeutic concept of green-pocket parks and rooftop gardens.

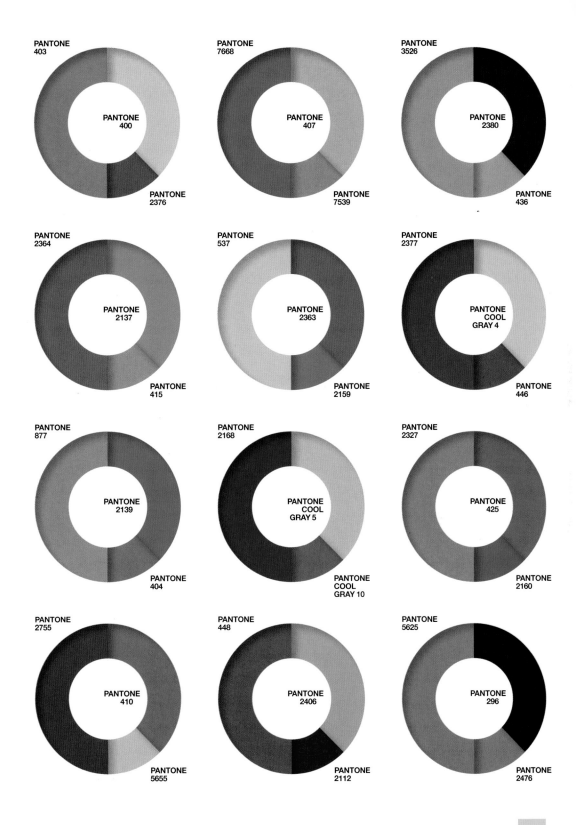

PANTONE
403

PANTONE
400

PANTONE
2376

PANTONE
7668

PANTONE
407

PANTONE
7539

PANTONE
3526

PANTONE
2380

PANTONE
436

PANTONE
2364

PANTONE
2137

PANTONE
415

PANTONE
537

PANTONE
2363

PANTONE
2159

PANTONE
2377

PANTONE
COOL
GRAY 4

PANTONE
446

PANTONE
877

PANTONE
2139

PANTONE
404

PANTONE
2168

PANTONE
COOL
GRAY 5

PANTONE
COOL
GRAY 10

PANTONE
2327

PANTONE
425

PANTONE
2160

PANTONE
2755

PANTONE
410

PANTONE
5655

PANTONE
448

PANTONE
2406

PANTONE
2112

PANTONE
5625

PANTONE
296

PANTONE
2476

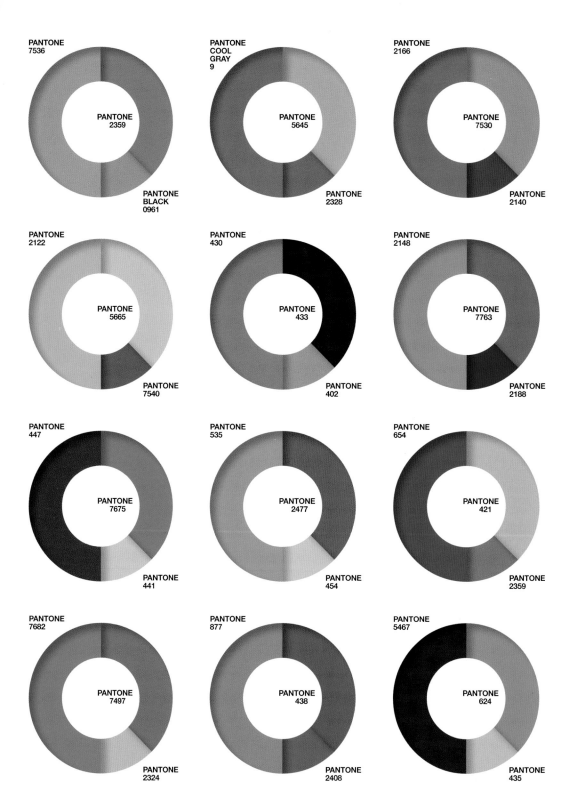

PANTONE
7536

PANTONE
2359

PANTONE
BLACK
0961

PANTONE
COOL
GRAY
9

PANTONE
5645

PANTONE
2328

PANTONE
2166

PANTONE
7530

PANTONE
2140

PANTONE
2122

PANTONE
5665

PANTONE
7540

PANTONE
430

PANTONE
433

PANTONE
402

PANTONE
2148

PANTONE
7763

PANTONE
2188

PANTONE
447

PANTONE
7675

PANTONE
441

PANTONE
535

PANTONE
2477

PANTONE
454

PANTONE
654

PANTONE
421

PANTONE
2359

PANTONE
7682

PANTONE
7497

PANTONE
2324

PANTONE
877

PANTONE
438

PANTONE
2408

PANTONE
5467

PANTONE
624

PANTONE
435

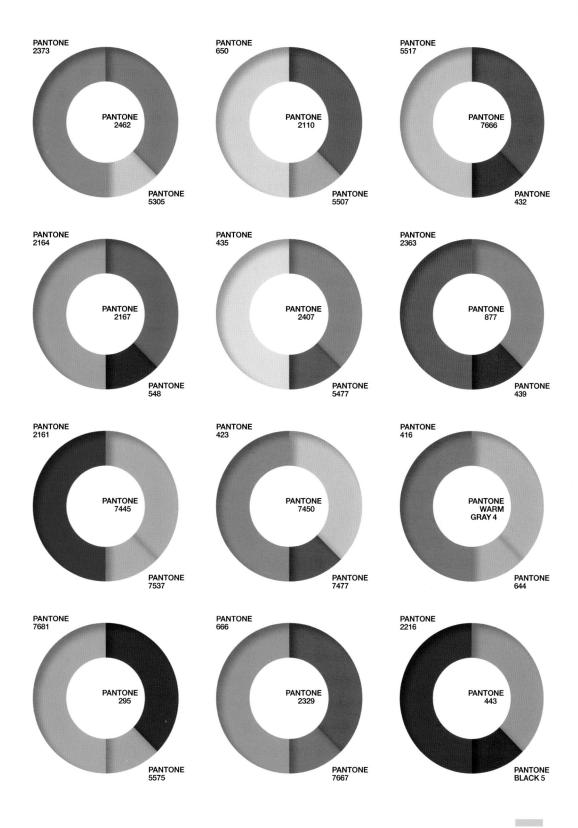

PANTONE
2373

PANTONE
2462

PANTONE
5305

PANTONE
650

PANTONE
2110

PANTONE
5507

PANTONE
5517

PANTONE
7666

PANTONE
432

PANTONE
2164

PANTONE
2167

PANTONE
548

PANTONE
435

PANTONE
2407

PANTONE
5477

PANTONE
2363

PANTONE
877

PANTONE
439

PANTONE
2161

PANTONE
7445

PANTONE
7537

PANTONE
423

PANTONE
7450

PANTONE
7477

PANTONE
416

PANTONE
WARM
GRAY 4

PANTONE
644

PANTONE
7681

PANTONE
295

PANTONE
5575

PANTONE
666

PANTONE
2329

PANTONE
7667

PANTONE
2216

PANTONE
443

PANTONE
BLACK 5

NURTURING

The nature of nurture is to care for, encourage, protect, and cherish. The colors are primarily warm, inviting, enveloping, seemingly tactile, and touchable. Just as the sun itself promises a warm and beautiful day, sunlit undertones draw us in. This is an easy-going, non-invasive palette eliciting thoughts of juicy peaches and melon, biscotti and latte, pistachio green, and creamy custard. Lamb's wool and winter wheat, scented lavender and placid blue, complete the inevitable feelings of ease and fulfillment that are spawned by these comforting tones.

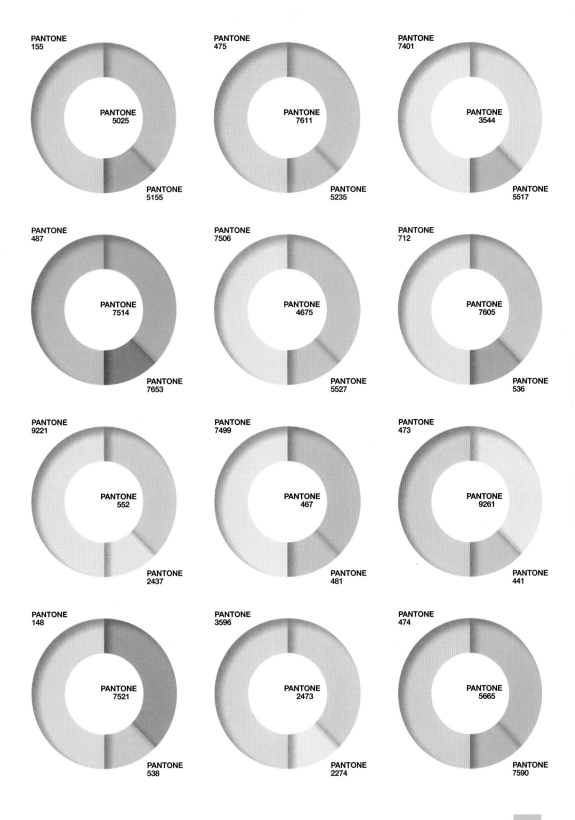

PANTONE
155

PANTONE
5025

PANTONE
5155

PANTONE
475

PANTONE
7611

PANTONE
5235

PANTONE
7401

PANTONE
3544

PANTONE
5517

PANTONE
487

PANTONE
7514

PANTONE
7653

PANTONE
7506

PANTONE
4675

PANTONE
5527

PANTONE
712

PANTONE
7605

PANTONE
536

PANTONE
9221

PANTONE
552

PANTONE
2437

PANTONE
7499

PANTONE
467

PANTONE
481

PANTONE
473

PANTONE
9261

PANTONE
441

PANTONE
148

PANTONE
7521

PANTONE
538

PANTONE
3596

PANTONE
2473

PANTONE
2274

PANTONE
474

PANTONE
5665

PANTONE
7590

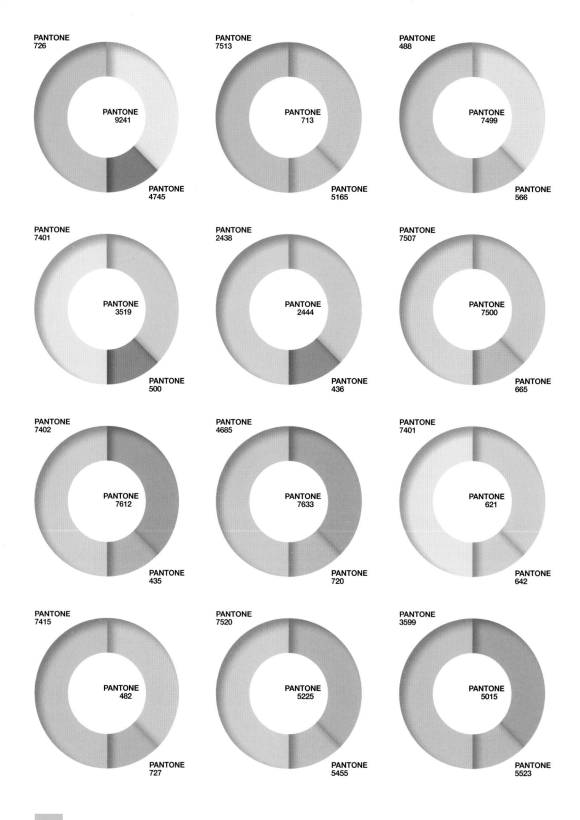

PANTONE
726

PANTONE
9241

PANTONE
4745

PANTONE
7513

PANTONE
713

PANTONE
5165

PANTONE
488

PANTONE
7499

PANTONE
566

PANTONE
7401

PANTONE
3519

PANTONE
500

PANTONE
2438

PANTONE
2444

PANTONE
436

PANTONE
7507

PANTONE
7500

PANTONE
665

PANTONE
7402

PANTONE
7612

PANTONE
435

PANTONE
4685

PANTONE
7633

PANTONE
720

PANTONE
7401

PANTONE
621

PANTONE
642

PANTONE
7415

PANTONE
482

PANTONE
727

PANTONE
7520

PANTONE
5225

PANTONE
5455

PANTONE
3599

PANTONE
5015

PANTONE
5523

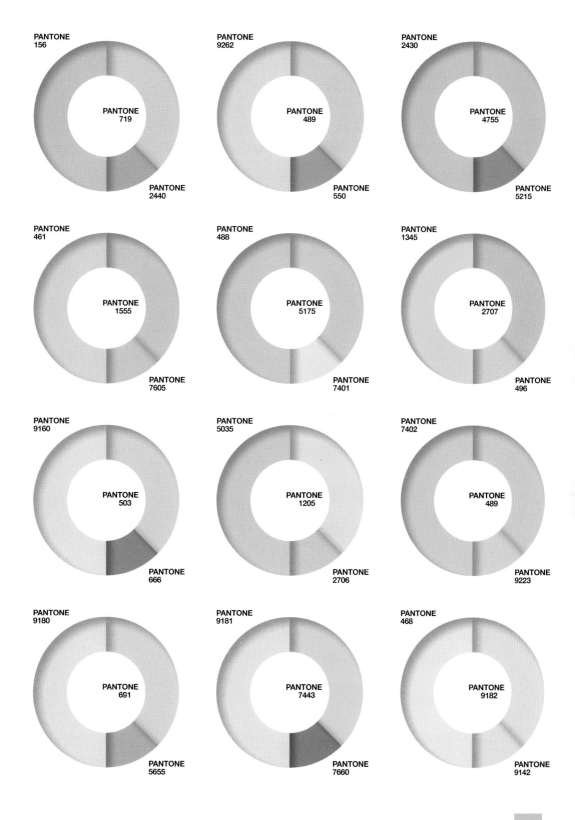

PANTONE
156

PANTONE
719

PANTONE
2440

PANTONE
9262

PANTONE
489

PANTONE
550

PANTONE
2430

PANTONE
4755

PANTONE
5215

PANTONE
461

PANTONE
1555

PANTONE
7605

PANTONE
488

PANTONE
5175

PANTONE
7401

PANTONE
1345

PANTONE
2707

PANTONE
496

PANTONE
9160

PANTONE
503

PANTONE
666

PANTONE
5035

PANTONE
1205

PANTONE
2706

PANTONE
7402

PANTONE
489

PANTONE
9223

PANTONE
9180

PANTONE
691

PANTONE
5655

PANTONE
9181

PANTONE
7443

PANTONE
7660

PANTONE
468

PANTONE
9182

PANTONE
9142

TROPICAL

Tropical is a palette immersed in the colors that take us away to an idyllic location, whether real or fanaticized. The palette is awash with a wide assortment of blue and blue greens, while the names of the colors themselves speak to our desired destinations. There are the translucent Hawaiian ocean or Bermuda blues, crystal-clear blues and deeper lagoon blues. There are vivid turquoise scuba-diving blue greens, and sprays of aqua, tidal foam, and beach-glass greens illuminated by a refreshing splash of icy lime. Coral reefs and the ever-present sunlit yellows provide the warming touch to this palette, promising an island paradise.

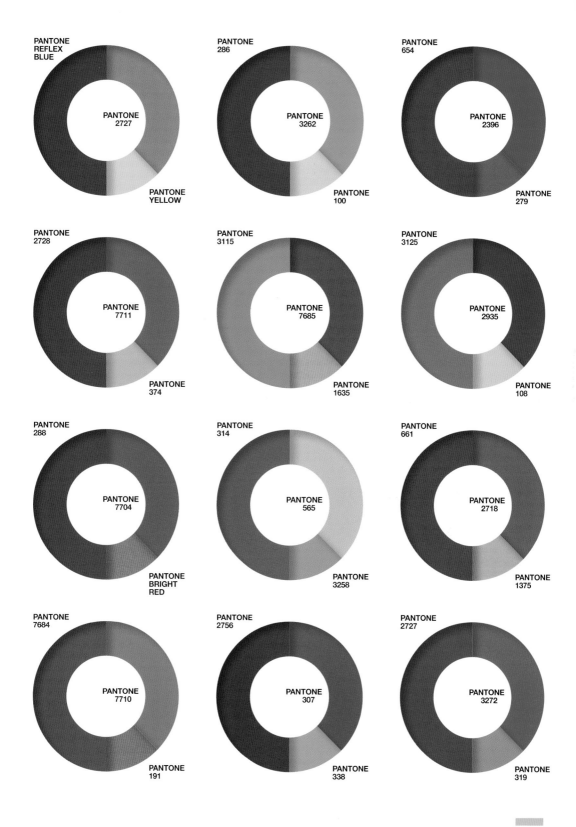

PANTONE
REFLEX
BLUE

PANTONE
2727

PANTONE
YELLOW

PANTONE
286

PANTONE
3262

PANTONE
100

PANTONE
654

PANTONE
2396

PANTONE
279

PANTONE
2728

PANTONE
7711

PANTONE
374

PANTONE
3115

PANTONE
7685

PANTONE
1635

PANTONE
3125

PANTONE
2935

PANTONE
108

PANTONE
288

PANTONE
7704

PANTONE
BRIGHT
RED

PANTONE
314

PANTONE
565

PANTONE
3258

PANTONE
661

PANTONE
2718

PANTONE
1375

PANTONE
7684

PANTONE
7710

PANTONE
191

PANTONE
2756

PANTONE
307

PANTONE
338

PANTONE
2727

PANTONE
3272

PANTONE
319

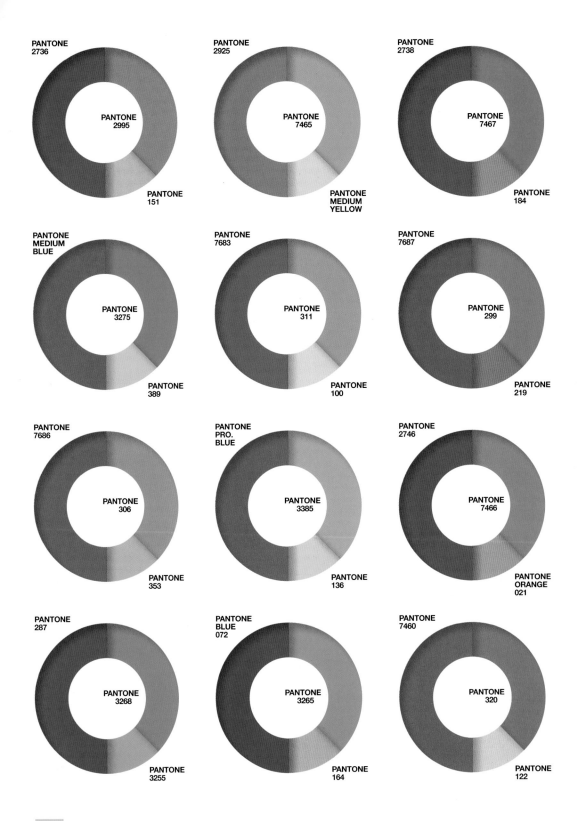

PANTONE
2736

PANTONE
2995

PANTONE
151

PANTONE
2925

PANTONE
7465

PANTONE
MEDIUM
YELLOW

PANTONE
2738

PANTONE
7467

PANTONE
184

PANTONE
MEDIUM
BLUE

PANTONE
3275

PANTONE
389

PANTONE
7683

PANTONE
311

PANTONE
100

PANTONE
7687

PANTONE
299

PANTONE
219

PANTONE
7686

PANTONE
306

PANTONE
353

PANTONE
PRO.
BLUE

PANTONE
3385

PANTONE
136

PANTONE
2746

PANTONE
7466

PANTONE
ORANGE
021

PANTONE
287

PANTONE
3268

PANTONE
3255

PANTONE
BLUE
072

PANTONE
3265

PANTONE
164

PANTONE
7460

PANTONE
320

PANTONE
122

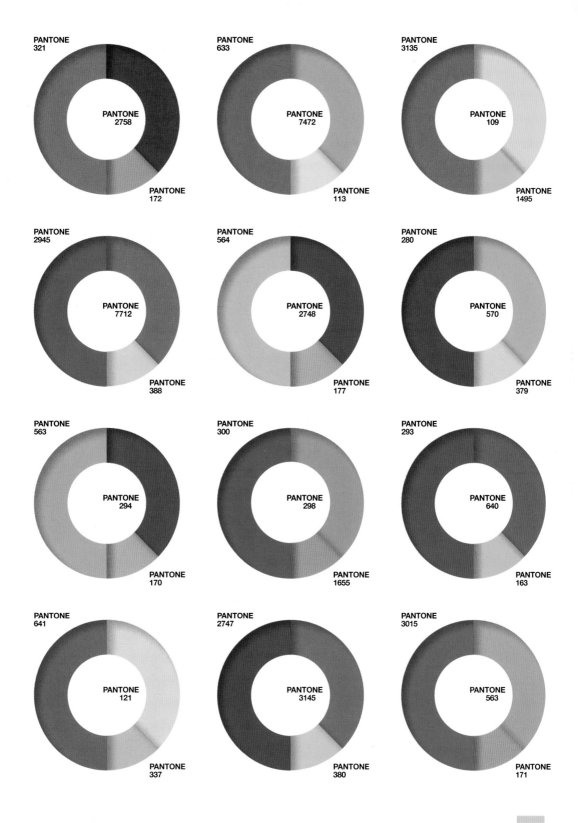

PANTONE
321

PANTONE
2758

PANTONE
172

PANTONE
633

PANTONE
7472

PANTONE
113

PANTONE
3135

PANTONE
109

PANTONE
1495

PANTONE
2945

PANTONE
7712

PANTONE
388

PANTONE
564

PANTONE
2748

PANTONE
177

PANTONE
280

PANTONE
570

PANTONE
379

PANTONE
563

PANTONE
294

PANTONE
170

PANTONE
300

PANTONE
298

PANTONE
1655

PANTONE
293

PANTONE
640

PANTONE
163

PANTONE
641

PANTONE
121

PANTONE
337

PANTONE
2747

PANTONE
3145

PANTONE
380

PANTONE
3015

PANTONE
563

PANTONE
171

SUBTLE

Just as the name implies, Subtle is a nuanced group of hues that is understated and upscale. Blatantly bright shades will not find a home here as the mood is muted, subdued, quiet, and contained, yet at the same time, the goal is not to make the palette so unobtrusive that it becomes boring. There is an artful simplicity that is expressed with a range of neutrals and shades like hazy aqua and celestial blue finessed into combinations with mellow mauves, grayish lavenders, and weeping-willow greens. The effect is composed and cool in color, temperature, and attitude.

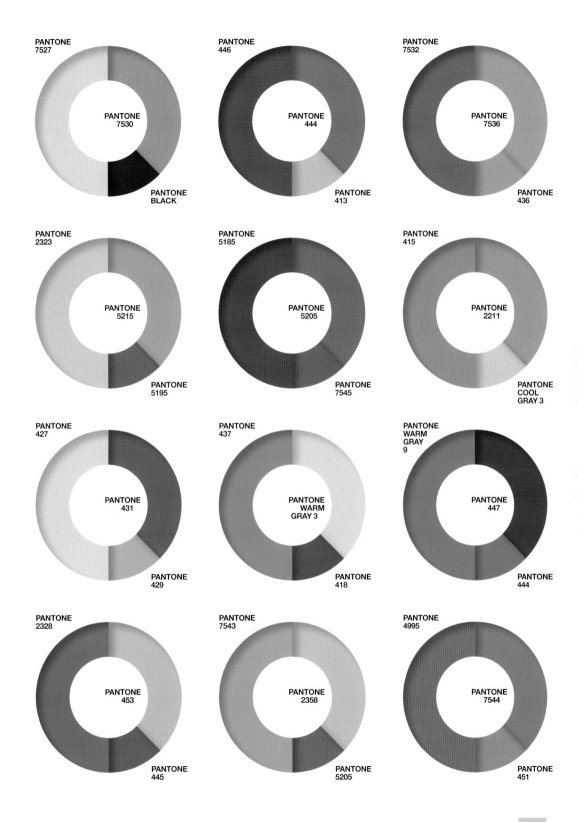

PANTONE
7527

PANTONE
7530

PANTONE
BLACK

PANTONE
446

PANTONE
444

PANTONE
413

PANTONE
7532

PANTONE
7536

PANTONE
436

PANTONE
2323

PANTONE
5215

PANTONE
5195

PANTONE
5185

PANTONE
5205

PANTONE
7545

PANTONE
415

PANTONE
2211

PANTONE
COOL
GRAY 3

PANTONE
427

PANTONE
431

PANTONE
429

PANTONE
437

PANTONE
WARM
GRAY 3

PANTONE
418

PANTONE
WARM
GRAY
9

PANTONE
447

PANTONE
444

PANTONE
2328

PANTONE
453

PANTONE
445

PANTONE
7543

PANTONE
2358

PANTONE
5205

PANTONE
4995

PANTONE
7544

PANTONE
451

COLOR AND MOOD:
SUBTLE 101

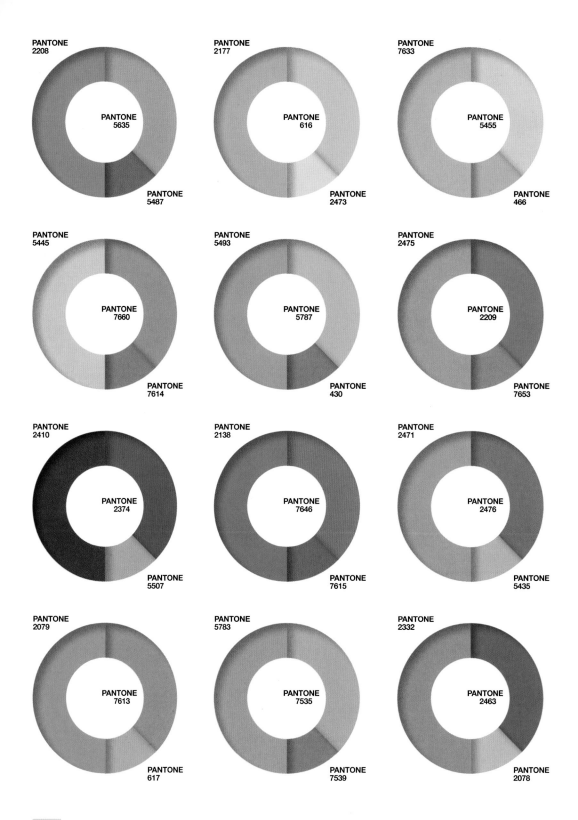

PANTONE
2208

PANTONE
5635

PANTONE
5487

PANTONE
2177

PANTONE
616

PANTONE
2473

PANTONE
7633

PANTONE
5455

PANTONE
466

PANTONE
5445

PANTONE
7660

PANTONE
7614

PANTONE
5493

PANTONE
5787

PANTONE
430

PANTONE
2475

PANTONE
2209

PANTONE
7653

PANTONE
2410

PANTONE
2374

PANTONE
5507

PANTONE
2138

PANTONE
7646

PANTONE
7615

PANTONE
2471

PANTONE
2476

PANTONE
5435

PANTONE
2079

PANTONE
7613

PANTONE
617

PANTONE
5783

PANTONE
7535

PANTONE
7539

PANTONE
2332

PANTONE
2463

PANTONE
2078

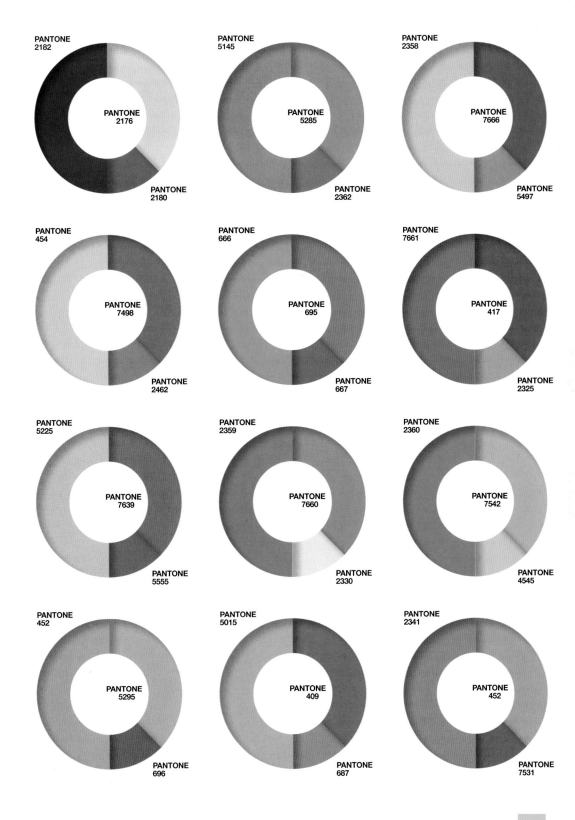

PANTONE
2182

PANTONE
2176

PANTONE
2180

PANTONE
5145

PANTONE
5285

PANTONE
2362

PANTONE
2358

PANTONE
7666

PANTONE
5497

PANTONE
454

PANTONE
7498

PANTONE
2462

PANTONE
666

PANTONE
695

PANTONE
667

PANTONE
7661

PANTONE
417

PANTONE
2325

PANTONE
5225

PANTONE
7639

PANTONE
5555

PANTONE
2359

PANTONE
7660

PANTONE
2330

PANTONE
2360

PANTONE
7542

PANTONE
4545

PANTONE
452

PANTONE
5295

PANTONE
696

PANTONE
5015

PANTONE
409

PANTONE
687

PANTONE
2341

PANTONE
452

PANTONE
7531

RICH

Rich is a word that is rich in meaning. Applied to the sense of taste, it suggests the deliciousness of a chocolate mousse, a sip of fine wine, or piquant olives in a long-stemmed martini glass. Rich can be tasteful as well as tasty; it is resonant, sumptuous, and above all, plentiful. A portrait rich in color can be painted in artful shades of aubergine, plum, berry, claret, sauterne, olive, café au lait, maroon, and cacao brown. It is similar in tone to the Robust palette, but the Rich palette adds more sparkling grape, vinous red, and the power of a distinctive caviar black.

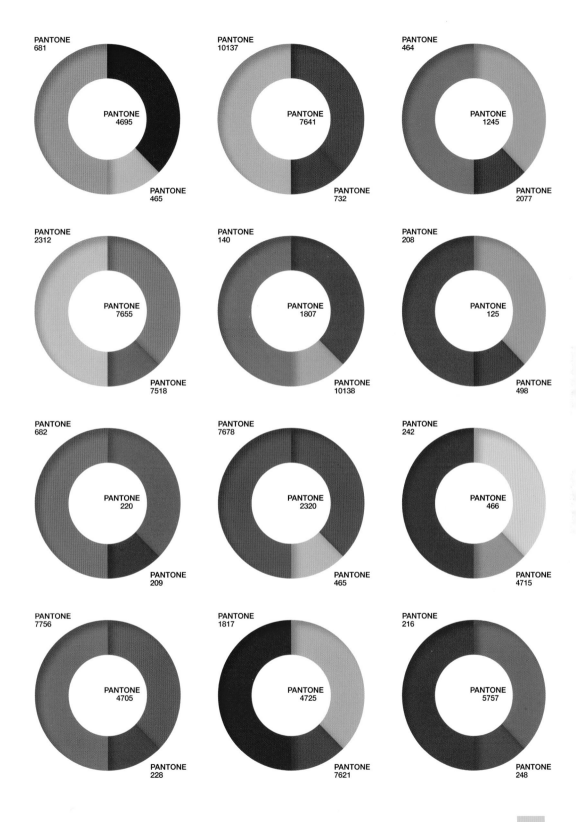

PANTONE
681

PANTONE
4695

PANTONE
465

PANTONE
10137

PANTONE
7641

PANTONE
732

PANTONE
464

PANTONE
1245

PANTONE
2077

PANTONE
2312

PANTONE
7655

PANTONE
7518

PANTONE
140

PANTONE
1807

PANTONE
10138

PANTONE
208

PANTONE
125

PANTONE
498

PANTONE
682

PANTONE
220

PANTONE
209

PANTONE
7678

PANTONE
2320

PANTONE
465

PANTONE
242

PANTONE
466

PANTONE
4715

PANTONE
7756

PANTONE
4705

PANTONE
228

PANTONE
1817

PANTONE
4725

PANTONE
7621

PANTONE
216

PANTONE
5757

PANTONE
248

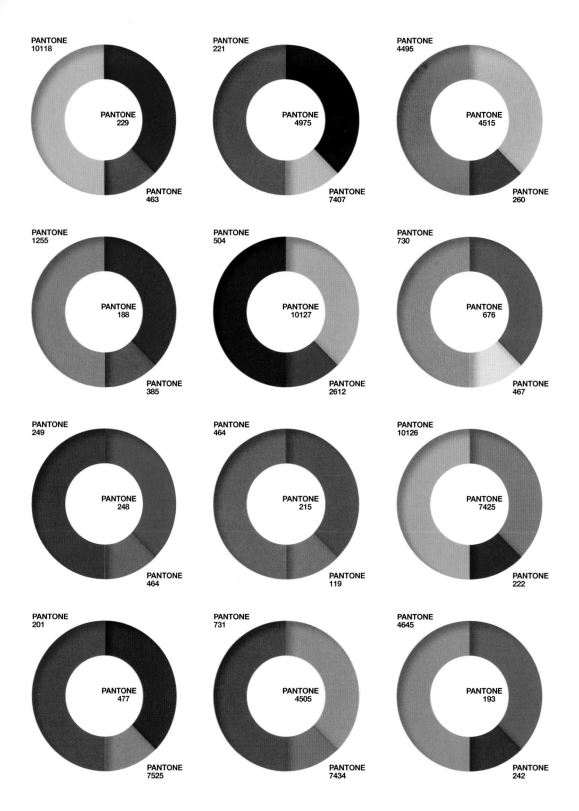

PANTONE
10118

PANTONE
229

PANTONE
463

PANTONE
221

PANTONE
4975

PANTONE
7407

PANTONE
4495

PANTONE
4515

PANTONE
260

PANTONE
1255

PANTONE
188

PANTONE
385

PANTONE
504

PANTONE
10127

PANTONE
2612

PANTONE
730

PANTONE
676

PANTONE
467

PANTONE
249

PANTONE
248

PANTONE
464

PANTONE
464

PANTONE
215

PANTONE
119

PANTONE
10126

PANTONE
7425

PANTONE
222

PANTONE
201

PANTONE
477

PANTONE
7525

PANTONE
731

PANTONE
4505

PANTONE
7434

PANTONE
4645

PANTONE
193

PANTONE
242

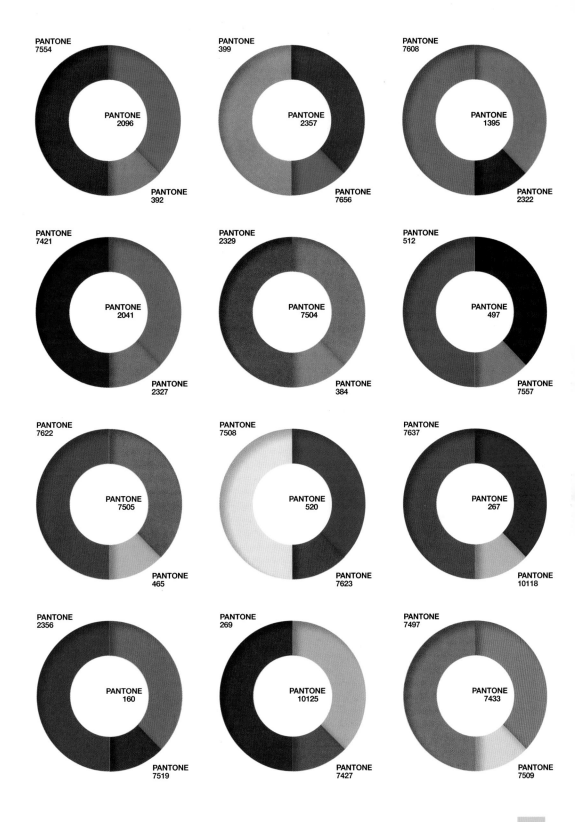

PANTONE
7554

PANTONE
2096

PANTONE
392

PANTONE
399

PANTONE
2357

PANTONE
7656

PANTONE
7608

PANTONE
1395

PANTONE
2322

PANTONE
7421

PANTONE
2041

PANTONE
2327

PANTONE
2329

PANTONE
7504

PANTONE
384

PANTONE
512

PANTONE
497

PANTONE
7557

PANTONE
7622

PANTONE
7505

PANTONE
465

PANTONE
7508

PANTONE
520

PANTONE
7623

PANTONE
7637

PANTONE
267

PANTONE
10118

PANTONE
2356

PANTONE
160

PANTONE
7519

PANTONE
269

PANTONE
10125

PANTONE
7427

PANTONE
7497

PANTONE
7433

PANTONE
7509

PLAYFUL

This lively, joyful, exuberant grouping of color is an invitation to come out and play. These are energizing, "up" colors that elicit a smile and are inherently understood by both kids and grown-ups who are young at heart. Irrepressible fun and spontaneity are expressed through this mash-up of jelly bean colors, including shades that would beg for sweetened or tarted-up names like: orange popsicle, pink lemonade, lollipop red, dewberry purple, lemon zest, kiwi, daiquiri, and just to cool things down a bit, a blue-green [age-of] aquarius.

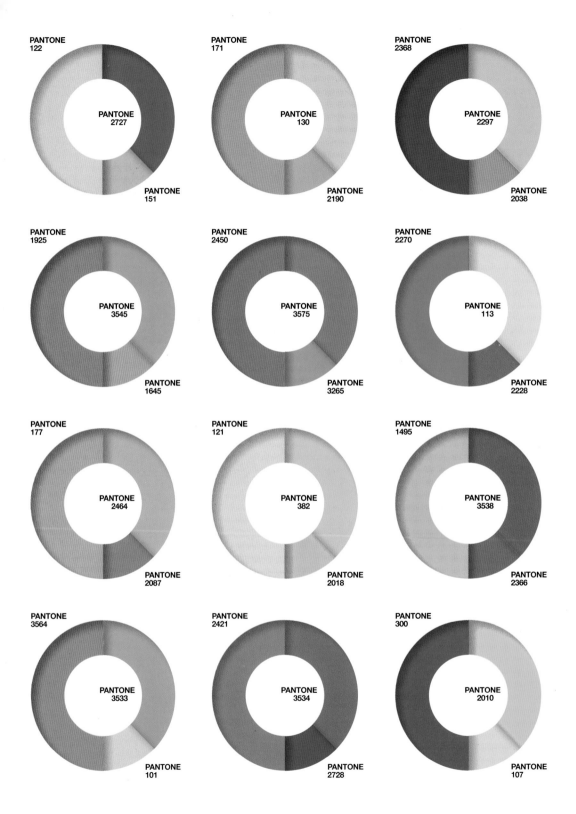

PANTONE
122

PANTONE
2727

PANTONE
151

PANTONE
171

PANTONE
130

PANTONE
2190

PANTONE
2368

PANTONE
2297

PANTONE
2038

PANTONE
1925

PANTONE
3545

PANTONE
1645

PANTONE
2450

PANTONE
3575

PANTONE
3265

PANTONE
2270

PANTONE
113

PANTONE
2228

PANTONE
177

PANTONE
2464

PANTONE
2087

PANTONE
121

PANTONE
382

PANTONE
2018

PANTONE
1495

PANTONE
3538

PANTONE
2366

PANTONE
3564

PANTONE
3533

PANTONE
101

PANTONE
2421

PANTONE
3534

PANTONE
2728

PANTONE
300

PANTONE
2010

PANTONE
107

THE COMPLETE COLOR HARMONY:
PANTONE EDITION

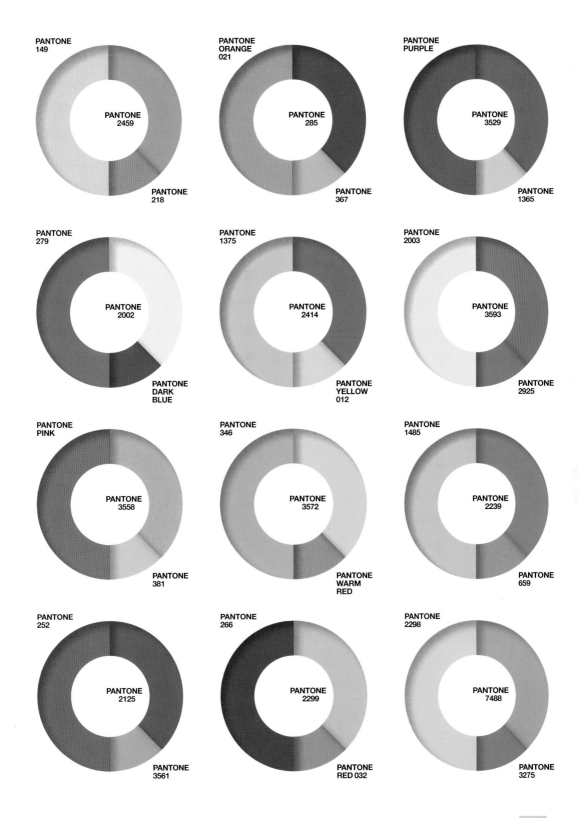

PANTONE
149

PANTONE
2459

PANTONE
218

PANTONE
ORANGE
021

PANTONE
285

PANTONE
367

PANTONE
PURPLE

PANTONE
3529

PANTONE
1365

PANTONE
279

PANTONE
2002

PANTONE
DARK
BLUE

PANTONE
1375

PANTONE
2414

PANTONE
YELLOW
012

PANTONE
2003

PANTONE
3593

PANTONE
2925

PANTONE
PINK

PANTONE
3558

PANTONE
381

PANTONE
346

PANTONE
3572

PANTONE
WARM
RED

PANTONE
1485

PANTONE
2239

PANTONE
659

PANTONE
252

PANTONE
2125

PANTONE
3561

PANTONE
266

PANTONE
2299

PANTONE
RED 032

PANTONE
2298

PANTONE
7488

PANTONE
3275

RELIABLE

The dictionary definition of "reliable" is: "something (or someone) that is dependable, well-founded, authentic, honest, genuine, loyal, constant, and true." As these are the qualities often ascribed to the blue family, there are many examples of that hue, from light to mid to dark, included in this palette, as well as other hues that are blue based. Rather than a volatile red, there are more serious cordovan shades. The blue-based purples are less pinkish or passionate, and a bit more sober. Greens are inclined to the bluer teals, and rock-solid gray has a strong positioning in this trustworthy and upstanding group.

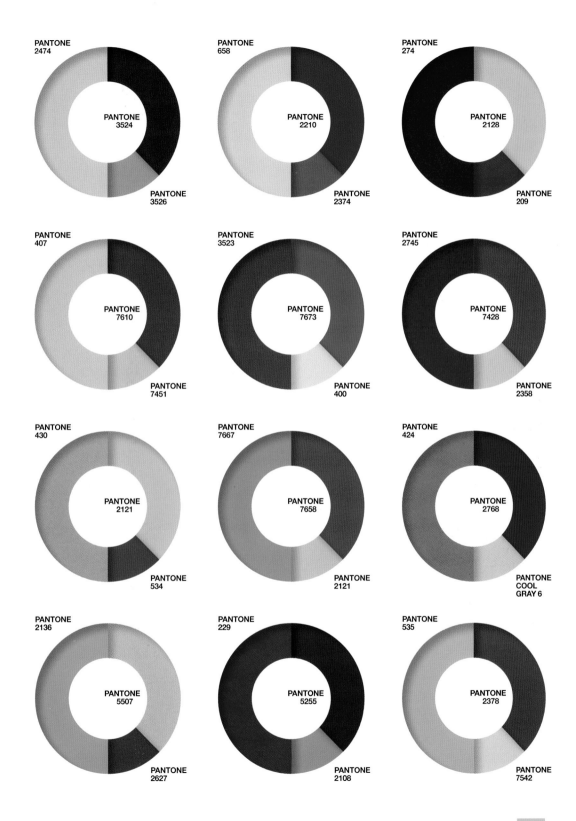

PANTONE
2474

PANTONE
3524

PANTONE
3526

PANTONE
658

PANTONE
2210

PANTONE
2374

PANTONE
274

PANTONE
2128

PANTONE
209

PANTONE
407

PANTONE
7610

PANTONE
7451

PANTONE
3523

PANTONE
7673

PANTONE
400

PANTONE
2745

PANTONE
7428

PANTONE
2358

PANTONE
430

PANTONE
2121

PANTONE
534

PANTONE
7667

PANTONE
7658

PANTONE
2121

PANTONE
424

PANTONE
2768

PANTONE
COOL
GRAY 6

PANTONE
2136

PANTONE
5507

PANTONE
2627

PANTONE
229

PANTONE
5255

PANTONE
2108

PANTONE
535

PANTONE
2378

PANTONE
7542

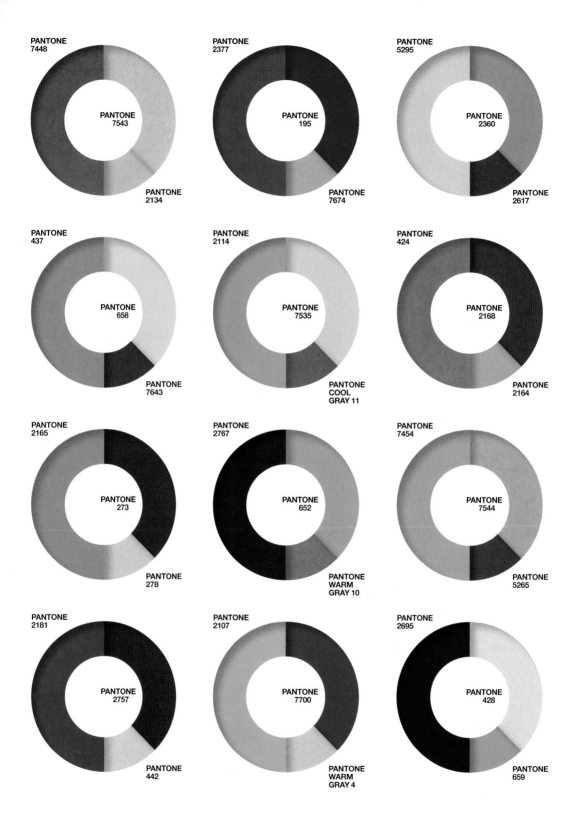

PANTONE
7448

PANTONE
7543

PANTONE
2134

PANTONE
2377

PANTONE
195

PANTONE
7674

PANTONE
5295

PANTONE
2360

PANTONE
2617

PANTONE
437

PANTONE
658

PANTONE
7643

PANTONE
2114

PANTONE
7535

PANTONE
COOL
GRAY 11

PANTONE
424

PANTONE
2168

PANTONE
2164

PANTONE
2165

PANTONE
273

PANTONE
278

PANTONE
2767

PANTONE
652

PANTONE
WARM
GRAY 10

PANTONE
7454

PANTONE
7544

PANTONE
5265

PANTONE
2181

PANTONE
2757

PANTONE
442

PANTONE
2107

PANTONE
7700

PANTONE
WARM
GRAY 4

PANTONE
2695

PANTONE
428

PANTONE
659

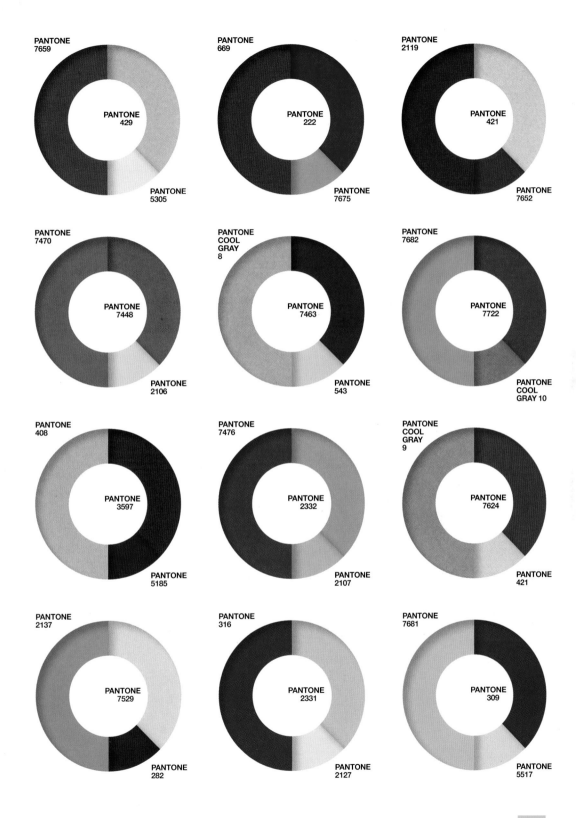

PANTONE
7659

PANTONE
429

PANTONE
5305

PANTONE
669

PANTONE
222

PANTONE
7675

PANTONE
2119

PANTONE
421

PANTONE
7652

PANTONE
7470

PANTONE
7448

PANTONE
2106

PANTONE
COOL
GRAY
8

PANTONE
7463

PANTONE
543

PANTONE
7682

PANTONE
7722

PANTONE
COOL
GRAY 10

PANTONE
408

PANTONE
3597

PANTONE
5185

PANTONE
7476

PANTONE
2332

PANTONE
2107

PANTONE
COOL
GRAY
9

PANTONE
7624

PANTONE
421

PANTONE
2137

PANTONE
7529

PANTONE
282

PANTONE
316

PANTONE
2331

PANTONE
2127

PANTONE
7681

PANTONE
309

PANTONE
5517

TRANSCENDENT

Both thoughtful and thought provoking, this pensive palette is based in contemplative blues, enigmatic purples, dusky mauves, ephemeral grays, and wispy off-whites. The hues seem to have a floating quality, seemingly weightless and lighter-than-air. There is an air of mysticism and/or spirituality present in the combination of hues, somewhat magical, contemplative, mysterious, and other–worldly, implying that the tones take us beyond the physical realm into the metaphysical world.

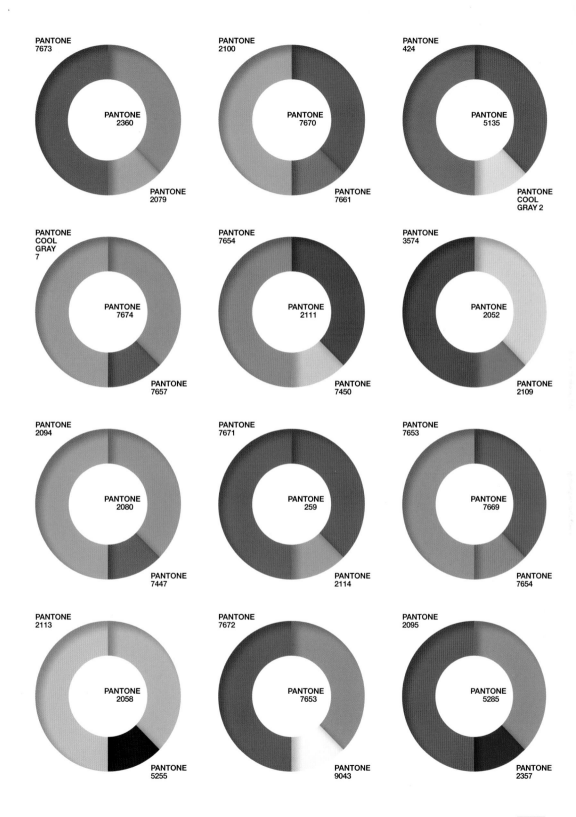

PANTONE
7673

PANTONE
2360

PANTONE
2079

PANTONE
2100

PANTONE
7670

PANTONE
7661

PANTONE
424

PANTONE
5135

PANTONE
COOL
GRAY 2

PANTONE
COOL
GRAY
7

PANTONE
7674

PANTONE
7657

PANTONE
7654

PANTONE
2111

PANTONE
7450

PANTONE
3574

PANTONE
2052

PANTONE
2109

PANTONE
2094

PANTONE
2080

PANTONE
7447

PANTONE
7671

PANTONE
259

PANTONE
2114

PANTONE
7653

PANTONE
7669

PANTONE
7654

PANTONE
2113

PANTONE
2058

PANTONE
5255

PANTONE
7672

PANTONE
7653

PANTONE
9043

PANTONE
2095

PANTONE
5285

PANTONE
2357

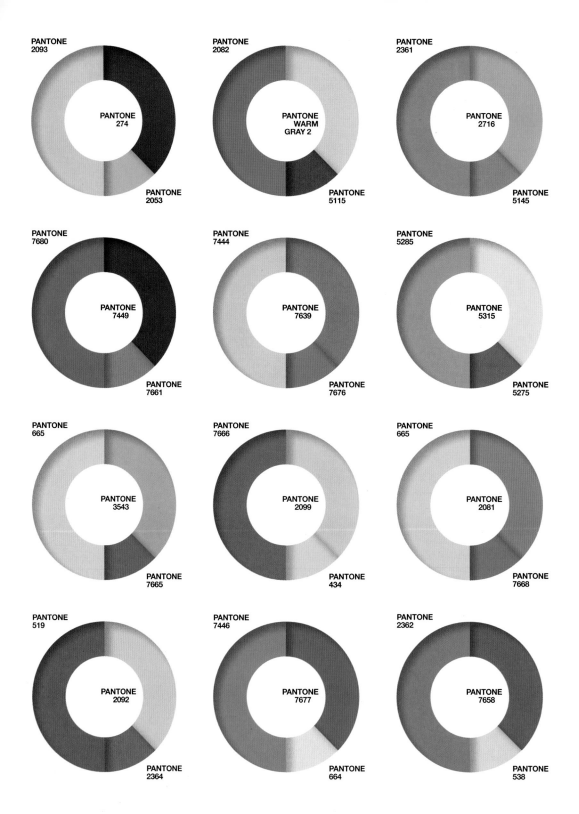

PANTONE
2093

PANTONE
274

PANTONE
2053

PANTONE
2082

PANTONE
WARM
GRAY 2

PANTONE
5115

PANTONE
2361

PANTONE
2716

PANTONE
5145

PANTONE
7680

PANTONE
7449

PANTONE
7661

PANTONE
7444

PANTONE
7639

PANTONE
7676

PANTONE
5285

PANTONE
5315

PANTONE
5275

PANTONE
665

PANTONE
3543

PANTONE
7665

PANTONE
7666

PANTONE
2099

PANTONE
434

PANTONE
665

PANTONE
2081

PANTONE
7668

PANTONE
519

PANTONE
2092

PANTONE
2364

PANTONE
7446

PANTONE
7677

PANTONE
664

PANTONE
2362

PANTONE
7658

PANTONE
538

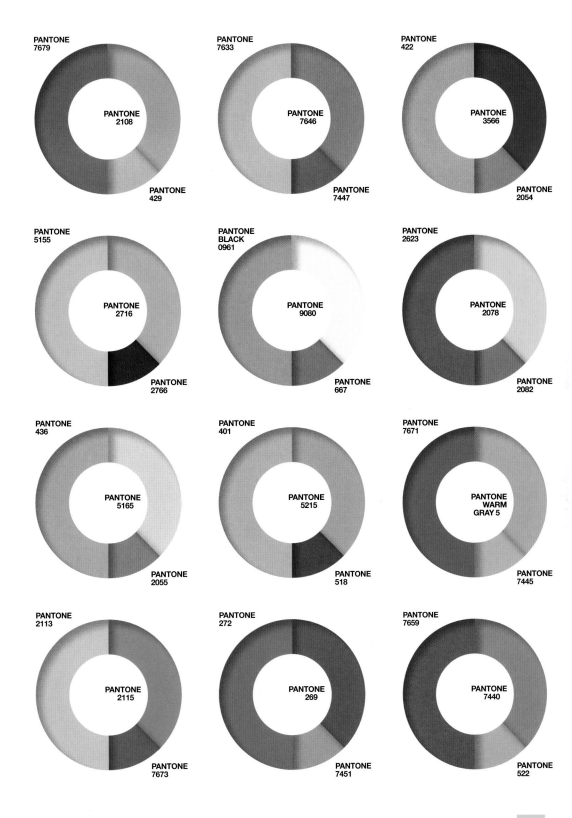

PANTONE
7679

PANTONE
2108

PANTONE
429

PANTONE
7633

PANTONE
7646

PANTONE
7447

PANTONE
422

PANTONE
3566

PANTONE
2054

PANTONE
5155

PANTONE
2716

PANTONE
2766

PANTONE
BLACK
0961

PANTONE
9080

PANTONE
667

PANTONE
2623

PANTONE
2078

PANTONE
2082

PANTONE
436

PANTONE
5165

PANTONE
2055

PANTONE
401

PANTONE
5215

PANTONE
518

PANTONE
7671

PANTONE
WARM
GRAY 5

PANTONE
7445

PANTONE
2113

PANTONE
2115

PANTONE
7673

PANTONE
272

PANTONE
269

PANTONE
7451

PANTONE
7659

PANTONE
7440

PANTONE
522

POWERFUL

The concept of power is personified by all that is strong, forceful, weighty, and impactful. Often, just two assertive colors, such as all-empowering black used with imperial purple, black with royal blue, or black combined with a well-fortified red gets the message across. Black stung with yellow instantly arouses as it signals us to be wary of bumble-bees or predatory animals, while black with deep green reminds us of the power of hard cash. Three shades used in combination in any of the above-mentioned colors can pack an even bigger punch. A solid banker's gray can stand in for black as can the authoritative shades of military green and navy blue.

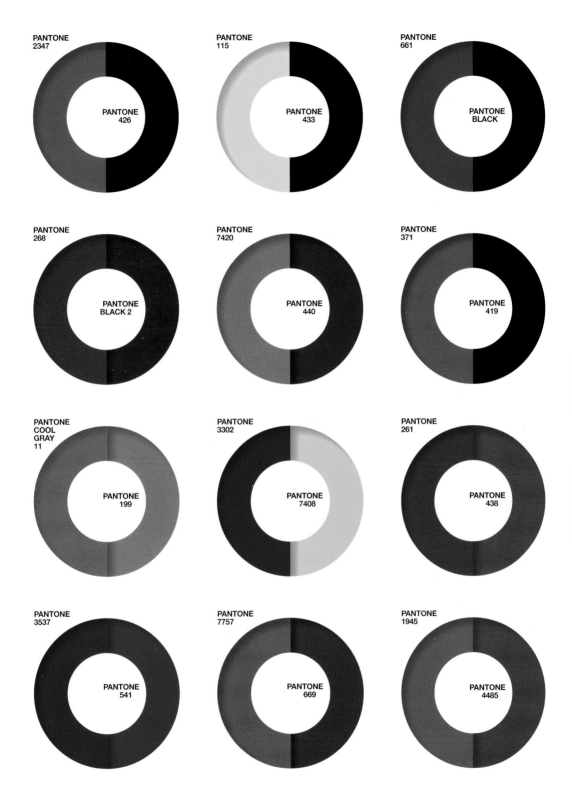

PANTONE
2347

PANTONE
426

PANTONE
115

PANTONE
433

PANTONE
661

PANTONE
BLACK

PANTONE
268

PANTONE
BLACK 2

PANTONE
7420

PANTONE
440

PANTONE
371

PANTONE
419

PANTONE
COOL
GRAY
11

PANTONE
199

PANTONE
3302

PANTONE
7408

PANTONE
261

PANTONE
438

PANTONE
3537

PANTONE
541

PANTONE
7757

PANTONE
669

PANTONE
1945

PANTONE
4485

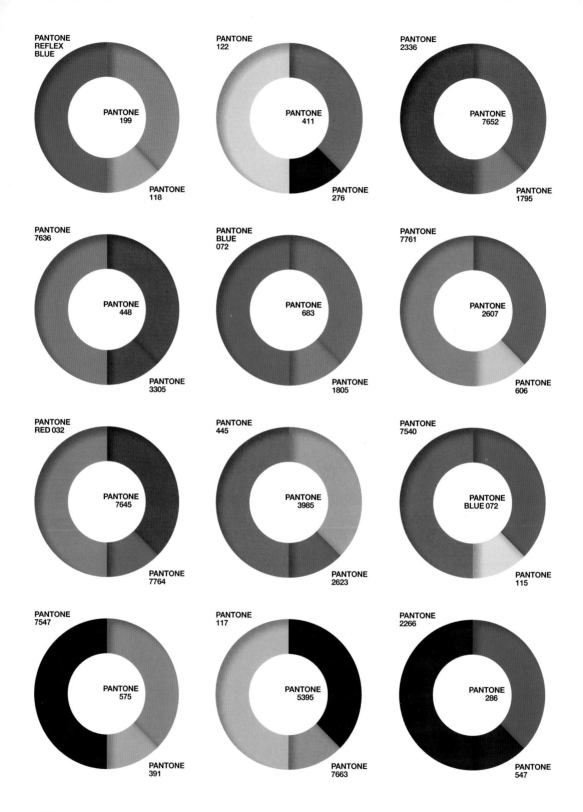

PANTONE
REFLEX
BLUE

PANTONE
199

PANTONE
118

PANTONE
122

PANTONE
411

PANTONE
276

PANTONE
2336

PANTONE
7652

PANTONE
1795

PANTONE
7636

PANTONE
448

PANTONE
3305

PANTONE
BLUE
072

PANTONE
683

PANTONE
1805

PANTONE
7761

PANTONE
2607

PANTONE
606

PANTONE
RED 032

PANTONE
7645

PANTONE
7764

PANTONE
445

PANTONE
3985

PANTONE
2623

PANTONE
7540

PANTONE
BLUE 072

PANTONE
115

PANTONE
7547

PANTONE
575

PANTONE
391

PANTONE
117

PANTONE
5395

PANTONE
7663

PANTONE
2266

PANTONE
286

PANTONE
547

THE COMPLETE COLOR HARMONY:
PANTONE EDITION

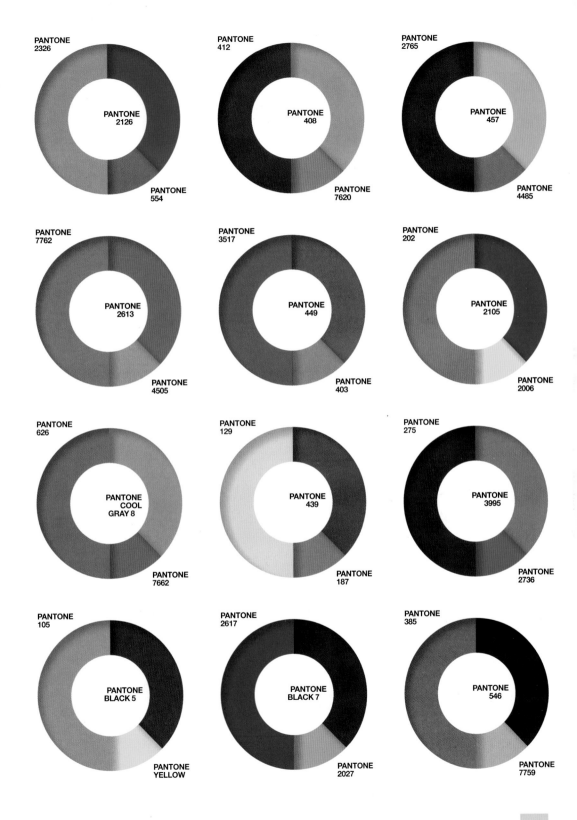

PANTONE
2326

PANTONE
2126

PANTONE
554

PANTONE
412

PANTONE
408

PANTONE
7620

PANTONE
2765

PANTONE
457

PANTONE
4485

PANTONE
7762

PANTONE
2613

PANTONE
4505

PANTONE
3517

PANTONE
449

PANTONE
403

PANTONE
202

PANTONE
2105

PANTONE
2006

PANTONE
626

PANTONE
COOL
GRAY 8

PANTONE
7662

PANTONE
129

PANTONE
439

PANTONE
187

PANTONE
275

PANTONE
3995

PANTONE
2736

PANTONE
105

PANTONE
BLACK 5

PANTONE
YELLOW

PANTONE
2617

PANTONE
BLACK 7

PANTONE
2027

PANTONE
385

PANTONE
546

PANTONE
7759

ROMANTIC

The Romantic palette aptly depicts intimacy, tenderness, and love. Idyllic images of picturesque spaces (think of the diffused light of candle-lit dinners for two), the romantic mood is filled with softened shades that range from pastels to mid-tones. The palette embraces both warm and cool tones of creamy white, forget-me-not blues, corn-silk yellows, and discreet green. As they are descended from the most sensual shades of red and purple, variations of rose and lavender are the most plentiful in the palette. But these charming, acquiescent, and agreeable tones are perceived as far more subtle and affectionate than blatantly seductive, more demure than voluptuous.

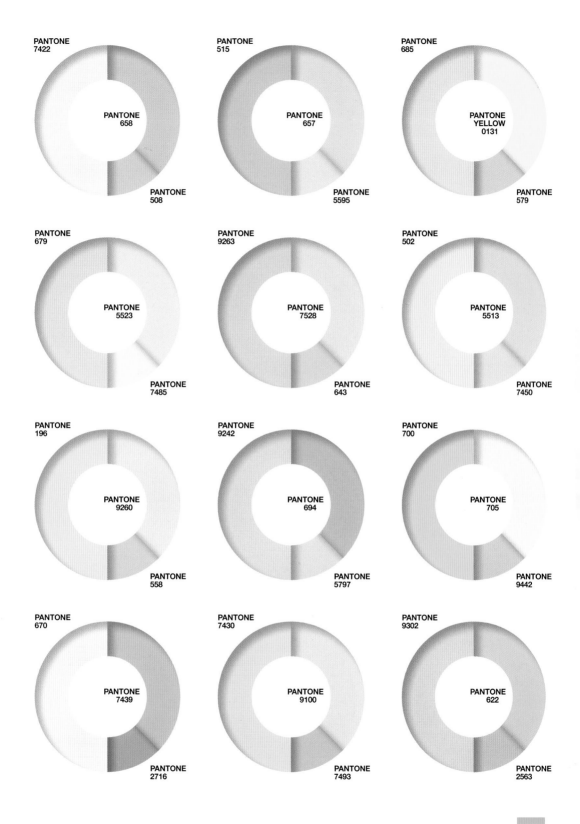

PANTONE
7422

PANTONE
658

PANTONE
508

PANTONE
515

PANTONE
657

PANTONE
5595

PANTONE
685

PANTONE
YELLOW
0131

PANTONE
579

PANTONE
679

PANTONE
5523

PANTONE
7485

PANTONE
9263

PANTONE
7528

PANTONE
643

PANTONE
502

PANTONE
5513

PANTONE
7450

PANTONE
196

PANTONE
9260

PANTONE
558

PANTONE
9242

PANTONE
694

PANTONE
5797

PANTONE
700

PANTONE
705

PANTONE
9442

PANTONE
670

PANTONE
7439

PANTONE
2716

PANTONE
7430

PANTONE
9100

PANTONE
7493

PANTONE
9302

PANTONE
622

PANTONE
2563

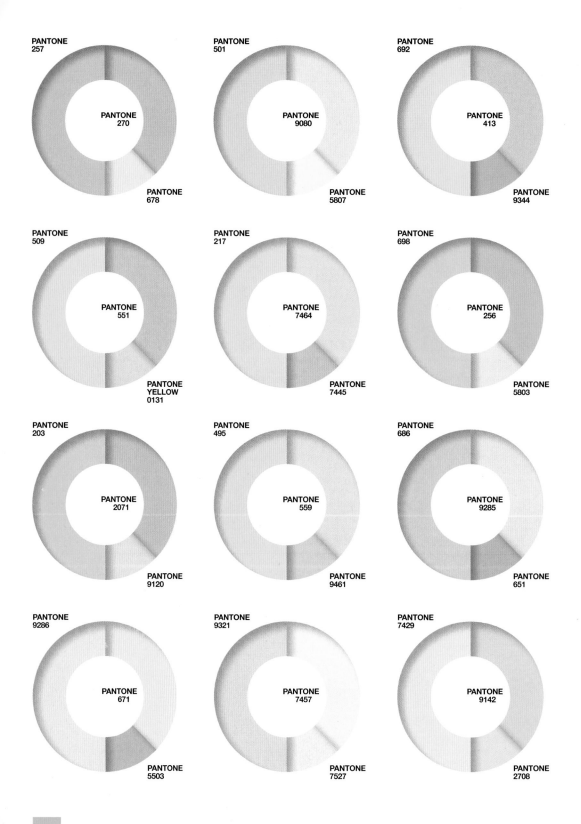

PANTONE
257

PANTONE
270

PANTONE
678

PANTONE
501

PANTONE
9080

PANTONE
5807

PANTONE
692

PANTONE
413

PANTONE
9344

PANTONE
509

PANTONE
551

PANTONE
YELLOW
0131

PANTONE
217

PANTONE
7464

PANTONE
7445

PANTONE
698

PANTONE
256

PANTONE
5803

PANTONE
203

PANTONE
2071

PANTONE
9120

PANTONE
495

PANTONE
559

PANTONE
9461

PANTONE
686

PANTONE
9285

PANTONE
651

PANTONE
9286

PANTONE
671

PANTONE
5503

PANTONE
9321

PANTONE
7457

PANTONE
7527

PANTONE
7429

PANTONE
9142

PANTONE
2708

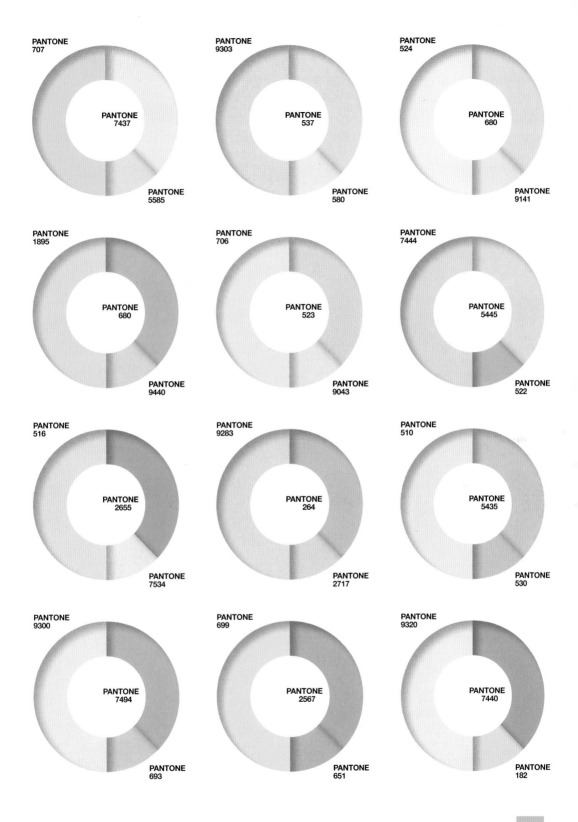

PANTONE
707

PANTONE
7437

PANTONE
5585

PANTONE
9303

PANTONE
537

PANTONE
580

PANTONE
524

PANTONE
680

PANTONE
9141

PANTONE
1895

PANTONE
680

PANTONE
9440

PANTONE
706

PANTONE
523

PANTONE
9043

PANTONE
7444

PANTONE
5445

PANTONE
522

PANTONE
516

PANTONE
2655

PANTONE
7534

PANTONE
9283

PANTONE
264

PANTONE
2717

PANTONE
510

PANTONE
5435

PANTONE
530

PANTONE
9300

PANTONE
7494

PANTONE
693

PANTONE
699

PANTONE
2567

PANTONE
651

PANTONE
9320

PANTONE
7440

PANTONE
182

PROVOCATIVE

The Provocative palette is replete with tantalizing and tempting tones. By definition, provocative means that which incites, arouses, allures, and seduces, whether in the color of a garment, in cosmetics, in food, or beverage, and most of all, in attitude. The shades are mid- to deep and/or bright tones. This is not the place for shrinking violets but a perfect setting for passionate purples, spicy reds, succulent oranges, hot pinks, pungent curries, and rich chocolates, often against a background of potent black. The message is suggestive, captivating, daring, and definitive; it strives to be irresistible and most often succeeds.

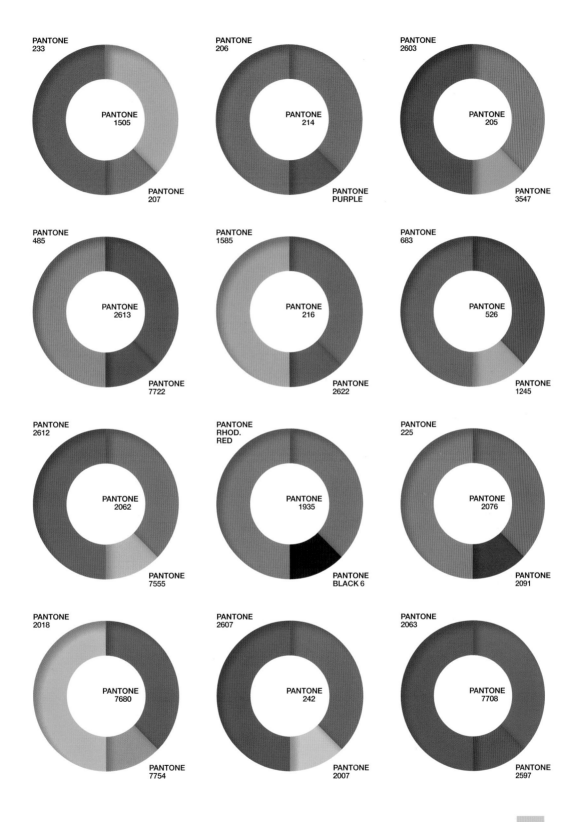

PANTONE
233

PANTONE
1505

PANTONE
207

PANTONE
206

PANTONE
214

PANTONE
PURPLE

PANTONE
2603

PANTONE
205

PANTONE
3547

PANTONE
485

PANTONE
2613

PANTONE
7722

PANTONE
1585

PANTONE
216

PANTONE
2622

PANTONE
683

PANTONE
526

PANTONE
1245

PANTONE
2612

PANTONE
2062

PANTONE
7555

PANTONE
RHOD.
RED

PANTONE
1935

PANTONE
BLACK 6

PANTONE
225

PANTONE
2076

PANTONE
2091

PANTONE
2018

PANTONE
7680

PANTONE
7754

PANTONE
2607

PANTONE
242

PANTONE
2007

PANTONE
2063

PANTONE
7708

PANTONE
2597

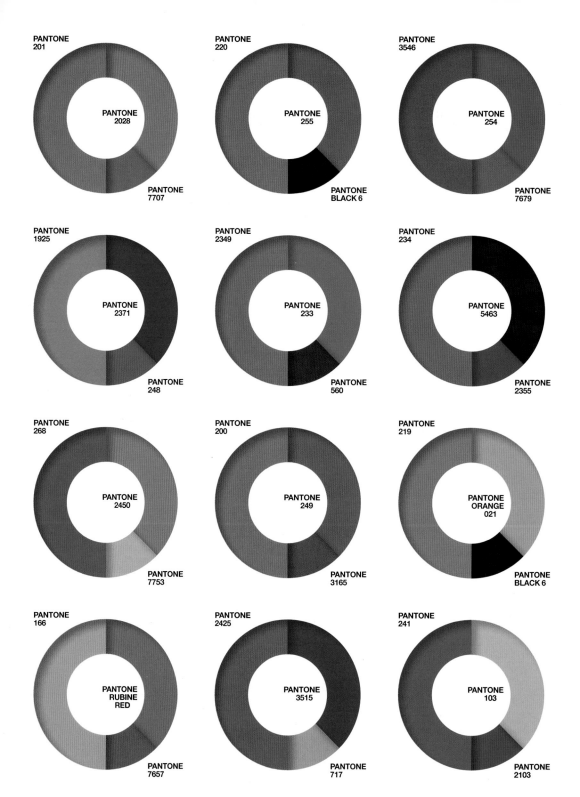

PANTONE
201

PANTONE
2028

PANTONE
7707

PANTONE
220

PANTONE
255

PANTONE
BLACK 6

PANTONE
3546

PANTONE
254

PANTONE
7679

PANTONE
1925

PANTONE
2371

PANTONE
248

PANTONE
2349

PANTONE
233

PANTONE
560

PANTONE
234

PANTONE
5463

PANTONE
2355

PANTONE
268

PANTONE
2450

PANTONE
7753

PANTONE
200

PANTONE
249

PANTONE
3165

PANTONE
219

PANTONE
ORANGE
021

PANTONE
BLACK 6

PANTONE
166

PANTONE
RUBINE
RED

PANTONE
7657

PANTONE
2425

PANTONE
3515

PANTONE
717

PANTONE
241

PANTONE
103

PANTONE
2103

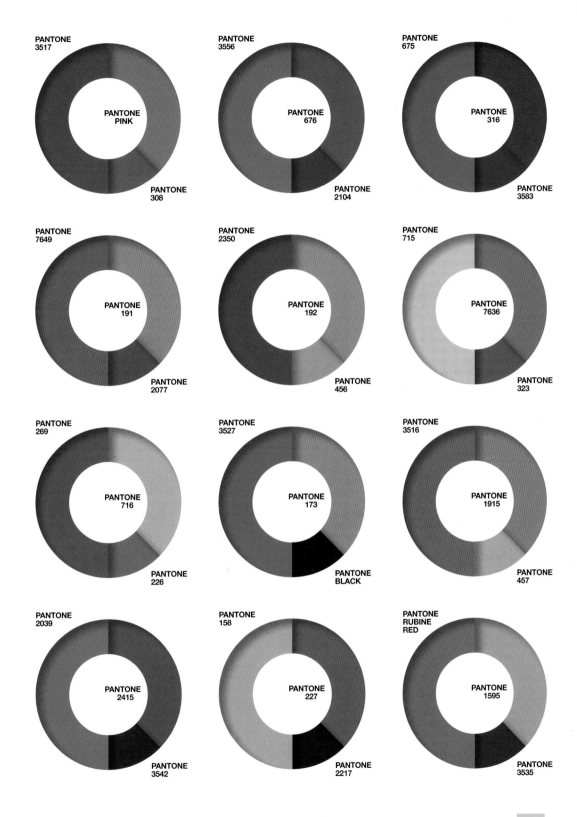

PANTONE
3517

PANTONE
PINK

PANTONE
308

PANTONE
3556

PANTONE
676

PANTONE
2104

PANTONE
675

PANTONE
316

PANTONE
3583

PANTONE
7649

PANTONE
191

PANTONE
2077

PANTONE
2350

PANTONE
192

PANTONE
456

PANTONE
715

PANTONE
7636

PANTONE
323

PANTONE
269

PANTONE
716

PANTONE
226

PANTONE
3527

PANTONE
173

PANTONE
BLACK

PANTONE
3516

PANTONE
1915

PANTONE
457

PANTONE
2039

PANTONE
2415

PANTONE
3542

PANTONE
158

PANTONE
227

PANTONE
2217

PANTONE
RUBINE
RED

PANTONE
1595

PANTONE
3535

NOSTALGIC

Nostalgia holds a sentimental appeal—one that speaks of remembrance, recollections, contemplation, and "wishful thinking." The colors are reminders of days past in tinted postcards, pictures in a treasured scrapbook, and a corsage or boutonniere pressed between the pages. The colors bring a suggestion of flowers that are beyond their original full bloom, yet still evolving into a different form of aging beauty, similar to a fading hydrangea. The names are evocative of this tender and thoughtful palette, among them: antique white, pastel parchment, old rose, lilac sachet, cameo brown, winsome orchid, pale mauve, keepsake lilac, powder blue, dusky citron, green haze, dusty yellow, tender peach, and wispy gray.

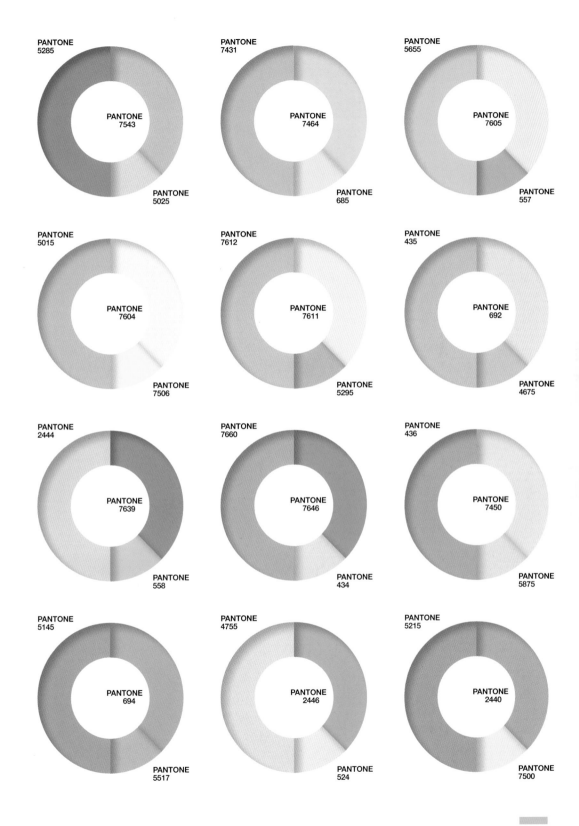

PANTONE
5285

PANTONE
7543

PANTONE
5025

PANTONE
7431

PANTONE
7464

PANTONE
685

PANTONE
5655

PANTONE
7605

PANTONE
557

PANTONE
5015

PANTONE
7604

PANTONE
7506

PANTONE
7612

PANTONE
7611

PANTONE
5295

PANTONE
435

PANTONE
692

PANTONE
4675

PANTONE
2444

PANTONE
7639

PANTONE
558

PANTONE
7660

PANTONE
7646

PANTONE
434

PANTONE
436

PANTONE
7450

PANTONE
5875

PANTONE
5145

PANTONE
694

PANTONE
5517

PANTONE
4755

PANTONE
2446

PANTONE
524

PANTONE
5215

PANTONE
2440

PANTONE
7500

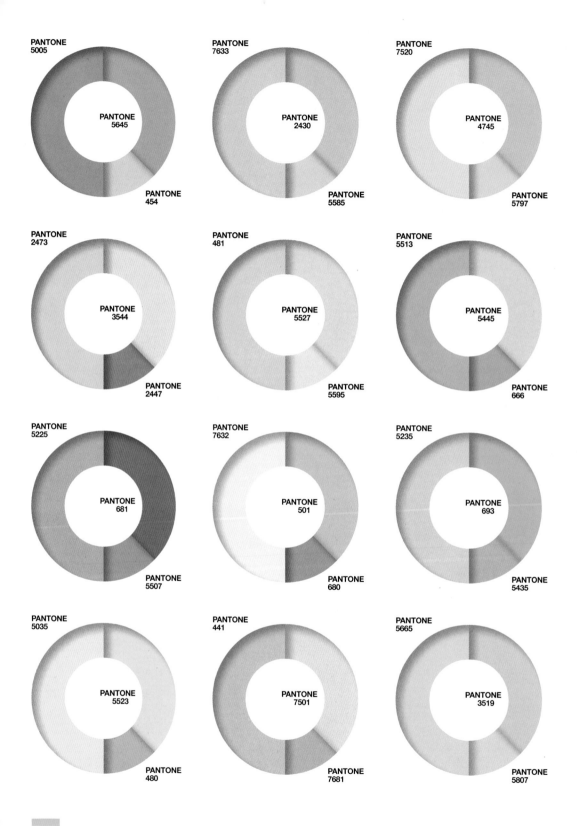

PANTONE
5005

PANTONE
5645

PANTONE
454

PANTONE
7633

PANTONE
2430

PANTONE
5585

PANTONE
7520

PANTONE
4745

PANTONE
5797

PANTONE
2473

PANTONE
3544

PANTONE
2447

PANTONE
481

PANTONE
5527

PANTONE
5595

PANTONE
5513

PANTONE
5445

PANTONE
666

PANTONE
5225

PANTONE
681

PANTONE
5507

PANTONE
7632

PANTONE
501

PANTONE
680

PANTONE
5235

PANTONE
693

PANTONE
5435

PANTONE
5035

PANTONE
5523

PANTONE
480

PANTONE
441

PANTONE
7501

PANTONE
7681

PANTONE
5665

PANTONE
3519

PANTONE
5807

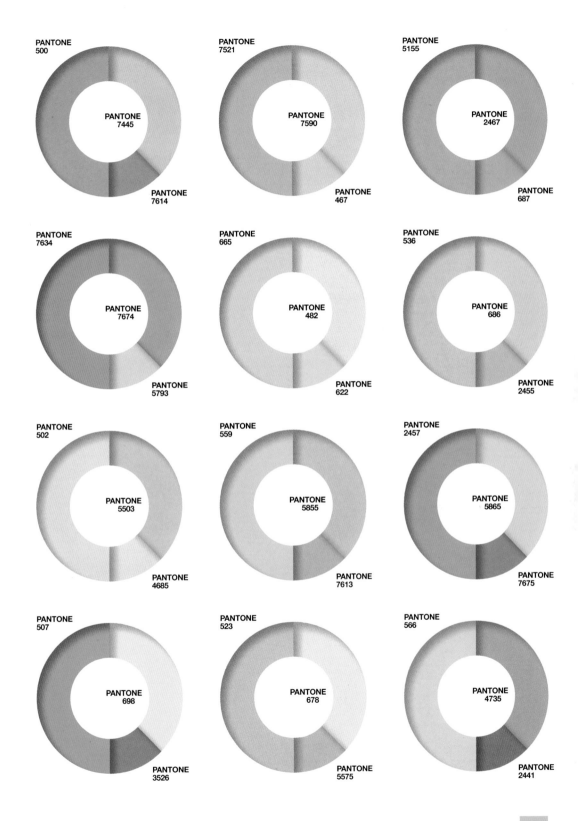

PANTONE
500

PANTONE
7445

PANTONE
7614

PANTONE
7521

PANTONE
7590

PANTONE
467

PANTONE
5155

PANTONE
2467

PANTONE
687

PANTONE
7634

PANTONE
7674

PANTONE
5793

PANTONE
665

PANTONE
482

PANTONE
622

PANTONE
536

PANTONE
686

PANTONE
2455

PANTONE
502

PANTONE
5503

PANTONE
4685

PANTONE
559

PANTONE
5855

PANTONE
7613

PANTONE
2457

PANTONE
5865

PANTONE
7675

PANTONE
507

PANTONE
698

PANTONE
3526

PANTONE
523

PANTONE
678

PANTONE
5575

PANTONE
566

PANTONE
4735

PANTONE
2441

ROBUST

Robust is a palette of flavorful and full-bodied shades, especially in the berry and grape family. Hearty wine hues also play a big part in the deliciousness of this palette, as in a savory stew of coq au vin. It is redolent with shades that are tempting to both the eye and the taste buds with evocative and tempting names like beaujolais and burgundy, sangria and syrah, pomegranate, port and purple plum, chablis and chardonnay, raspberry and boysenberry. Supporting shades are roasted coffee browns and vineyard greens.

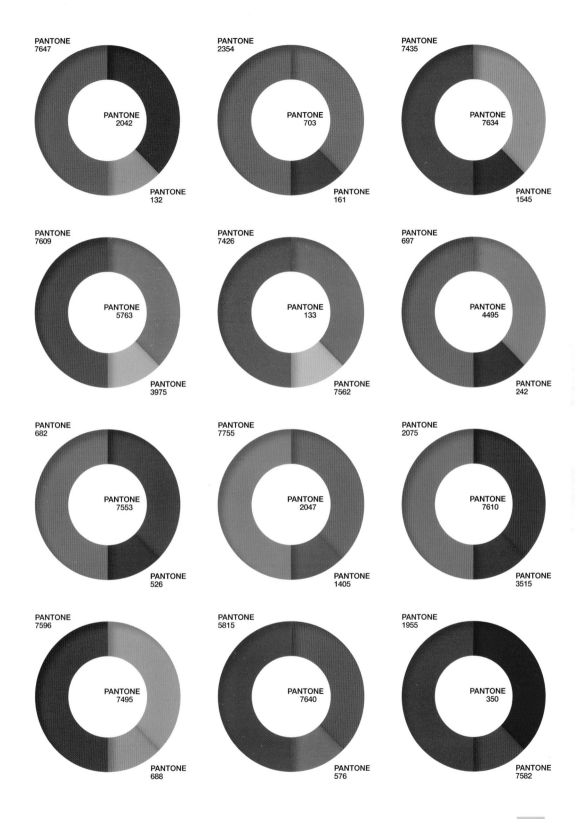

PANTONE
7647

PANTONE
2042

PANTONE
132

PANTONE
2354

PANTONE
703

PANTONE
161

PANTONE
7435

PANTONE
7634

PANTONE
1545

PANTONE
7609

PANTONE
5763

PANTONE
3975

PANTONE
7426

PANTONE
133

PANTONE
7562

PANTONE
697

PANTONE
4495

PANTONE
242

PANTONE
682

PANTONE
7553

PANTONE
526

PANTONE
7755

PANTONE
2047

PANTONE
1405

PANTONE
2075

PANTONE
7610

PANTONE
3515

PANTONE
7596

PANTONE
7495

PANTONE
688

PANTONE
5815

PANTONE
7640

PANTONE
576

PANTONE
1955

PANTONE
350

PANTONE
7582

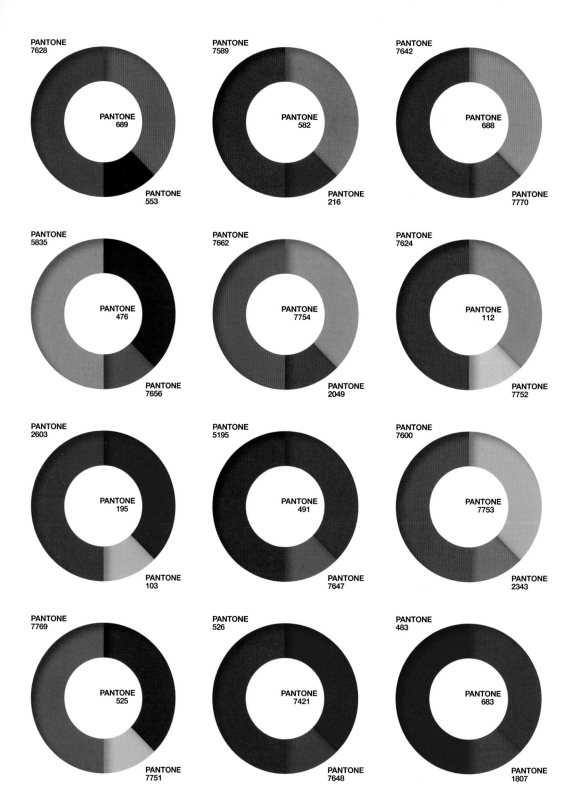

PANTONE
7628

PANTONE
689

PANTONE
553

PANTONE
7589

PANTONE
582

PANTONE
216

PANTONE
7642

PANTONE
688

PANTONE
7770

PANTONE
5835

PANTONE
476

PANTONE
7656

PANTONE
7662

PANTONE
7754

PANTONE
2049

PANTONE
7624

PANTONE
112

PANTONE
7752

PANTONE
2603

PANTONE
195

PANTONE
103

PANTONE
5195

PANTONE
491

PANTONE
7647

PANTONE
7600

PANTONE
7753

PANTONE
2343

PANTONE
7769

PANTONE
525

PANTONE
7751

PANTONE
526

PANTONE
7421

PANTONE
7648

PANTONE
483

PANTONE
683

PANTONE
1807

THE COMPLETE COLOR HARMONY:
PANTONE EDITION

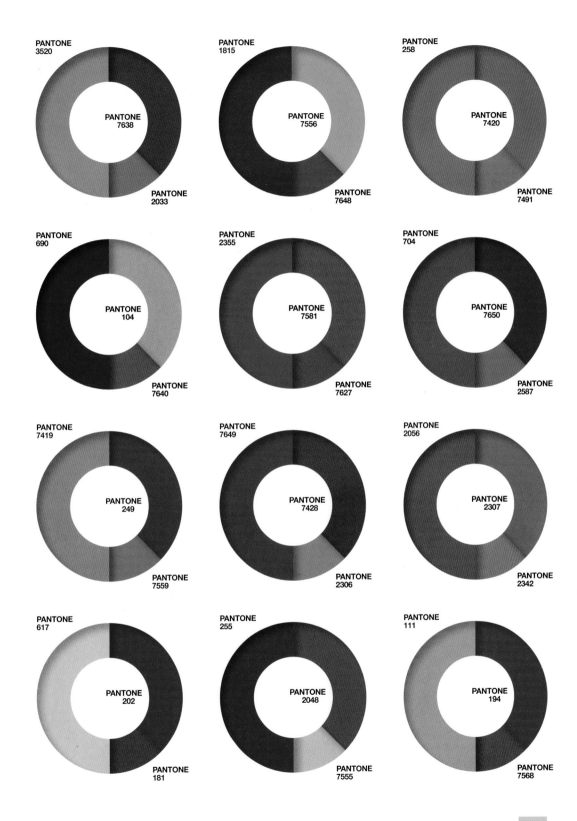

PANTONE
3520

PANTONE
7638

PANTONE
2033

PANTONE
1815

PANTONE
7556

PANTONE
7648

PANTONE
258

PANTONE
7420

PANTONE
7491

PANTONE
690

PANTONE
104

PANTONE
7640

PANTONE
2355

PANTONE
7581

PANTONE
7627

PANTONE
704

PANTONE
7650

PANTONE
2587

PANTONE
7419

PANTONE
249

PANTONE
7559

PANTONE
7649

PANTONE
7428

PANTONE
2306

PANTONE
2056

PANTONE
2307

PANTONE
2342

PANTONE
617

PANTONE
202

PANTONE
181

PANTONE
255

PANTONE
2048

PANTONE
7555

PANTONE
111

PANTONE
194

PANTONE
7568

SOOTHING

To soothe is to create a gently calming effect, inducing a tranquil, restful, peaceful, relaxed, and reposeful mood. A passive rather than active palette, it is based in the cooler side of the color wheel balanced by some natural, quieting tones like a tactile, plushy angora white, or a dove gray. A rosewater pink brings just a splash of warmth while an ecru almond oil smooths and soothes. Lightly bracing cool tones, like cresting wave and sea-spray greens, aquamarines, frosted lavenders, and dew-touched blues, refresh and revive. Above all is the color of a placid blue sky.

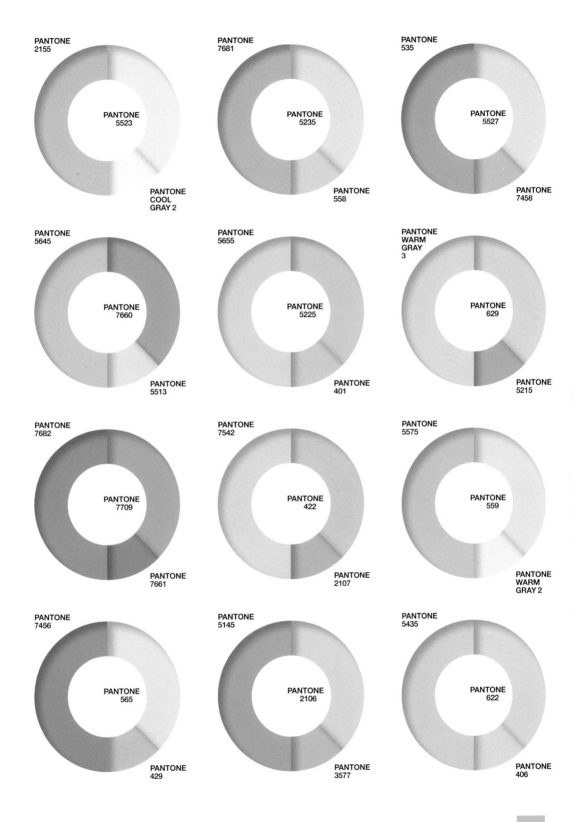

PANTONE
2155

PANTONE
5523

PANTONE
COOL
GRAY 2

PANTONE
7681

PANTONE
5235

PANTONE
558

PANTONE
535

PANTONE
5527

PANTONE
7458

PANTONE
5645

PANTONE
7660

PANTONE
5513

PANTONE
5655

PANTONE
5225

PANTONE
401

PANTONE
WARM
GRAY
3

PANTONE
629

PANTONE
5215

PANTONE
7682

PANTONE
7709

PANTONE
7661

PANTONE
7542

PANTONE
422

PANTONE
2107

PANTONE
5575

PANTONE
559

PANTONE
WARM
GRAY 2

PANTONE
7456

PANTONE
565

PANTONE
429

PANTONE
5145

PANTONE
2106

PANTONE
3577

PANTONE
5435

PANTONE
622

PANTONE
406

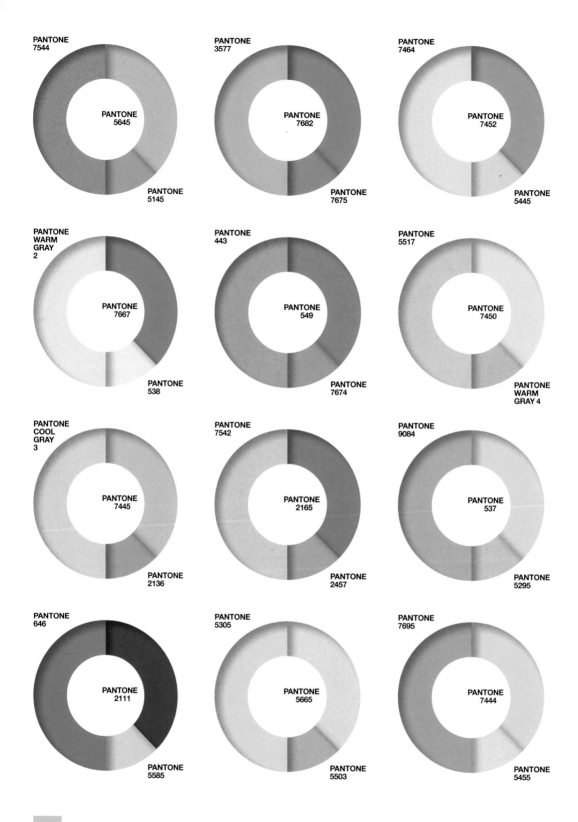

PANTONE
7544

PANTONE
5645

PANTONE
5145

PANTONE
3577

PANTONE
7682

PANTONE
7675

PANTONE
7464

PANTONE
7452

PANTONE
5445

PANTONE
WARM
GRAY
2

PANTONE
7667

PANTONE
538

PANTONE
443

PANTONE
549

PANTONE
7674

PANTONE
5517

PANTONE
7450

PANTONE
WARM
GRAY 4

PANTONE
COOL
GRAY
3

PANTONE
7445

PANTONE
2136

PANTONE
7542

PANTONE
2165

PANTONE
2457

PANTONE
9084

PANTONE
537

PANTONE
5295

PANTONE
646

PANTONE
2111

PANTONE
5585

PANTONE
5305

PANTONE
5665

PANTONE
5503

PANTONE
7695

PANTONE
7444

PANTONE
5455

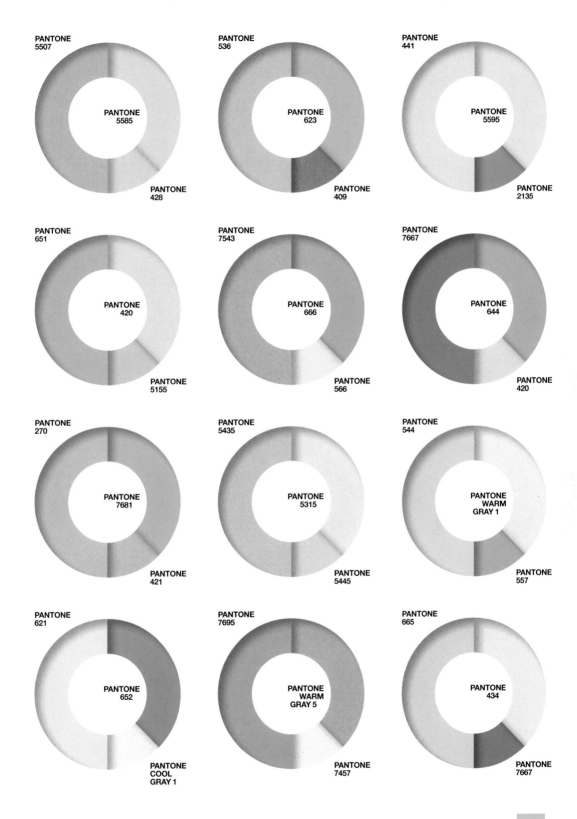

PANTONE
5507

PANTONE
5585

PANTONE
428

PANTONE
536

PANTONE
623

PANTONE
409

PANTONE
441

PANTONE
5595

PANTONE
2135

PANTONE
651

PANTONE
420

PANTONE
5155

PANTONE
7543

PANTONE
666

PANTONE
566

PANTONE
7667

PANTONE
644

PANTONE
420

PANTONE
270

PANTONE
7681

PANTONE
421

PANTONE
5435

PANTONE
5315

PANTONE
5445

PANTONE
544

PANTONE
WARM
GRAY 1

PANTONE
557

PANTONE
621

PANTONE
652

PANTONE
COOL
GRAY 1

PANTONE
7695

PANTONE
WARM
GRAY 5

PANTONE
7457

PANTONE
665

PANTONE
434

PANTONE
7667

MAQUILLÉ

Maquillage is the beautiful French word that says so much more than the English equivalent of "makeup." Paying homage to skin tones from the world over, the Maquillé palette includes the various tints and tones found within the fairest buff and ecru of the beige family to mellow mocha, sepia, sienna, honey, and the deepest, velvety rich tones of the brown family. Amongst this beautiful array of colors, there are the complexion enhancing shades of rosy red and lilac, flush pink, and creamy coral, in addition to burnished wine and violet.

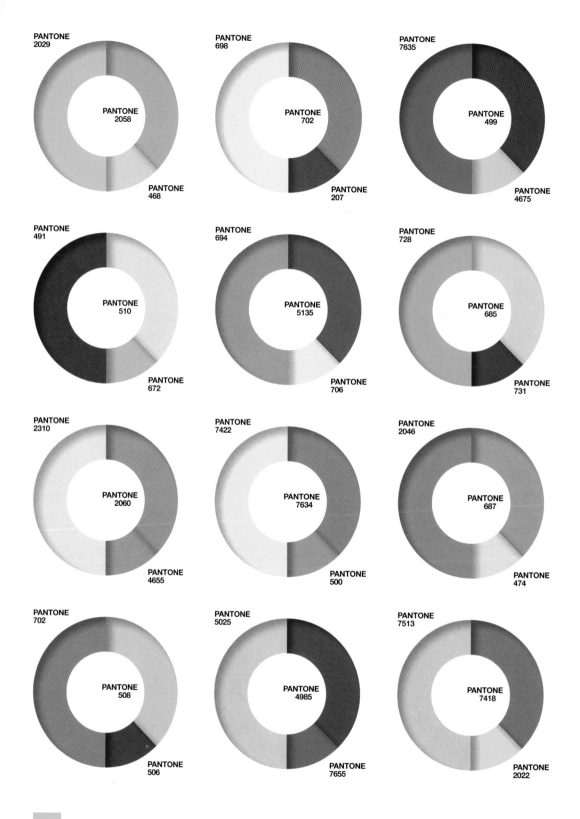

PANTONE
2029

PANTONE
2058

PANTONE
468

PANTONE
698

PANTONE
702

PANTONE
207

PANTONE
7635

PANTONE
499

PANTONE
4675

PANTONE
491

PANTONE
510

PANTONE
672

PANTONE
694

PANTONE
5135

PANTONE
706

PANTONE
728

PANTONE
685

PANTONE
731

PANTONE
2310

PANTONE
2060

PANTONE
4655

PANTONE
7422

PANTONE
7634

PANTONE
500

PANTONE
2046

PANTONE
687

PANTONE
474

PANTONE
702

PANTONE
508

PANTONE
506

PANTONE
5025

PANTONE
4985

PANTONE
7655

PANTONE
7513

PANTONE
7418

PANTONE
2022

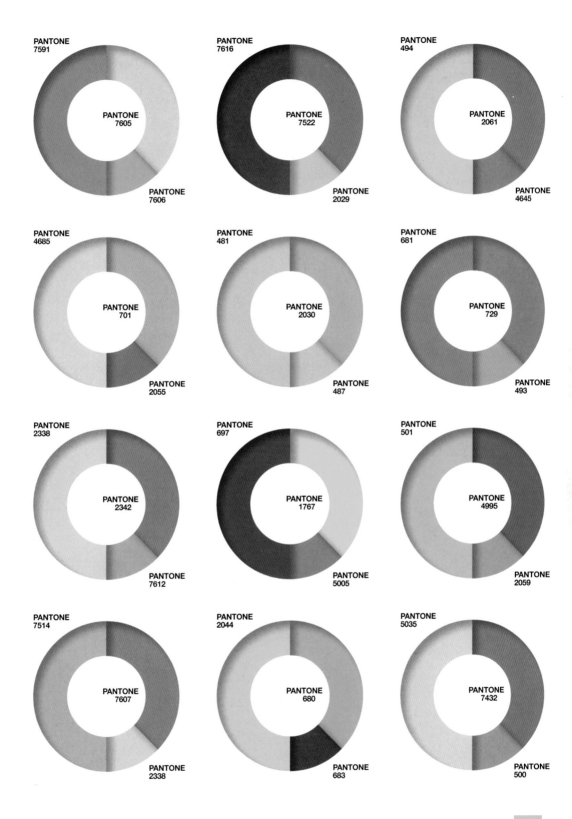

PANTONE
7591

PANTONE
7605

PANTONE
7606

PANTONE
7616

PANTONE
7522

PANTONE
2029

PANTONE
494

PANTONE
2061

PANTONE
4645

PANTONE
4685

PANTONE
701

PANTONE
2055

PANTONE
481

PANTONE
2030

PANTONE
487

PANTONE
681

PANTONE
729

PANTONE
493

PANTONE
2338

PANTONE
2342

PANTONE
7612

PANTONE
697

PANTONE
1767

PANTONE
5005

PANTONE
501

PANTONE
4995

PANTONE
2059

PANTONE
7514

PANTONE
7607

PANTONE
2338

PANTONE
2044

PANTONE
680

PANTONE
683

PANTONE
5035

PANTONE
7432

PANTONE
500

TRIBAL

Given that there are many tribal communities that exist all over the world, the colors in this palette are as varied as the diversity they represent, yet they construct a universal linkage rooted in natural pigments, minerals, and dyestuffs. African cultures have historically rendered some of the most intriguing examples of complex hues used in particularly artful designs and color combinations. Shadings of lion and leopard co-mingle with raw sienna and burnt orange. Red clay and oxblood are juxtaposed against potent mineral purples and terra-firma greens, a dazzling sunlight yellow is paired with curry or lapis blue. Color combinations may be disarmingly simple or as complex as inter-woven threads.

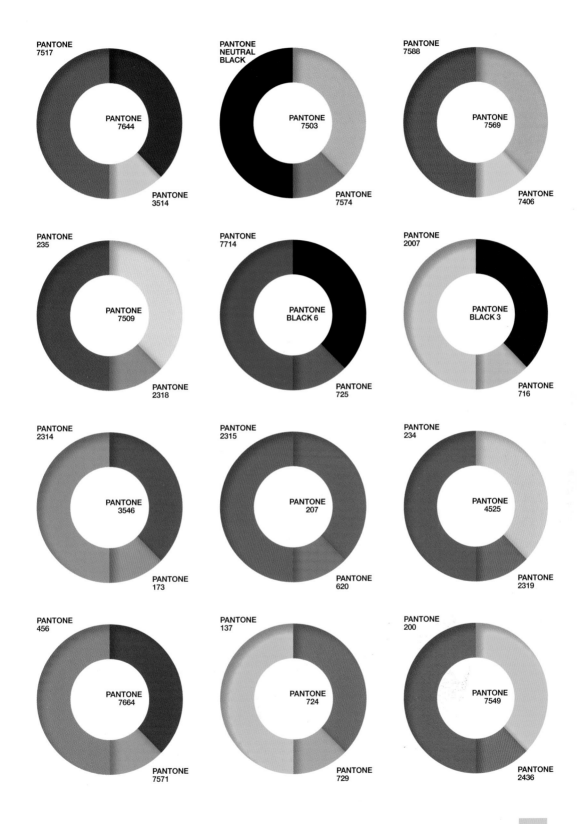

PANTONE
7517

PANTONE
7644

PANTONE
3514

PANTONE
NEUTRAL
BLACK

PANTONE
7503

PANTONE
7574

PANTONE
7588

PANTONE
7569

PANTONE
7406

PANTONE
235

PANTONE
7509

PANTONE
2318

PANTONE
7714

PANTONE
BLACK 6

PANTONE
725

PANTONE
2007

PANTONE
BLACK 3

PANTONE
716

PANTONE
2314

PANTONE
3546

PANTONE
173

PANTONE
2315

PANTONE
207

PANTONE
620

PANTONE
234

PANTONE
4525

PANTONE
2319

PANTONE
456

PANTONE
7664

PANTONE
7571

PANTONE
137

PANTONE
724

PANTONE
729

PANTONE
200

PANTONE
7549

PANTONE
2436

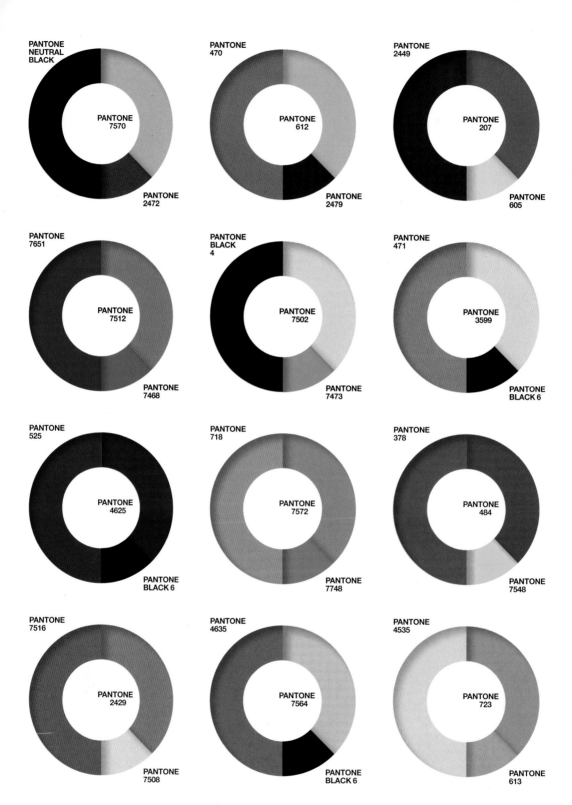

PANTONE
NEUTRAL
BLACK

PANTONE
7570

PANTONE
2472

PANTONE
470

PANTONE
612

PANTONE
2479

PANTONE
2449

PANTONE
207

PANTONE
605

PANTONE
7651

PANTONE
7512

PANTONE
7468

PANTONE
BLACK
4

PANTONE
7502

PANTONE
7473

PANTONE
471

PANTONE
3599

PANTONE
BLACK 6

PANTONE
525

PANTONE
4625

PANTONE
BLACK 6

PANTONE
718

PANTONE
7572

PANTONE
7748

PANTONE
378

PANTONE
484

PANTONE
7548

PANTONE
7516

PANTONE
2429

PANTONE
7508

PANTONE
4635

PANTONE
7564

PANTONE
BLACK 6

PANTONE
4535

PANTONE
723

PANTONE
613

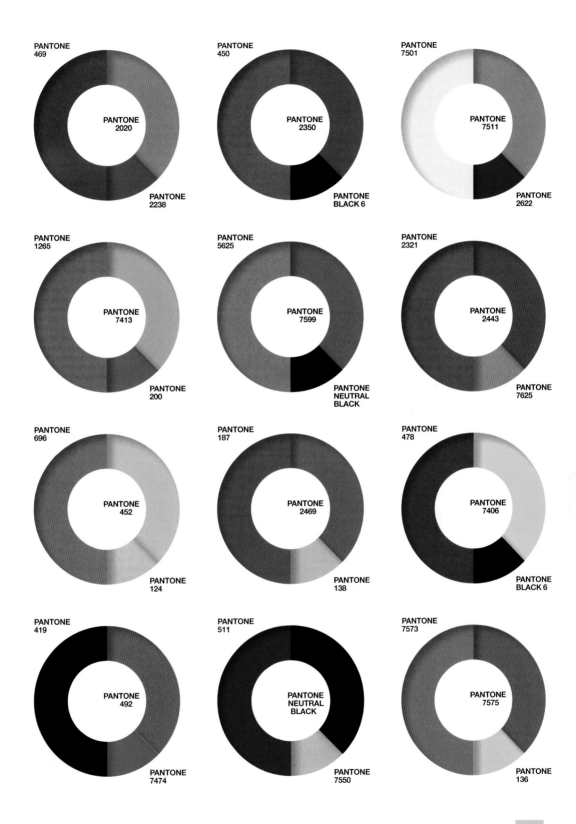

PANTONE
469

PANTONE
2020

PANTONE
2238

PANTONE
450

PANTONE
2350

PANTONE
BLACK 6

PANTONE
7501

PANTONE
7511

PANTONE
2622

PANTONE
1265

PANTONE
7413

PANTONE
200

PANTONE
5625

PANTONE
7599

PANTONE
NEUTRAL
BLACK

PANTONE
2321

PANTONE
2443

PANTONE
7625

PANTONE
696

PANTONE
452

PANTONE
124

PANTONE
187

PANTONE
2469

PANTONE
138

PANTONE
478

PANTONE
7406

PANTONE
BLACK 6

PANTONE
419

PANTONE
492

PANTONE
7474

PANTONE
511

PANTONE
NEUTRAL
BLACK

PANTONE
7550

PANTONE
7573

PANTONE
7575

PANTONE
136

TIMELESS

No matter what the time or trend, these are the hues that never go out of style. They are dependable, credible, and classic. Included are the hues of striated stone and resilient rock, of grayed granite, and deep blue slate, contrasted with the muted shadings of shifting sand. In addition, there are ancient statues or artifacts often covered with a weathered greenish patina. These are the familiar shades associated with feats of ancient architecture, the enduring temples, monuments, and statuary that have withstood the test of time.

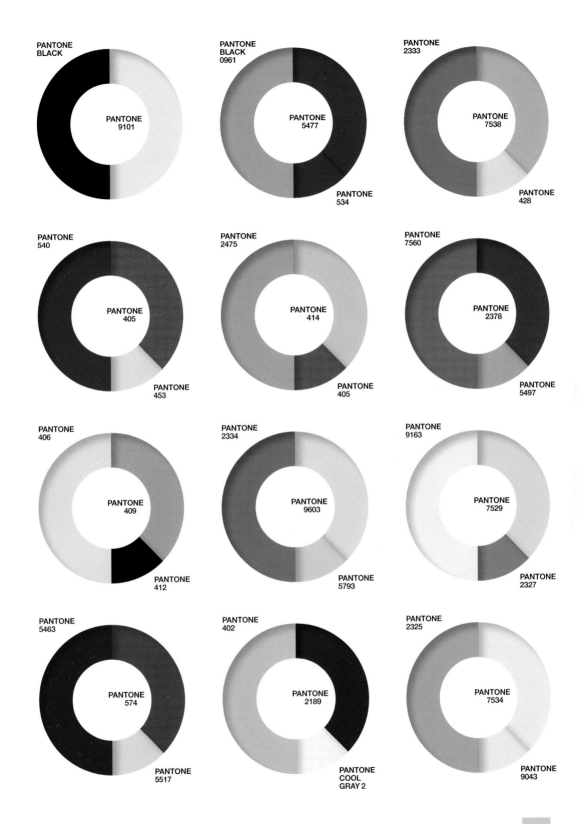

PANTONE
BLACK

PANTONE
9101

PANTONE
BLACK
0961

PANTONE
5477

PANTONE
534

PANTONE
2333

PANTONE
7538

PANTONE
428

PANTONE
540

PANTONE
405

PANTONE
453

PANTONE
2475

PANTONE
414

PANTONE
405

PANTONE
7560

PANTONE
2378

PANTONE
5497

PANTONE
406

PANTONE
409

PANTONE
412

PANTONE
2334

PANTONE
9603

PANTONE
5793

PANTONE
9163

PANTONE
7529

PANTONE
2327

PANTONE
5463

PANTONE
574

PANTONE
5517

PANTONE
402

PANTONE
2189

PANTONE
COOL
GRAY 2

PANTONE
2325

PANTONE
7534

PANTONE
9043

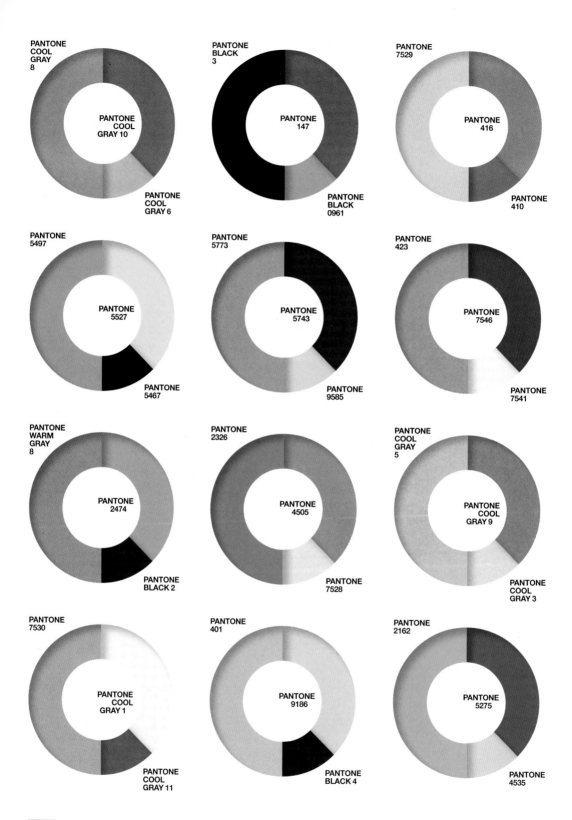

PANTONE
COOL
GRAY
8

PANTONE
COOL
GRAY 10

PANTONE
COOL
GRAY 6

PANTONE
BLACK
3

PANTONE
147

PANTONE
BLACK
0961

PANTONE
7529

PANTONE
416

PANTONE
410

PANTONE
5497

PANTONE
5527

PANTONE
5467

PANTONE
5773

PANTONE
5743

PANTONE
9585

PANTONE
423

PANTONE
7546

PANTONE
7541

PANTONE
WARM
GRAY
8

PANTONE
2474

PANTONE
BLACK 2

PANTONE
2326

PANTONE
4505

PANTONE
7528

PANTONE
COOL
GRAY
5

PANTONE
COOL
GRAY 9

PANTONE
COOL
GRAY 3

PANTONE
7530

PANTONE
COOL
GRAY 1

PANTONE
COOL
GRAY 11

PANTONE
401

PANTONE
9186

PANTONE
BLACK 4

PANTONE
2162

PANTONE
5275

PANTONE
4535

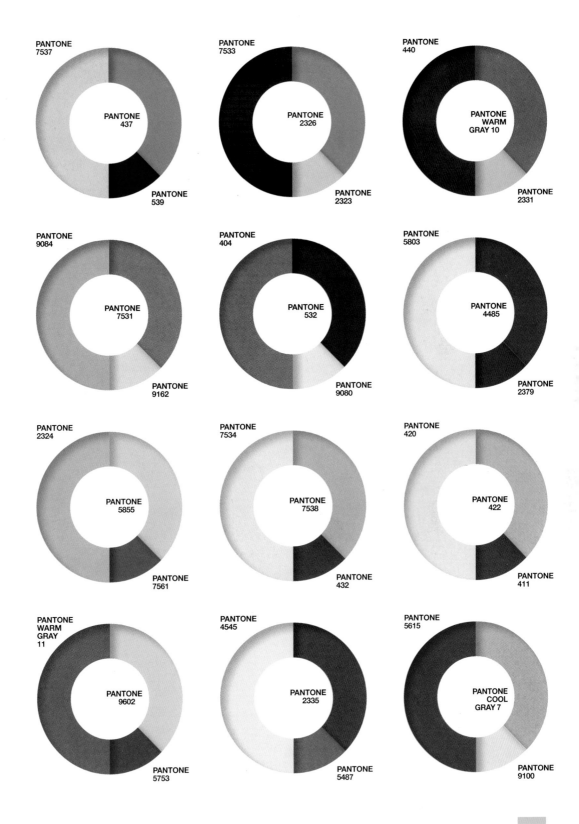

POWER-CLASHING

There are times when a discordant mood in color combinations best expresses the intention or impression to get a concept across to a viewer. Perfect harmony is not always the goal, especially when some irreverence is called into play. Bright shades might be mixed with delicate tones and widely divergent color families can be juxtaposed. A deliberate choice of clashing colors might be the attention-getter that will make the product or environs seem more unique than anything else in the surroundings—and that might be exactly the intended goal. It can express whimsy or a kind of impudent, impertinent, cheeky, or not-taking-yourself-too seriously kind of a mood. Even though the expression "power clashing" was more recently invented as part of the language of women's fashion, there is some history of deliberately mismatching color, pattern, and design, both in interior décor and interestingly in men's fashion, that is now extending to all areas of design.

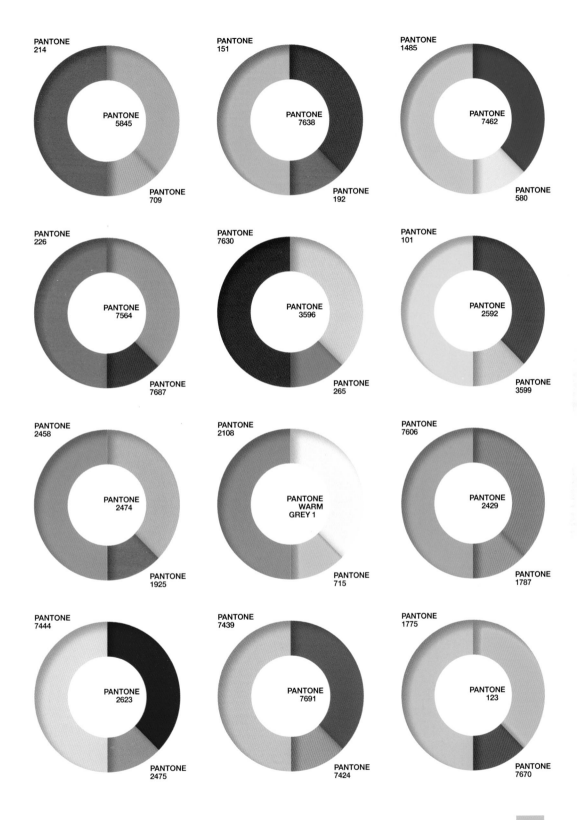

PANTONE
214

PANTONE
5845

PANTONE
709

PANTONE
151

PANTONE
7638

PANTONE
192

PANTONE
1485

PANTONE
7462

PANTONE
580

PANTONE
226

PANTONE
7564

PANTONE
7687

PANTONE
7630

PANTONE
3596

PANTONE
265

PANTONE
101

PANTONE
2592

PANTONE
3599

PANTONE
2458

PANTONE
2474

PANTONE
1925

PANTONE
2108

PANTONE
WARM
GREY 1

PANTONE
715

PANTONE
7606

PANTONE
2429

PANTONE
1787

PANTONE
7444

PANTONE
2623

PANTONE
2475

PANTONE
7439

PANTONE
7691

PANTONE
7424

PANTONE
1775

PANTONE
123

PANTONE
7670

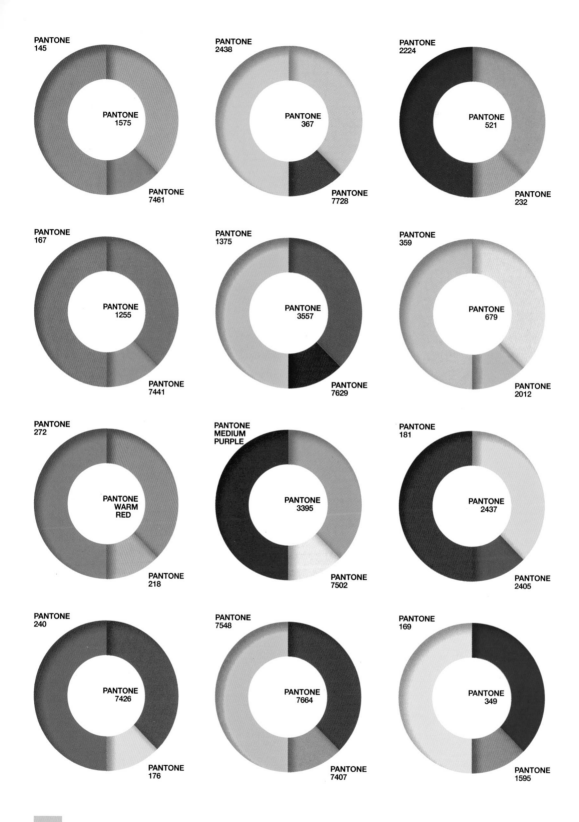

PANTONE 145
PANTONE 1575
PANTONE 7461

PANTONE 2438
PANTONE 367
PANTONE 7728

PANTONE 2224
PANTONE 521
PANTONE 232

PANTONE 167
PANTONE 1255
PANTONE 7441

PANTONE 1375
PANTONE 3557
PANTONE 7629

PANTONE 359
PANTONE 679
PANTONE 2012

PANTONE 272
PANTONE WARM RED
PANTONE 218

PANTONE MEDIUM PURPLE
PANTONE 3395
PANTONE 7502

PANTONE 181
PANTONE 2437
PANTONE 2405

PANTONE 240
PANTONE 7426
PANTONE 176

PANTONE 7548
PANTONE 7664
PANTONE 7407

PANTONE 169
PANTONE 349
PANTONE 1595

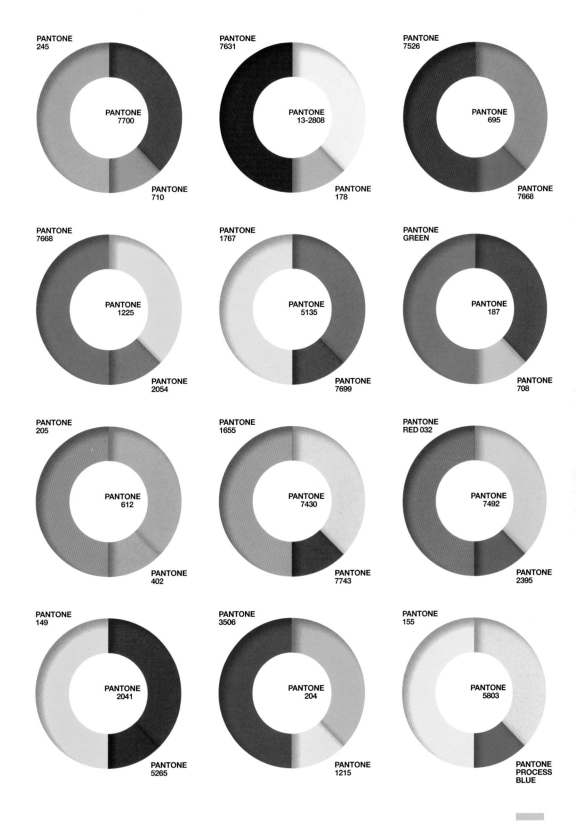

PANTONE
245

PANTONE
7700

PANTONE
710

PANTONE
7631

PANTONE
13-2808

PANTONE
178

PANTONE
7526

PANTONE
695

PANTONE
7668

PANTONE
7668

PANTONE
1225

PANTONE
2054

PANTONE
1767

PANTONE
5135

PANTONE
7699

PANTONE
GREEN

PANTONE
187

PANTONE
708

PANTONE
205

PANTONE
612

PANTONE
402

PANTONE
1655

PANTONE
7430

PANTONE
7743

PANTONE
RED 032

PANTONE
7492

PANTONE
2395

PANTONE
149

PANTONE
2041

PANTONE
5265

PANTONE
3506

PANTONE
204

PANTONE
1215

PANTONE
155

PANTONE
5803

PANTONE
PROCESS
BLUE

EXTRA-TERRESTRIAL

When we gaze outside the earth and surrounding atmosphere we can behold light shows more spectacular than any we view on earth. The Milkyway is lined with glittering white lights seen against a wide range of blues, from mid-tone periwinkle to the deepest cosmic blues of the universe. Sapphire blue stars twinkle abundantly and vaporous blue and silver plumes issue forth from shooting comet trails, while a tinge of yellow gold encircles the solar system. The aurora borealis splashes expansive varieties of emerald and glassy greens, majestic purples, and radiant orchids in breathtaking and dramatic displays.

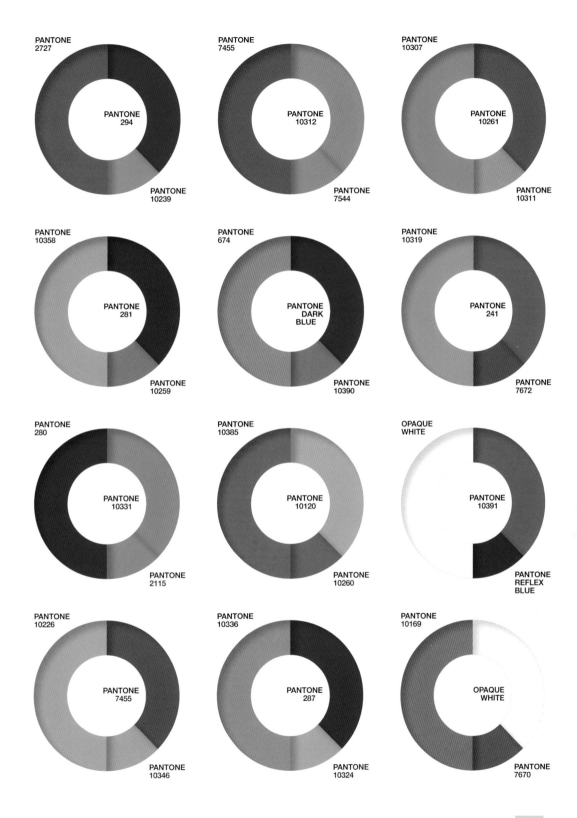

PANTONE
2727

PANTONE
294

PANTONE
10239

PANTONE
7455

PANTONE
10312

PANTONE
7544

PANTONE
10307

PANTONE
10261

PANTONE
10311

PANTONE
10358

PANTONE
281

PANTONE
10259

PANTONE
674

PANTONE
DARK
BLUE

PANTONE
10390

PANTONE
10319

PANTONE
241

PANTONE
7672

PANTONE
280

PANTONE
10331

PANTONE
2115

PANTONE
10385

PANTONE
10120

PANTONE
10260

OPAQUE
WHITE

PANTONE
10391

PANTONE
REFLEX
BLUE

PANTONE
10226

PANTONE
7455

PANTONE
10346

PANTONE
10336

PANTONE
287

PANTONE
10324

PANTONE
10169

OPAQUE
WHITE

PANTONE
7670

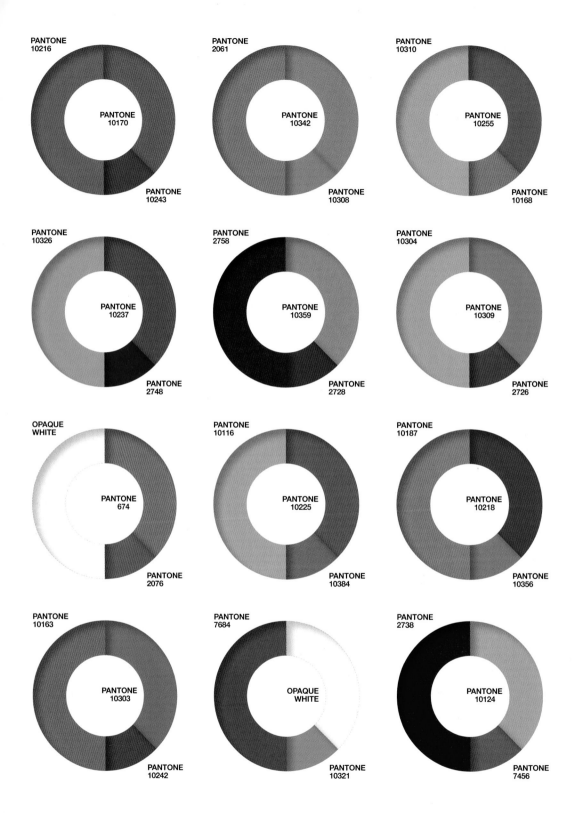

PANTONE
10216

PANTONE
10170

PANTONE
10243

PANTONE
2061

PANTONE
10342

PANTONE
10308

PANTONE
10310

PANTONE
10255

PANTONE
10168

PANTONE
10326

PANTONE
10237

PANTONE
2748

PANTONE
2758

PANTONE
10359

PANTONE
2728

PANTONE
10304

PANTONE
10309

PANTONE
2726

OPAQUE
WHITE

PANTONE
674

PANTONE
2076

PANTONE
10116

PANTONE
10225

PANTONE
10384

PANTONE
10187

PANTONE
10218

PANTONE
10356

PANTONE
10163

PANTONE
10303

PANTONE
10242

PANTONE
7684

OPAQUE
WHITE

PANTONE
10321

PANTONE
2738

PANTONE
10124

PANTONE
7456

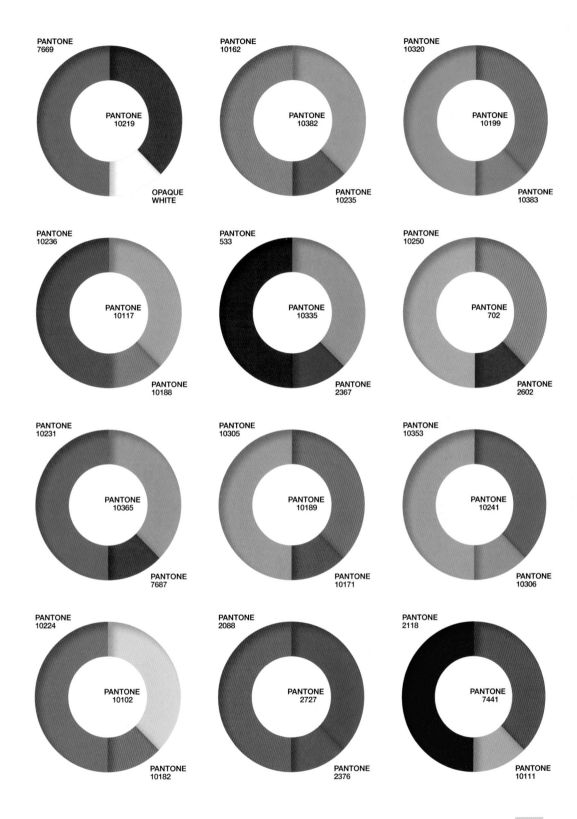

PANTONE
7669

PANTONE
10219

OPAQUE
WHITE

PANTONE
10162

PANTONE
10382

PANTONE
10235

PANTONE
10320

PANTONE
10199

PANTONE
10383

PANTONE
10236

PANTONE
10117

PANTONE
10188

PANTONE
533

PANTONE
10335

PANTONE
2367

PANTONE
10250

PANTONE
702

PANTONE
2602

PANTONE
10231

PANTONE
10365

PANTONE
7687

PANTONE
10305

PANTONE
10189

PANTONE
10171

PANTONE
10353

PANTONE
10241

PANTONE
10306

PANTONE
10224

PANTONE
10102

PANTONE
10182

PANTONE
2088

PANTONE
2727

PANTONE
2376

PANTONE
2118

PANTONE
7441

PANTONE
10111

GLAMOROUS

Glamour is such an evocative word, filled with images of svelte and perfectly coiffed Hollywood stars. The very meaning of the word itself suggests a certain allure and attraction, a thrilling promise of bright lights, glitter, glitz, and glam. Sheen and sparkle in lustrous surfaces and metallic finishes reflect enticing promises of what any product encased in these colors can deliver: sultry reds and lavish wines, absinth and cognac, purple to the more sensual red side of the spectrum, fuchsias and hot pinks, accented by cheeky blush tones and complementary turquoises. Gold and copper complete the picture of this warm and opulent palette.

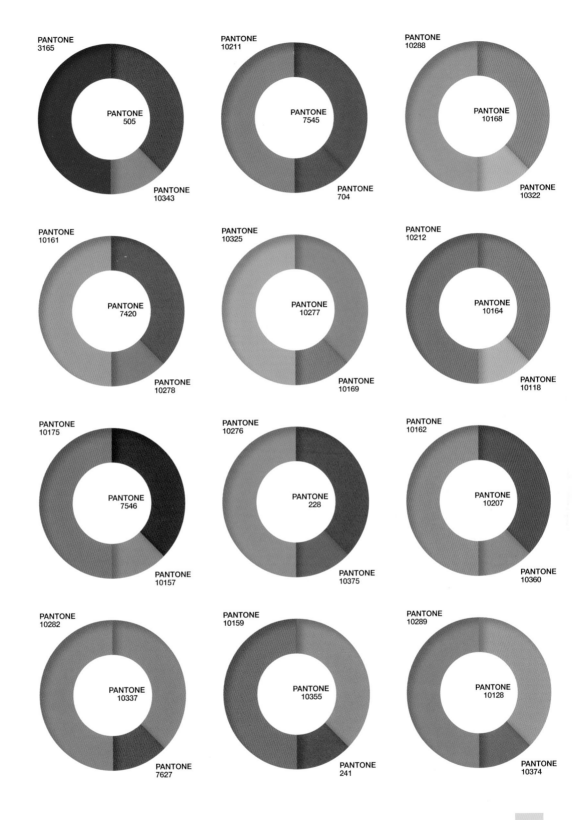

PANTONE
3165

PANTONE
505

PANTONE
10343

PANTONE
10211

PANTONE
7545

PANTONE
704

PANTONE
10288

PANTONE
10168

PANTONE
10322

PANTONE
10161

PANTONE
7420

PANTONE
10278

PANTONE
10325

PANTONE
10277

PANTONE
10169

PANTONE
10212

PANTONE
10164

PANTONE
10118

PANTONE
10175

PANTONE
7546

PANTONE
10157

PANTONE
10276

PANTONE
228

PANTONE
10375

PANTONE
10162

PANTONE
10207

PANTONE
10360

PANTONE
10282

PANTONE
10337

PANTONE
7627

PANTONE
10159

PANTONE
10355

PANTONE
241

PANTONE
10289

PANTONE
10128

PANTONE
10374

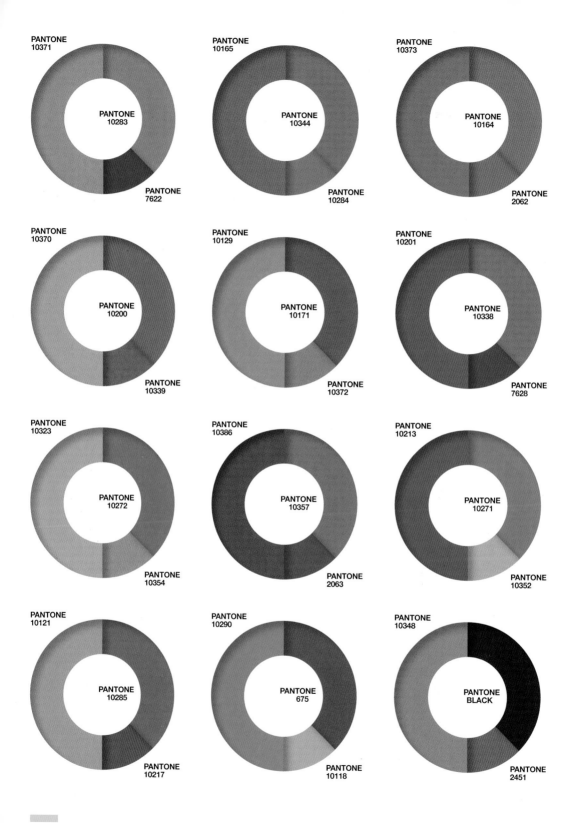

PANTONE
10371

PANTONE
10283

PANTONE
7622

PANTONE
10165

PANTONE
10344

PANTONE
10284

PANTONE
10373

PANTONE
10164

PANTONE
2062

PANTONE
10370

PANTONE
10200

PANTONE
10339

PANTONE
10129

PANTONE
10171

PANTONE
10372

PANTONE
10201

PANTONE
10338

PANTONE
7628

PANTONE
10323

PANTONE
10272

PANTONE
10354

PANTONE
10386

PANTONE
10357

PANTONE
2063

PANTONE
10213

PANTONE
10271

PANTONE
10352

PANTONE
10121

PANTONE
10285

PANTONE
10217

PANTONE
10290

PANTONE
675

PANTONE
10118

PANTONE
10348

PANTONE
BLACK

PANTONE
2451

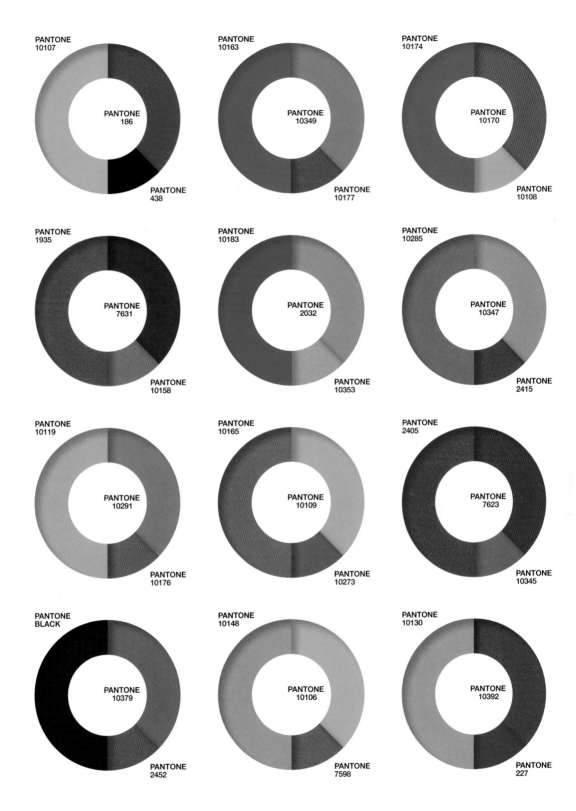

PANTONE
10107

PANTONE
186

PANTONE
438

PANTONE
10163

PANTONE
10349

PANTONE
10177

PANTONE
10174

PANTONE
10170

PANTONE
10108

PANTONE
1935

PANTONE
7631

PANTONE
10158

PANTONE
10183

PANTONE
2032

PANTONE
10353

PANTONE
10285

PANTONE
10347

PANTONE
2415

PANTONE
10119

PANTONE
10291

PANTONE
10176

PANTONE
10165

PANTONE
10109

PANTONE
10273

PANTONE
2405

PANTONE
7623

PANTONE
10345

PANTONE
BLACK

PANTONE
10379

PANTONE
2452

PANTONE
10148

PANTONE
10106

PANTONE
7598

PANTONE
10130

PANTONE
10392

PANTONE
227

SOPHISTICATED

Sophisticated is the cooler opposite, both in attitude and tonal value, of the more sumptuous Glamorous palette. Colors for the Sophisticated palette are considered cosmopolitan and worldly-wise, the essence of elegance and above all, understated stylishness. Quintessential black is an important statement in this refined grouping. Polished is another word to describe the desired effects of the colors, all of them done with a subtle glimmer that is found in cultured pearls, with appropriate names like pearlescent pink and rose, opalescent blue and green, champagne, sparkling sherry, lustered lavender, and mauve mist. Adding the final glimmer of patina to the palette are both a pewterized silver and a shiny silver.

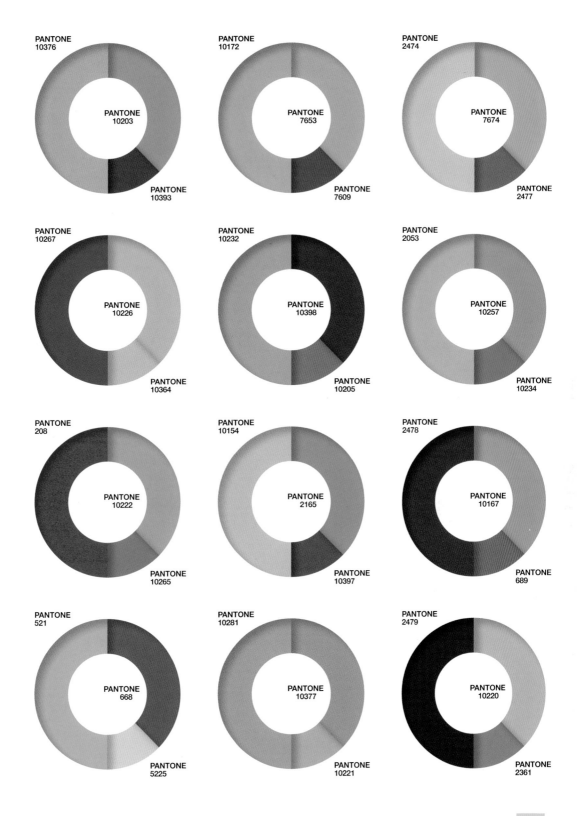

PANTONE
10376

PANTONE
10203

PANTONE
10393

PANTONE
10172

PANTONE
7653

PANTONE
7609

PANTONE
2474

PANTONE
7674

PANTONE
2477

PANTONE
10267

PANTONE
10226

PANTONE
10364

PANTONE
10232

PANTONE
10398

PANTONE
10205

PANTONE
2053

PANTONE
10257

PANTONE
10234

PANTONE
208

PANTONE
10222

PANTONE
10265

PANTONE
10154

PANTONE
2165

PANTONE
10397

PANTONE
2478

PANTONE
10167

PANTONE
689

PANTONE
521

PANTONE
668

PANTONE
5225

PANTONE
10281

PANTONE
10377

PANTONE
10221

PANTONE
2479

PANTONE
10220

PANTONE
2361

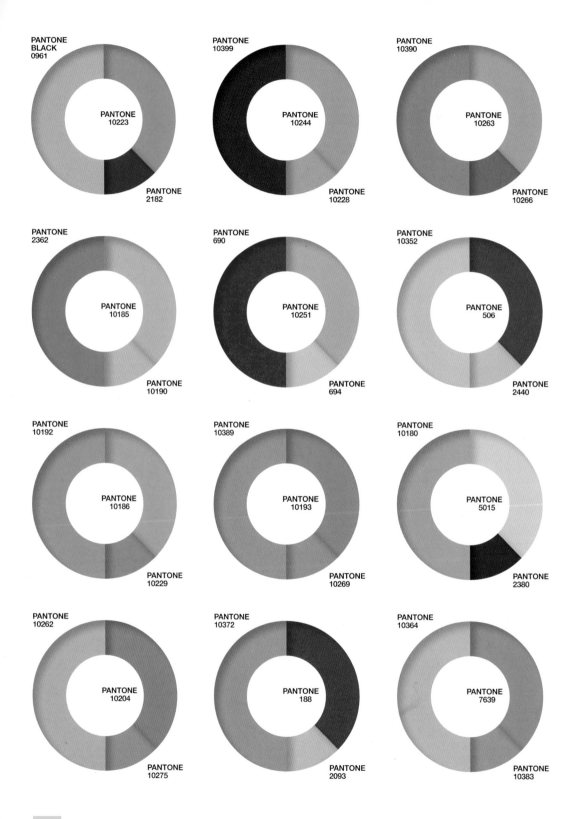

PANTONE
BLACK
0961

PANTONE
10223

PANTONE
2182

PANTONE
10399

PANTONE
10244

PANTONE
10228

PANTONE
10390

PANTONE
10263

PANTONE
10266

PANTONE
2362

PANTONE
10185

PANTONE
10190

PANTONE
690

PANTONE
10251

PANTONE
694

PANTONE
10352

PANTONE
506

PANTONE
2440

PANTONE
10192

PANTONE
10186

PANTONE
10229

PANTONE
10389

PANTONE
10193

PANTONE
10269

PANTONE
10180

PANTONE
5015

PANTONE
2380

PANTONE
10262

PANTONE
10204

PANTONE
10275

PANTONE
10372

PANTONE
188

PANTONE
2093

PANTONE
10364

PANTONE
7639

PANTONE
10383

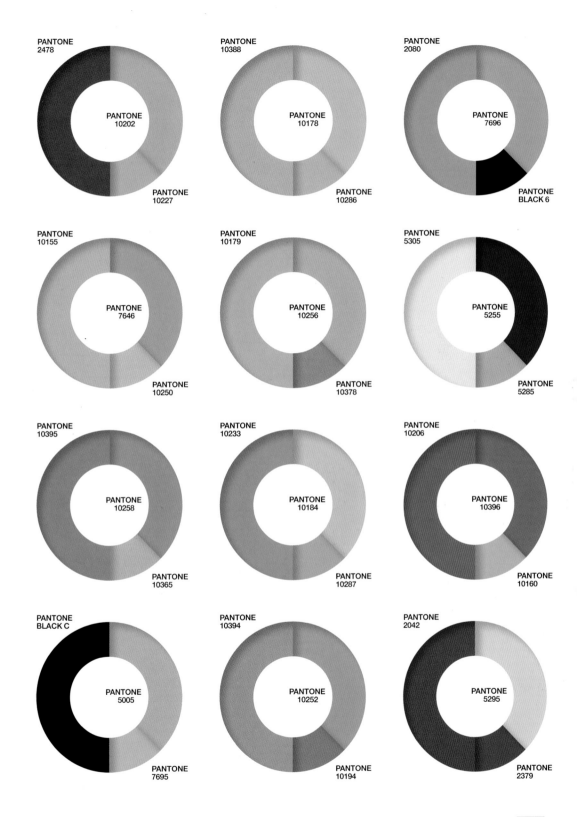

ACTIVE

An Active palette demands colors that are filled with bursts of energy. Many of the "call-to-action" colors lean to the warmer side of the spectrum, as heat is perceived as more energy producing. This does not preclude the use of cooler tones, but if they are chosen, it is best to utilize the brighter variations, such as electric blue or vibrant turquoise. This palette is exactly the right place for "special effects" colors found in neon or fluorescent finishes characterized by names such as: lime punch, racing red, fiery orange, blazing purple, solar yellow, and flaming fuchsia.

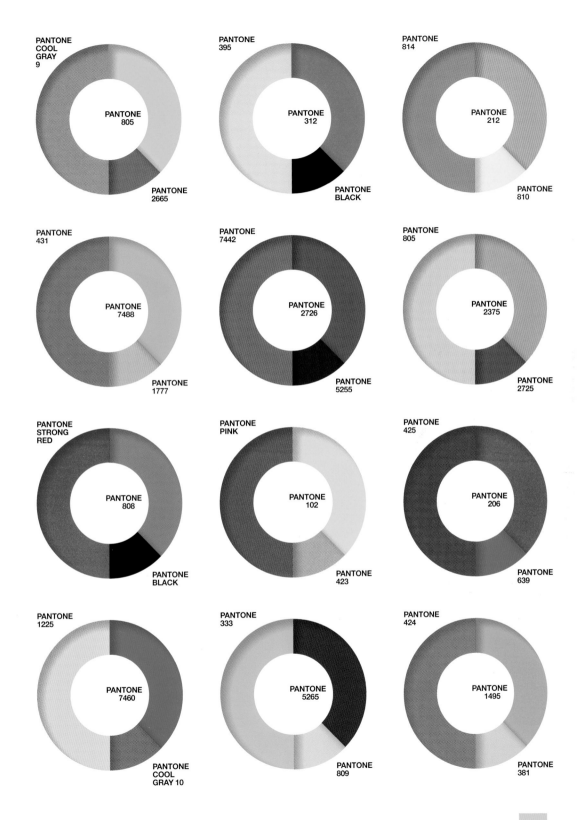

PANTONE
COOL
GRAY
9

PANTONE
805

PANTONE
2665

PANTONE
395

PANTONE
312

PANTONE
BLACK

PANTONE
814

PANTONE
212

PANTONE
810

PANTONE
431

PANTONE
7488

PANTONE
1777

PANTONE
7442

PANTONE
2726

PANTONE
5255

PANTONE
805

PANTONE
2375

PANTONE
2725

PANTONE
STRONG
RED

PANTONE
808

PANTONE
BLACK

PANTONE
PINK

PANTONE
102

PANTONE
423

PANTONE
425

PANTONE
206

PANTONE
639

PANTONE
1225

PANTONE
7460

PANTONE
COOL
GRAY 10

PANTONE
333

PANTONE
5265

PANTONE
809

PANTONE
424

PANTONE
1495

PANTONE
381

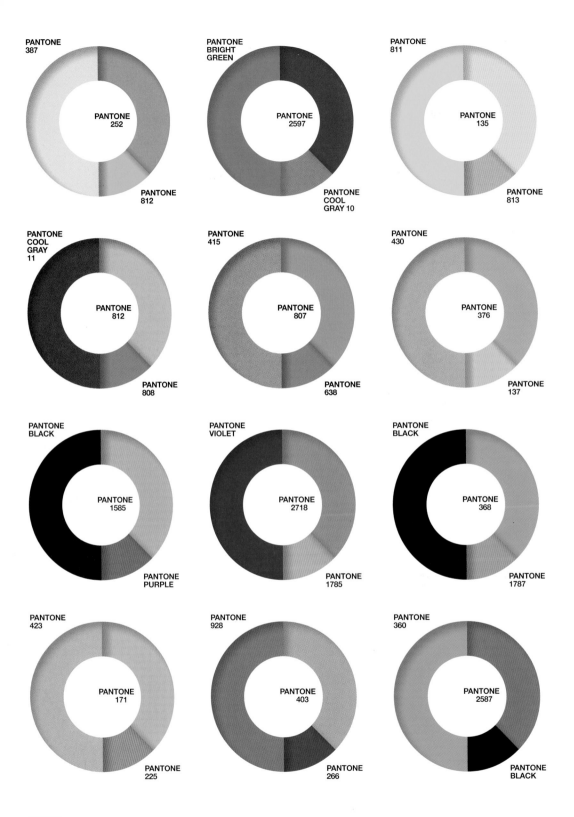

PANTONE
387

PANTONE
252

PANTONE
812

PANTONE
BRIGHT
GREEN

PANTONE
2597

PANTONE
COOL
GRAY 10

PANTONE
811

PANTONE
135

PANTONE
813

PANTONE
COOL
GRAY
11

PANTONE
812

PANTONE
808

PANTONE
415

PANTONE
807

PANTONE
638

PANTONE
430

PANTONE
376

PANTONE
137

PANTONE
BLACK

PANTONE
1585

PANTONE
PURPLE

PANTONE
VIOLET

PANTONE
2718

PANTONE
1785

PANTONE
BLACK

PANTONE
368

PANTONE
1787

PANTONE
423

PANTONE
171

PANTONE
225

PANTONE
928

PANTONE
403

PANTONE
266

PANTONE
360

PANTONE
2587

PANTONE
BLACK

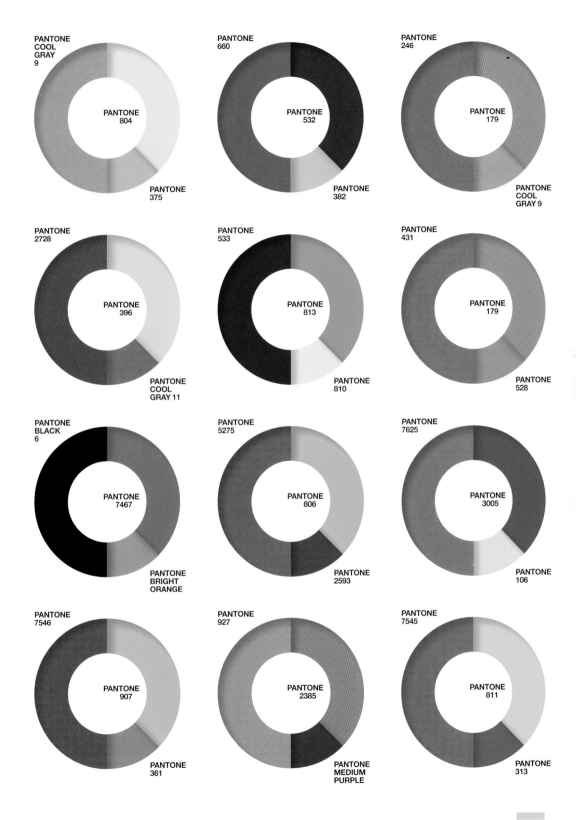

PANTONE
COOL
GRAY
9

PANTONE
804

PANTONE
375

PANTONE
660

PANTONE
532

PANTONE
382

PANTONE
246

PANTONE
179

PANTONE
COOL
GRAY 9

PANTONE
2728

PANTONE
396

PANTONE
COOL
GRAY 11

PANTONE
533

PANTONE
813

PANTONE
810

PANTONE
431

PANTONE
179

PANTONE
528

PANTONE
BLACK
6

PANTONE
7467

PANTONE
BRIGHT
ORANGE

PANTONE
5275

PANTONE
806

PANTONE
2593

PANTONE
7625

PANTONE
3005

PANTONE
106

PANTONE
7546

PANTONE
907

PANTONE
361

PANTONE
927

PANTONE
2385

PANTONE
MEDIUM
PURPLE

PANTONE
7545

PANTONE
811

PANTONE
313

PERSONAL COLORS: WHAT DO THEY SAY ABOUT YOU?

Can color likes and dislikes really tell us something about our personalities? After listening to stories and experiences of former students, clients, interviewers, and attendees at presentations I have given, that question can be answered with a resounding YES. People often tell me how spot-on color preferences can come to describing their personalities at a particular time in their lives.

We've seen in The Psychology of Color [page 26], that colors do carry an inherent meaning. As individuals, we carry those meanings around in our internal computers that never run out of memory. We can either adhere to that messaging or alter those meanings somewhat, based on our personal experiences and history.

Your likes and dislikes can—and often do—change over the years. Your responses tell you where you are at this particular time. Your preferences can also reveal some of your secret desires. For example, if you choose red as your favorite, you might not see yourself as passionate or extroverted, however you undoubtedly have some hidden desires that you have never acted on but secretly would love to express. Perhaps now is the time to be more like your favorite color? Paint the kitchen cabinets chili pepper red or make your next car that same shade instead of gray.

Having a favorite color doesn't mean that you surround yourself with it or wear it constantly. It simply means that something special happens every time you look at that color—it speaks to you and brings you joy.

RED

If you like red:

Passion, daring, boldness, provocation, and determination are key words in your color vocabulary and you crave fullness of experience. Red is a force to be reckoned with, is always up for adventure and the fullness of life, and your eagerness is infectious.

Just as red is on top of the rainbow hierarchy, you either aspire to be or are the leader, not the follower. However, remembering that red can speed up the pulse, increase the respiration rate, and raise blood pressure, it is sometimes necessary for you to temper the intensity. Red is impossible to ignore and so are you (or you would like to be). You are high maintenance, high profile, and like to shake things up.

Since you crave so much excitement in your life, routine can drive you a bit bonkers. In your pursuit of new things to excite and challenge you, it's hard for you to be objective as you have a tendency to listen to others and then follow your own instincts. Patience is not one of your virtues. If you're unhappy about something, you rarely suffer in silence.

If you dislike red:

Since red is primarily associated with a zest for life, exhilaration, and zeal, disliking this hue could mean that these feelings are a bit overwhelming at this point in your life. Perhaps you are bothered by the aggressiveness and intensity that red can signify. Maybe you want more fulfillment but hesitate to get involved. People who are irritable, exhausted, or bothered by many problems often reject red and turn to the calmer colors for rest and relaxation. They are often self-protective and insular.

At one time, pinks and roses were considered quintessentially feminine, like the frosting on a little girl's birthday cake, but now they are worn by men in solidarity with women and without seeming less masculine—after all, pinks and roses are related to red but take a more tender approach.

If you love pinks and roses, you are talented though not overly ambitious. You are charming and warm and are probably an incurable romantic who enjoys creating ceremonies and special occasions. Pink people are friendly but tend to keep their inner feelings hidden, as they often sublimate that bit of red that sometimes peeks through.

If you dislike pink or rose:

Some people are simply indifferent to pink. It is sweetness, innocence, and naiveté—red with tempered passion. So if you dislike pink or rose, you're looking for excitement in your life, and these lighter forms of red simply don't do it for you.

If you like (or dislike) Hot Pink:

Hot pinks and shocking pinks are much more closely related to red than the softer pinks or roses, so they feature many of the same characteristics as the "mother color" of red. If you read the red messages listed previously, they can apply to you as well.

PINK OR ROSE

If you like pink or rose:

These are softened reds, so they temper passion with purity. There is no blatant sensuality in pink or rose as there can be in red. Pink and rose are associated with romance, sweetness, delicacy, refinement, and tenderness. Pink people are interested in the world around them, but they don't throw themselves into participating with the ardor of the red person. While red is assertive, pink is gentle. Aggressiveness in any form is upsetting to you.

YELLOW

If you like yellow:

Yellow is seen as luminous and warm because it's strongly associated with sunshine. It sparkles with outgoing activity. People who are yellow-prone are highly original, innovative, imaginative, idealistic, artistic, and spiritual, often striving for a sense of enlightenment.

You love novelty and the expression "inquiring minds need to know" really expresses your inquisitive state of mind. You are a reliable friend and confidant and have high expectations that your friends, families and co-workers are as well. You are optimistic, hopeful, and encourage others to do their best, so your friends appreciate your uplifting attitude.

Your ambitions are often realized and actualized; you are inclined to see the glass half full rather than half empty; and you usually have a sunny disposition (except for a very few bad days), which makes you a fun "playmate."

If you dislike yellow:

If you dislike yellow, more than likely you are averse to the livelier qualities of this luminous color. You are a realist—a practical, pragmatic person and probably critical of others who are not. You are somewhat skeptical of new ideas, and rather than try something innovative, you prefer to concentrate on things you know you can accomplish. Guaranteed results are important to you, because you feel it important to protect yourself from disappointment and rejection.

ORANGE

If you like orange:

Orange is a combination of red and yellow, so it takes on many of the characteristics of both colors. It is vibrant and warm, like a glorious sunset. Orange has the physical force of red, but it is less intense, passionate, and assertive. Lovers of this color work and play hard, are adventurous and enthusiastic, and are always looking for new worlds to conquer. Your ideas are unique and you are very determined.

You are good-natured, expansive, and extroverted, with a disposition as bright as your favorite color. You prefer being with people as opposed to being alone. At the same time, you are more agreeable than aggressive, and people are drawn to you because of your warmth, energy, and magnetism. Gregarious could be your middle name.

There are times when you will need to ramp down the energy level because being with you can get a bit exhausting.

If you dislike orange:

Life is definitely not a dish of gumdrops for the person who rejects orange. Nothing flamboyant or seemingly "over the top" appeals to you. You dislike too much partying, hilarity, loud laughter, showing off, and obvious intimacy. As a result, you may be difficult to get to know, if not a loner. You prefer a few genuine close friends to a large circle of acquaintances, and once you make a friend, that person is your friend forever.

BROWN

If you like brown:

The color of Mother Earth is the hue associated with substance, stability, and real sense of worth. A preference for brown means you have a steady, reliable character with a keen sense of duty and responsibility. You are the down-to-earth person with a subtle sense of humor. You prefer simplicity, comfort, quality, harmony, hearth, and home.

You are a loyal friend—understanding but firm. You have strong views and may be intolerant of others who think, talk, or act too quickly. You strive to be a good money manager (some would say say "thrifty"), drive a good bargain, and demand the best quality you can get. Quality is a key word, so it's not just about organic and homespun; there is a striving for the best that money can buy.

You might find it difficult to be carefree and spontaneous, but you often rebel internally against accepting things the way they are. You feel very uncomfortable about losing control, but will work hard to change a situation that seems unjust or unfair.

You'll make a good marriage partner and a good parent because you have a strong need for security and sense of belonging. Family life is very important to you.

If you dislike brown:

You probably fantasize about a lot of things, perhaps traveling to exotic places or racing cars. Novelty excites you, and routine drives you crazy. You are witty, impetuous, and generous. Living on a farm is not for you, and homespun people bore you. You do like people, but they must be bright and outgoing. A meaningful relationship with you might be risky business—it's hard to get you to sit still!

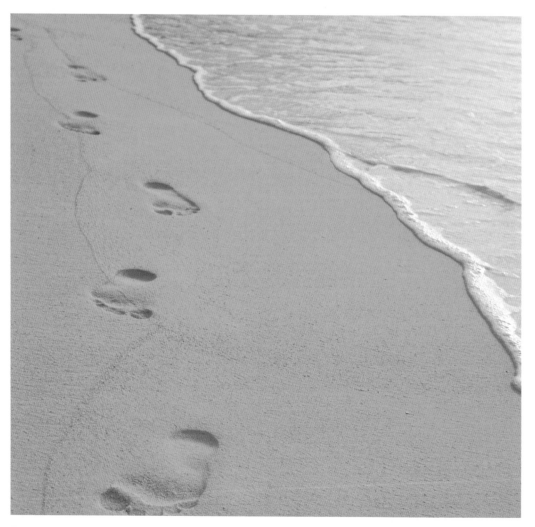

BEIGE

If you like beige:

As beige is so closely related to brown, you have many of the same characteristics as those who prefer brown, though you are somewhat less intense and serious. Creamy beiges and honeyed tones take on a lot of yellow qualities, while rose beiges take on pink characteristics. You are warm, appreciate quality, and are carefully neutral in most situations. You are usually well adjusted and practical, preferring traditional or classic looks to trendiness.

If you dislike beige:

You are less frenetic and impetuous than one who dislikes brown, but you have many of the same characteristics. To you, beige represents a beige existence—boring, bland, and tiresome. You hate routine.

GREEN

If you like green:

Nature's most plentiful color promises a balance between warmth and coolness, so green people are usually stable, balanced types. You are the good citizen, concerned parent, involved neighbor—the joiner of clubs and organizations. You are fastidious, kind, and generous, especially with your time, and, you're a good listener.

It's important for you to win the admiration of peers, so you have been called a "do-gooder." You are a caring companion, a loyal friend, partner, and family member and are supersensitive about doing the right thing and embracing a cause you feel is right. You can occasionally get a bit preachy. You are intelligent and understand new concepts, however, you are less inclined to risk something new than to do what is popular and conventional. The worst vice for a green is the tendency to gossip. Are you a little green with envy?

If you dislike green:

Since lovers of green are usually very social types, those who dislike green often put those qualities down. You may have an unfulfilled need to be recognized that causes you to pull away from people rather than joining them. You don't like thinking, looking, and doing things the way you see the majority of people thinking, looking, and doing them. Company picnics, cocktail or office parties, and conventions in Las Vegas, are not your thing as you are a bit "aloof."

Biliousness and certain bodily functions are often associated with yellow green, as are snakes, lizards, dragons, and various other creepy-crawlies. Did something slithery frighten you as a child?

BLUE

If you like blue:

The color of tranquility and peace, blue is the most preferred color. Although cool and confident (or wishing to be), blue people can also be vulnerable, so you are trusting and need to be trusted. You are sensitive to the needs of others, forming strong attachments and are deeply hurt if your trust has been betrayed.

Blue people aspire to harmony, serenity, patience, perseverance, and peace, and have a calming influence on other people. You are somewhat social but prefer sticking to your own close circle of friends. You think twice before speaking or acting. You are generally unflappable, even-tempered and reliable, a team player and good co-worker. Once they get to know you, people are drawn to you because you are so discreet and loyal—great traits in a friend.

Because of the highly developed sense of responsibility of the blue personality, you must be careful of perfectionist tendencies that may make you unrealistically demanding. Your gentleness, however, wins out.

If you have trouble falling asleep at night, count blue sheep.

If you dislike blue:

A dislike of blue may mean restlessness—a need to break away from the sameness that bores you. Perhaps you want to change your job, a relationship, or even your life, and long for more excitement. You may be tired of being "depended on," but your conscience makes you stay. You wish that you were wealthy or brilliant (or both), because that would enable you to have all the good things in life without working so hard. Deeper blues may mean sadness and melancholy to you—blue may simply give you the blues.

BLUE GREEN

If you like blue green:

Since this is a marriage of both blue and green, many of the traits for these two hues are combined, but there are added dimensions. You are more highly evolved and a bit complex. You are neat (to the point of fussiness) and well groomed. You are sensitive, but also sophisticated, self-assured, and strive for stability.

You help others and usually manage your own affairs very well. Courtesy, charm, and self-confidence are other characteristics that serve you well. Blue-greens love to dress up to elicit the admiration of others; but along with admiration, you may provoke some of the "blue-green-eyed monsters"; however, you can handle it.

If you dislike blue green:

Since love of blue green means orderliness and neatness, dislike of blue green means that, as messy as you'd like to be, a little voice inside you (was it your mother, your father, or your room-mate?) keeps telling you to clean up your room. As much as you try to ignore that little voice, it doesn't go away. You really love to relax more and not pay attention to petty details, and you prefer earthy types to fussy people.

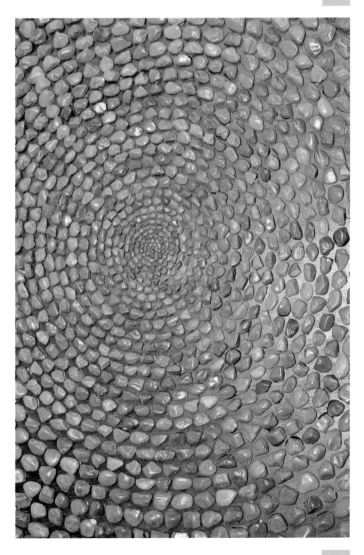

PURPLE

If you like purple:

This hue has an aura of mystery and intrigue. The purple person is enigmatic and highly creative, with a quick perception of spiritual ideas. Purple is often preferred by artists or people who support the arts. Those who like to consider themselves unconventional or different from the common herd often prefer purple. Mystical concepts hold great appeal for these dreamers who prefer purple on the cooler blue side. Those who prefer the redder side of purple are more passionate and sensual. Lovers of purple seek novel solutions through new perspectives.

You are often generous and charismatic. Purple is also associated with wit, keen observation, super sensitivity, vanity, and moodiness. Because purple is a combination of red and blue, which are opposites in many ways, you often have conflicting traits. You constantly try to balance those opposites—the excitement of red with the tranquility of blue. It has been said that purple people are easy to live with but hard to know. You can be secretive, so that even when you seem to confide freely, your closest friends may say they don't always understand you.

If you dislike purple:

If you are anti-purple, you need sincerity, honesty, and a lack of pretense in your life. You don't like to get involved unless you know exactly what you're getting yourself into. You usually exercise good judgment, and frankness is a quality you look for in your friends. You may not have any particular artistic talent, but you make a good critic!

Because of purple's association with royalty, this color may seem puffed up and pompous to you, or because of its association with mourning, you may see it as melancholy. In certain parts of the world, bright purple is worn by ladies of questionable reputation. Perhaps you're still hearing that little voice in your ear telling you that nice people don't wear purple and that is definitely not true!

LAVENDER

If you like lavender:

People who love this tint sometimes use it to the exclusion of all other colors. Just as with the purple lover, you do like to be considered different. You may have some of the same passions as purple people, but with a much softer touch. You are quick-witted and quick with compliments, but only when they are well-deserved. Gentility and sentimental leanings also go along with this color, as do romance, refinement, nostalgia, and delicacy.

The lavender person seeks refinement in life and is often a bit naïve. Yours is a fantasyland where ugliness and the baser aspects of life are ignored or denied. Good manners are important to you as are outward appearances.

If you dislike lavender:

Yours is a no-nonsense approach to life. You don't like others to be coy with you—you prefer them to be direct. Nostalgia is not your thing; you live in the present. Just as with the anti-purple people, you don't like superficiality in manners or appearance, and you usually let people know about it (or wish that you had). You may also see lavender as insipid or aging.

GRAY

If you like gray:

People who prefer this most neutral of all shades are carefully neutral about life. You like to protect yourself from the hectic world, wrapping yourself in the security blanket of a noncommittal color. You prefer a secure, safe, balanced existence, and so, unlike the reds in life, you never crave real excitement, just contentment and life on an even keel with no extremes of highs and lows. It is important for you to maintain the status quo.

You often make compromises in your lifestyle. You are practical, pragmatic, and calm and do not like to attract attention. You are willing to work hard (the gray flannel suit) and to be of service. You are the middle-of-the-road type—cool, composed, and reliable. You are the solid rock on whom others rely. If this makes you feel a little boring, the consolation is that you would consider using a splash of color to make some sort of statement. So you really aren't all that dull!

If you dislike gray:

To dislike gray is to dislike neutrality. You would rather be right or wrong, high or low but never indifferent or disinterested. Routine bores you; you look for a richer, fuller life. This may lead you to one involvement, hobby, or interest after another in the pursuit of happiness. Gray may mean eerie ghosts, ashes, cobwebs, and the dust of a haunted house or other scary gray things that scared you when you were a little kid.

TAUPE

If you like taupe:

This color also speaks of neutrality, but it combines the character and dependability of gray with the warmth of beige, resulting in a color that the French call greige. You like classic and so-called natural looks and are careful about allowing too much excitement into you life. You are practical, fair, well-balanced, and you make a good arbitrator.

If you dislike taupe:

If taupe doesn't appeal to you, it may be because it is so balanced and classic. You prefer to make a more definitive statement, whether with color or something else. You're probably not known for your subtlety.

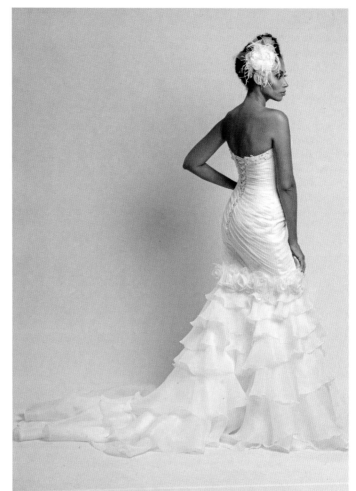

WHITE

If you like white:

White is cleanliness, purity, and complete simplicity. Those who prefer white are neat and immaculate in their clothing and homes, with everything in its place and well organized. You are inclined to be a cautious buyer and shrewd trader, causing you to be critical and fussy. If you got a spot on your tie or your scarf in a restaurant, you ask for a glass of water immediately to clean it off. White signifies a self-sufficient person, but at the same time white can also mean a longing to be young again, to return to a time of innocence and new beginnings.

If you dislike white:

Although white represents cleanliness and purity, to dislike white does not exactly mean that you are a messy person, but it does mean that you have never been obsessed with order. You are not very fussy. Things that are a little off-center are much more interesting to you than those that are perfectly in line. A little dust on the shelves or on yourself doesn't propel you into a spasm of cleaning. You are not very uptight and are easy to be with. White to you is too sterile and cold.

BLACK

If you like black:

The person who chooses black may have a number of conflicting attitudes. You may be conventional, restrained, and serious, or you may like to think of yourself as rather worldly or sophisticated, a cut above everyone else, or very dignified.

You may also want to have an air of mystery, intensity, or, as in the language of the proverbial black negligee, be very sexy.

Elegance, cleverness, personal security, and prestige are very important to you. Black is the most powerful of colors, and you feel empowered when you wear it.

If you dislike black:

Since black is the negation of color, it may be a total negative to you. It is the eternal mystery, the bottomless pit, the black hole, the Halloween witch and her black cat. It may represent death and mourning to you. Things that go bump in the night are black.

Were you frightened by the dark in your childhood? That experience could be buried in the darkest recesses of your mind and may still haunt you when you look at anything black.

Black may simply be too heavy or depressing for you to handle at this point in your life. You are uncomfortable with the super sophisticated and feel insecure in their company. You like "real" people and are not dazzled by fame.

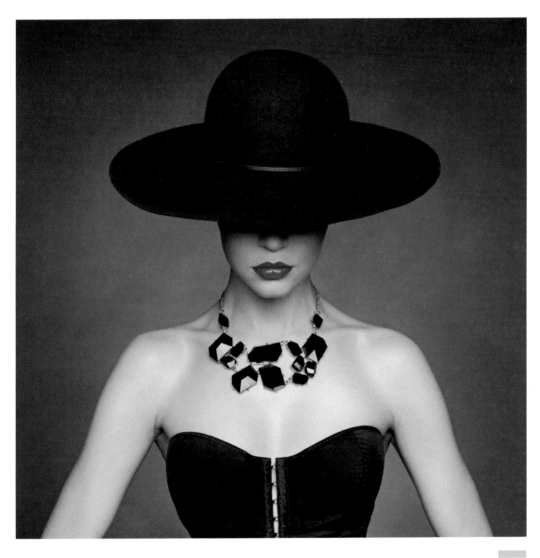

CHANGING COLORS AND CHANGING LIVES

If your favorite (or least favorite) is actually a combination color—such as caramel, which is a combination of brown and orange—you have some of the traits of both hues and a more complex personality. Some of these characteristics may actually seem in conflict with each other. For example, brown is focused on family life, whereas orange can be a bit frenetic. How much of you is orange and how much is brown?

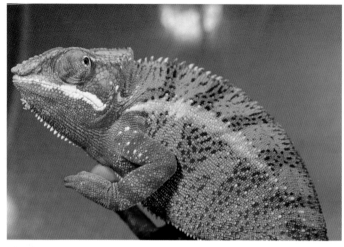

The closer to its neighbor a color gets, the more it takes on the personality of that color. A red purple is more exciting than a blue purple; a yellow orange is happier than a yellow green.

Lightening a hue takes some of the strength out of it. For example, if one of your favorites is a cream color, this is the lightest combination of yellow and brown. It never sparkles the way yellow does because it has been paled, yet the effect can still be cheering and warm. The more yellow is added, the happier the color is and so are you.

Darkening a hue adds dignity, depth, and strength. Shades like wine, dark greens, deep purple, navy blue, and charcoal gray take the basic characteristics

of those hues and make them more conservative, refined, and restrained. For example, deep wine reds like Beaujolais are positive and assured, but certainly more dignified than fiery fiesta red.

Many people who have remade their lives choose new colors to go with their new selves: people who are in periods of change, often after a breakup with a significant other or a career change. They feel like throwing everything away and starting all over again. I wouldn't suggest anything that drastic. Besides, it's too expensive. But if you are reinventing your life, maybe it's also the best time to reinvent your colors.

COLOR TRENDS AND FORECASTING

ORIGIN OF FORECASTS

Although we are inclined to think of predicting color usage as a more recent venture, forecasting color had its earliest beginnings at the end of WWI. From a commercial standpoint, it started as a way to coordinate color manufacturing through the textile and allied industries, ensuring that products across industries would complement each other. The forecasts afforded manufacturers some lead time for product planning and development so that there was less risky guesswork involved in predicting trends and more guidelines for them to follow in color selection.

Trend prediction samples started as simple color cards that illustrated the actual colors that were to be used in designs and/or products. Eventually they were developed into more robust forecasting books, catalogs, and reports complete with inspirational imagery. These could include either printed chips or paint chips, samples of yarn and/or fabric, and many are noted with Pantone specifications. *Pantone ViewHome + Interiors* is a forecast book specific to interiors and all related products, while the *PantoneView Color Planner* is applicable for all industries.

As so much of the success of a product, design, or environment relies on color usage (the stats vary anywhere between 80 to 95%), it is essential to get the best information from the most reliable and credible sources.

Forecasters' constant challenge is to keep their eyes (and ears) open to shifting patterns and cycles. Although the internet has provided a great deal of information via communication devices, if our eyes are constantly focused on those devices, we can miss the impact of the cues and clues that exist in the bountiful world that surrounds us.

How and where is trend information gathered?

TRAVEL

Those of us who are involved in the business of forecasting are intrepid travelers. We attend and/or speak at various trade shows, conventions, universities, and in-house trainings for businesses, and this gives us an international perspective. We gain a macro view gleaned from various locations and other research that will help us to expand our thinking and then zero in on specific micro influences that are appropriate to our forecasts. We must also be aware of cultural sensibilities to color in various areas of the world; with the proliferation of social networking, color trends have become more international in scope and can be shared instantaneously.

We also look at the "hot spots"—what areas of the world are gaining popularity as go-to travel destinations? A particular country and its indigenous colors can spawn new color trends.

FASHION AND BEAUTY

Both the fashion and the beauty industries have always been thought of as the forerunners of color trends that will make their way into all other industries. Although this is still true to a large extent, other design-oriented industries can and do bring much attention to a new trend. For example, the degree of shimmer and shine evident in cosmetics and fabric finishes can take the intensity of a color to a new level made possible through the marriage of technology and fashion.

Although high-end fashion still commands a great deal of attention, it is not with quite the same "trickle-down" effect that it has had in the past, when trends always started with high fashion and then descended to lower price points. Fashion designers are creating lines now for those lower price levels and that has brought a "democratization" of both style and color to the mass markets.

THE WORLD OF ENTERTAINMENT

The styles and colors that are either worn by the stars of popular television shows and films or are shown in the design of interior sets—as well as specific time periods and locations—can be very influential in formulating future color trends. Millions of people all over the world see the shows on TV or online, especially the awards shows that gain enormous attention and coverage. The show *Mad Men*, set in the 1960s, is a perfect example of how trends can find their way off the screen and into the wardrobe and interior color choices for many years.

The most important trend clues are found within animated children's films. These movies have the longest "shelf life," as they are often morphed into sequels that continue to popularize and prolong the style and color of the favorite characters.

Musical groups and stars and the colors they wear can also galvanize trends. The K Pop groups that originated in South Korea became an international phenomenon for young people, incorporating synthesized music, song, and dance routines all performed in trend-setting and colorful outfits.

The colors worn by major sports teams, the Olympics, or other upcoming international sports events, and the colors associated with their host cities or countries, are good indicators of trends that can be viewed well ahead of their actual performance dates.

THE WORLD OF ART

In years past, fine art was considered influential only to those with an interest in visiting museums and galleries and those with the disposable income to purchase art. There were patrons of art and members of the elite who supported the starving artists. This changed dramatically with the development of printing techniques that enabled convincing reproductions, allowing more people to own art. In particular, pop art has introduced many color trends that have captured the public's attention.

As they are highly popularized, a notable area for finding trends in art lies within projected traveling museum collections. Not unexpected in an American museum, the work of Andy Warhol has now made its way from Pittsburgh to the Guggenheim in Bilbao, Spain and 25 other countries. When a specific artist's work is anticipated, the colors associated with their work will often make their way into future forecasts.

SOCIO-ECONOMIC ISSUES

Social issues and causes that capture public awareness can play a large part in trend directions. For example, pink gained a great deal of attention when it first came into prominence as the symbolic color of women's breast cancer awareness campaigns in the 90s. In more recent years, men have been embracing pink as a symbol of solidarity in women's causes.

Green is another color that has steadily gained in importance, largely as a result of environmental causes that started in the late 60s and have remained an issue since then. There is no evidence that interest in this cause will wane, and many consider green as a symbolic lifestyle choice as opposed to being labeled a trend. The challenge for forecasters and designers is to keep the greens looking fresh, most often accomplished by creating unique combinations with other colors.

Although the state of the economy might sound far-fetched as an influence on trend direction, it has traditionally been an important consideration, especially when, during challenging economic times, consumers are considering the purchase of "big ticket" items. A sofa in charcoal gray seems a more practical choice than one upholstered in garnet red. However, largely because of instructive and aspirational home improvement shows and social media sites, consumers know that adding a few patterned pillows or painting a wall behind the gray sofa garnet red is less expensive than replacing the furniture. They can also buy everyday items in a wide array of hues, adding a "pop" of color without breaking the bank.

LIFESTYLES AND PLAY-STYLES

There is much to be learned by observing or researching upcoming lifestyles and answering relevant questions, such as: Are people going to be more (or less) involved in cooking and food prep? New food and beverage choices predicted for the future are often an indicator of future trends as well as the implements and products that go along with the consumption of those specific foods and beverages.

What sorts of sports activities or exercises are gaining momentum? Are they higher energy pursuits of the type that often spawn brighter colors? What about leisure time activities? Will consumers have cocoon-like pods they can retreat into for a sense of quiet and relaxation? And will they want quiet colors in those pods to encourage the needed silence and rest?

What are the design trends for the home? Do decorating trends seem to be going more in the direction of natural and organic fabrics and furnishings? Or do they appear to be more contemporary, polished, sleek, and high-tech inspired? In more recent years, we have seen less of an "either/or" mentality, allowing for more eclectic choices and styling. That is why home forecasts include several options for color palettes—there is no one definitive style direction. Consumers have different comfort levels that need to be acknowledged and not dogmatically structured for them. Trend reports deliver the design and color guidelines that are helpful to designers, manufacturers, and ultimately to the consumer.

CYCLICAL PATTERNS

In years past, colors would have a "run" that could last for just a few seasons or several years. They were "in" and then they were "out" and loudly proclaimed by some pundits as "so yesterday." Entire decades were personified by particular palettes. A typical scenario was when the psychedelic drug-culture colors of the 60s were eschewed in the 70s and replaced with more environmentally-aware earthtones.

Although there are some color families that gain more prominence within a given time period, there is less inclination to label any color family as "over." This is largely because of the trend to create more intriguing combinations and avoiding the uses of color palettes in exactly the same configurations that have been used in the past. The avocado green of the 70s can be gorgeously updated by adding amethyst or turquoise to the mix, unless a truly retro look is desired when the authentic depiction of the time is the goal, bringing avocado and harvest gold together again.

BUZZWORDS

When researching upcoming trends, it is important not only to keep your eyes open, but your ears as well. Are there words or phrases beginning to appear that are indicators of things to come or that are increasing in popularity and public awareness? Is this part of a larger movement that will continue to grow?

Wellness, the state of being in good physical and mental health, is a well-known term. It is not a brand new buzzword, yet we know that the pursuit of a healthy lifestyle is not going away. We look to new terminology as well as the trends that support the concept.

A good example of a buzz phrase is called "Forest Bathing." In English, it means "taking a walk in the forest atmosphere," as it creates calming, rejuvenating, and restorative benefits. The Japanese call it Shinrin-yoku and have practiced the art for several decades. More recently, the influence has spread internationally, and will continue to expand the concept of wellness. The forest canopy has inspired palettes of green in every area of the design world and eventually led to the choice of Pantone's Color of the Year, "Greenery," for 2017.

Similarly, "rescue" is the newest term being added to the lexicon of recycled, refurbished, re-invented, and remade goods—a newer term for a concept that is truly beyond trend and has crossed over into lifestyle. Look for the buzzwords that are going viral, or better yet, invent one yourself!

TECHNOLOGY

Technology is a more elusive concept for tracking trend direction as new advances continue to evolve at such a rapid-fire pace. There are progressing digital developments allowing for instantaneous visualization and communication that need to be examined, understood, and embraced (or not).

From a design perspective, novel surface treatments, textures, finishes, shapes, and color effects are made possible because of new or ongoing technology that would certainly play into forecasts. The sculpted look of 3D printing techniques brings new dimensions and intricacy to color. Equally impactful are the LED and other lighting methods that continue to progress technologically.

A field that traditionally was almost devoid of color—especially in electronics—industrial design has forged ahead and will continue to render meaningful research into color usage. An important area to watch, especially for finish treatments, is the automotive industry—not the cars that currently exist on the showroom floor, but those that are on the drawing board as the concept cars of the future.

NAMING COLORS

One of the most challenging (and fun) areas of color assignation is giving a color a name. In order to identify, communicate, or specify a color, a number is most often designated. While that might be sufficient for a quick ID for many projects, there are times when giving a color a descriptive name can further help to define or describe it.

The color-combination designations in this book are included in the Pantone® Plus series and used by professionals the world over. However, if you were discussing or writing about the qualities or the rationale for the selected colors, along with the number you would more than likely assign it a name.

If you are involved in selecting colors for a particular product or project, it is best to choose a name that could help to glamorize, strategize, romanticize, or tantalize the targeted customer or client. A specific purpley pink might be a visually attractive and appealing color, but calling it "bodacious" suggests it's both bold and audacious—the name gives it added sizzle. Similarly, while everyone understands the impact of a bright red, calling it "high-risk" or "racing red" really gets a revved-up message of speed and excitement across that could really help to sell both the color and the product in the proper context. When showing a client or customer various shades of brown, referring to a mocha, coffee, or chocolate will make the color significantly more likeable.

Describing a hue as a "medium grayed-green" might paint a picture of a particular shade, but naming it "herbal garden" stimulates the mind's eye and exerts a residual influence on all of the other senses as well. Whether delivered online or in-person, assigning a name to a color is especially helpful in presentations, as it can play up the attributes so important to the desired messaging.

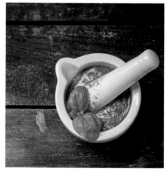

INSPIRATION FOR COLOR NAMES

The inspiration for color names can come from many sources, among them:

Natural Phenomena:
golden haze, bleached sand, moonstruck, cedar green, molten lava, cosmic sky, violet storm, lunar rock, tidal foam, twilight blue, canyon clay.

Flowers, Vegetation, and Woods: wisteria, periwinkle, golden poppy, iris orchid, cherry blossom, cornsilk, lichen, driftwood, mahogany, eucalyptus.

Minerals, Gemstones, and Metals: coral quartz, alabaster gleam, amber gold, amethyst, lapis, emerald, blue granite, silver lining, medal bronze, black onyx.

Animals, Birds, and Fish:
timber wolf, iguana, chocolate lab, flamingo, mallard green, nutria, mourning dove, white swan, robin's egg blue, lamb's wool, shrimp, koi.

Geography: Aegean Sea, Bordeaux, London fog, Rio red, Hawaiian surf, Bombay brown, calypso coral, Sedona sage.

Food and Drinks: lemon zest, pesto, pureed pumpkin, baked apple, tender greens, chanterelle, mocha mousse, frosted almond, caramel cream, fine wine, rum raisin, daiquiri, martini olive, mango mojito.

Spices, Herbs and Dyes:
coriander, ginger root, cinnamon stick, paprika, cumin, curry, basil, saffron, chili pepper, raw umber, blue indigo, tannin, cadmium, ginger root, spiced henna.

Additional color terms can spring forth from astute designers, copyrighters, marketers, authors, and colorists. It could be a flight of fancy, as in fuchsia shock or back to the fuchsia. Equally clever terms would be simply mauvelous or divine wine. A color name can convey a certain tactile quality like cashmere rose or peach fuzz, or perhaps take a simple classic light tan and elevate it into something more glamorous by naming it gilded beige. Chardonnay is far more evocative and tasteful than a light yellow and angel wing is perceived as more ethereal than a pale pink.

There has been a trend to some irreverent, funny (sometimes), and off-the-wall names, for example: jaded green, thanks-a-latte, wine not, and taupe-less and, given the right timing, product, or project, would add just the touch of humor or satire to a palette. There are names like electric banana that seem counter-intuitive, but given the right setting or targeted age group could be real attention-grabbers.

Then there are those choices that are simply not a good idea because of some really negative connotations. Unfortunately, one of the best examples is a traditional color, a brownish-reddish-purplish shade called puce. Not only does it seem a bit odoriferous, but it was referred to as pewke in early National Bureau of Standards lists! Obviously, not a good choice for inclusion

in a collection of new high-end car colors like: moon mist, silver cloud, vapor blue, greige, cream pearl, and pewke!

Crossing the line from impudence to disgusting is not recommended in color naming unless it is meant for the kids' markets. Creeping inchworm, slithering snake, squished caterpillar, or slime green might seem repulsive and icky to an adult, but kids love ick.

IMPORTANCE OF MARKETING

The American Marketing Association defines marketing as the activity, set of institutions, and processes for creating, communicating, delivering, and exchanging offerings that have value for customers, clients, partners, and society at large.

To create a market for these offerings, it is necessary to satisfy consumers' needs, wants, desires, demands, and requirements. When products or services are being marketed, they must be merchandized, publicized, advertised, and promoted. Color plays a vital part in the entire process and is a major factor in sales success.

In many instances, color actually encourages sales by attracting attention, whether in packaging, at point-of-purchase, online, or in printed matter. Color in packaging holds a promise of what lies within. Called sensation transference, the impressions and impact produced by the colors are transferred to the product in the package.

Another significant function of color is simply to make the product stand out in display and presentation or to help to distinguish it from the competition. Consumers can make up their minds about a product in a rapid-fire 90 seconds and approximately 62–90% of the assessment is based on the colors.

BRAND IMAGE

Colors are remembered more easily than words or shapes. The elegant Tiffany brand font is very effective style-wise, but people will remember most frequently the iconic Tiffany blue. UPS displays a sturdy signature imprint, yet it is brown background that is most identified with the brand.

Color is the most important factor in the design of a brand logo, playing an essential role in shaping the consumer's impression of the brand. Often referred to as "color ownership," it is an extremely valuable asset in increasing brand recognition by approximately 80%. The brand's mission, vision, intentions, and identity are all expressed by color. It becomes a vital part of the brand's personality.

When color, used singly or in combination, is consistently attached to a specific product line, service, or brand, recognition is gained and significantly retained. The imprint of the brand becomes more familiar, and memorability increases. Across all platforms, color in logos, symbols, and ideograms inform us instantly and our brain is rapidly processing those visual images.

The various attributes found in the sections on Color and Mood (p. 54) and Psychology of Color (p. 26) are essential contributors to the emotional messaging of a brand. Use those pages to validate your thinking on color choices or to provide an "aha moment" that will help you to move a project on to fruition—and at the very least, inspire you.

RESOURCES

PROCESS COLOR CONVERSIONS

The color combinations in each of the Moods in this book are based on the Pantone Plus color series. Keeping in mind that conversions are never going to be 100 percent accurate, there are several ways to match the Pantone color with an equivalent process color and its breakdown of CMYK values.

Books

Color Bridge Set

The best and most accurate guide is Pantone's own *Color Bridge Set*, for coated and uncoated color printing. (SKU: GP6102N) The *Color Bridge Set* provides a side-by-side visual comparison of Pantone spot colors verses their closest CMYK process printing match on coated and uncoated paper. The guide also includes corresponding CMYK, Hex, and RGB values, perfect for digital designers. Use *Color Bridge Set* for digital design, animation, and packaging when CMYK printing is required. The *Color Bridge Set* is available through Pantone and Amazon.

Formula Guide, Coated & Uncoated

The best-selling guide in the world for design inspiration, color specification, and printing accuracy, Pantone's *Formula Guide* (SKU: GP1601N) illustrates 1,867 Pantone spot colors with their corresponding ink formulations. Use this guide for logos and branding, marketing materials, packaging, and when spot-color printing is required.

INDEX

ABOUT THE AUTHOR & ACKNOWLEDGMENTS

About the Author

Leatrice Eiseman is a color specialist who has been called "the international color guru." Her color expertise is recognized internationally, especially as a prime consultant to Pantone, the leaders in color communication and specification. She has helped many companies to make the best and most educated choice of color for product development, brand imaging, interior/exterior design, fashion and cosmetics, or any other application where color choice is invaluable to the success of the product or environment. One of Lee's specialties is the field of color forecasting and trend direction.

She is also a sought-after speaker for trade shows, schools, in-house color presentations, and webinars on the subjects of color trends, the psychology of color and its usage, as well as consumer color preferences.

Lee's academic background includes studies in both design and business, a degree in psychology, and advanced work that earned her a Counseling Specialist certification from UCLA. She is a member of the Industrial Design Society of America (IDSA), Fashion Group International, a Chairholder in the Color Marketing Group. Her training courses and presentations have been accredited by the Interior Design Continuing Education Council (IDCEC.)

She heads the Eiseman Center for Color Information and Training and is also executive director of the Pantone Color Institute. Lee has been widely quoted in many publications and recognized by Fortune magazine and the Wall Street Journal as one of the most influential people in the world of color. This is her tenth book on color.

www.LeatriceEiseman.com

Acknowledgments

This book could not have happened without the help and encouragement of some very important people in my life. First, to my husband, Herb, for persuading me to pursue the path that led to my writing books on color, now reaching #10, and to the rest of my family, friends and colleagues who have fed my insatiable thirst for more information and resources. I appreciate the support staff at Pantone, especially Laurie Pressman, the Vice President of the Pantone Color Institute. The group at Quarto, the publishers of this book, including, Winnie Prentiss, Publisher, Mary Ann Hall, Editorial Director, Judith Cressy, Aquisitions Editor, and David Martinell, Art Director, have been wonderful to work with.

I am also grateful to my students, clients, and dedicated followers for their understanding of the importance of color, both from a personal and professional standpoint. Most of all, I profusely thank my associate, Melissa Bolt, not only for her unerring eye for color, her contribution to this book and her many other talents, but also for constantly researching on- line or in person, sprinting with me through airports, navigating cavernous trade show halls, visiting museums, stopping (occasionally) for some serious shoe shopping and nourishment in our continuous quest for all things colorful.

ALSO AVAILABLE

Color Design Workbook: New, Revised Edition

A Real-World Guide to Using Color in Graphic Design
Sean Adams
978-1-63159-292-8

From the meanings behind colors to working with color in presentations, Color Design Workbook provides readers with the vital information needed to apply color creatively and effectively to design work.

Design Elements, Color Fundamentals

A Graphic Style Manual for Understanding How Color Affects Design
Aaris Sherin
978-1-59253-719-8

Design Elements, Color Fundamentals takes an in-depth look at using color in design applications, integrating color with type and image, affecting meaning, creating order, and applying principles to effectively communicate with color.

Playing with Color

50 Graphic Experiments for Exploring Color Design Principles
Richard Mehl
978-1-59253-808-9

Playing with Color is a highly accessible, fun approach to learning color application and principles. This hands-on book includes an introduction to the philosophy of learning through the process of play, as well as experimental design projects with an emphasis on color, providing the reader with a "toolkit" of ideas and skills.

Color Harmony Compendium

A Complete Color Reference for Designers of All Types, 25th Anniversary Edition
Terry Marks, MINE, Origin, Tina Sutton
978-1-59253-590-3

A selection of content from the Color Harmony library offers readers a comprehensive reference book on the usage of color. Included is exclusive access to a downloadable application that allows users to choose layouts, logos, and package details featured in the book, experiment with colors, and print them for reference.